The FASB Conceptual Framework Project 1973–1985

To Michela

The FASB Conceptual Framework Project 1973–1985
An analysis

Pelham Gore

Manchester University Press
Manchester and New York
Distributed exclusively in the USA and Canada by St. Martin's Press

Copyright © Pelham Gore 1992

Published by Manchester University Press
Oxford Road, Manchester M13 9PL, UK
and Room 400, 175 Fifth Avenue, New York, NY 10010, USA

Distributed exclusively in the USA and Canada
by St. Martin's Press, Inc., 175 Fifth Avenue, New York,
NY 10010, USA

British Library Cataloguing-in-Publication Data

A catalogue record for this book is available from the British
Library

Library of Congress cataloging in publication data

ISBN 0 7190 3633 X *hardback*

Printed in Great Britain
by Biddles Ltd, Guildford and King's Lynn

Contents

Preface

This book is the result of a project the initial aim of which was to conduct a technical analysis of the FASB's CF. The commencement of the project in 1985 coincided with the issuance of the last of the CF output. Even at that stage, a great deal of criticism had been levelled at the CF, and one of my objectives was to investigate why this was.

Although a straightforward technical analysis of the documentary output of the FASB's effort proved interesting and informative, I soon became concerned with why it was that certain changes had occurred during the course of the CF's development. Why was it that the final result was so at variance with the original plan? Soon I was reading material from outside the normal scope of accounting, simply as a way of giving structure to my consideration of the process and pressures to which CF production was subject. Perhaps it is not surprising that one of the conclusions of the study as a whole is that the CF producers would have been well advised to have similarly considered material from outside mainstream accounting in designing their effort.

At the beginning of my work, I was an enthusiastic supporter of a CF for financial reporting. Such a framework simply had to result in better standards than the incoherent body of rules then (and now) extant. By the end of my study, I was still convinced that current standards and their method of production was unsatisfactory, but I was also less sanguine as to the likely success of a CF in solving these problems. The main load that a CF must bear is that so much is expected of it. It is *not* an answer to all ills, but it is often treated as such. What a CF can do is provide a focus to the debate that leads to a new financial reporting standard. It can force certain key issues to be faced and either answers to be provided or explanations given as to why they were not provided. Unfortunately there still exists a gap between the realistic capabilities of a CF and what is generally expected.

In Australia and the UK, CF projects are under way. It is to be hoped that this book, amongst a plethora of other comment and advice being given to those responsible will help the formulators in their task.

The inspiration behind this study was Professor Edward Stamp, Director of the International Centre for Research in Accounting at Lancaster University. The subject matter was very much a concern of his, and he was to have supervised the work involved. Tragically he died shortly after the initiation of the project and thus I was not able to take advantage of his knowledge and learning. I can but hope that he would have felt this end product to be adequate.

On Professor Stamp's death, Professor Ken Peasnell took on the role Director of ICRA and also that of my supervisor and thus it is he I must thank for providing me with much guidance. Thanks are also due for useful comments to Paul Taylor of Lancaster University and Professor John Arnold of the University of Manchester.

Generous financial support for the work was provided firstly by Price Waterhouse, and later by the Institute of Chartered Accountants in England and Wales' CATER fund, and by the International Centre for Research in Accounting at Lancaster University. Grateful thanks are due to each of these organisations. (Naturally the usual disclaimer that the views expressed in this study do not necessarily coincide with those funding the work applies here.)

One use of the funding provided by the above was the undertaking of a trip to the USA to 'get closer' to my subject matter. The warmth and generosity of those who I met whilst conducting my whistle-stop tour will long stay with me. Amongst these were (with their positions then):

Robert Sprouse	Professor, San Diego State University and former FASB Board member
Frank Weston	Former partner, Arthur Young and member of the Trueblood Study Group
Philip Bell	Professor, Rice University, Houston
Stephen Zeff	Professor, Rice University, Houston and FASAC member
Todd Johnson	Former (and now once more) FASB staff member and then Professor, University of Houston, Clear Lake
George Staubus	Professor, University of California, Berkeley and former FASB Director of Research
Robert Sterling	Professor, University of Utah and former FASB Senior Fellow
Robert Mautz	Editor, Accounting Horizons and former FASB advisor
Paul Miller	Professor, University of Colorado, Colorado Springs and former FASB staff member

Ken Meisenger	Professor, University of Colorado, Colorado Springs
Oscar Gellein	Former FASB Board member
Robert Streit	Senior Partner, Ernst & Whinney, Chicago and former Trueblood Study Group staff member
David Solomons	Emeritus Professor, University of Pennsylvania and former FASB advisor
Michael Alexander	Director, The International Forum, University of Pennsylvania and former FASB Director of RTA
Robert Anthony	Emeritus Professor, Harvard Business School and former FASB advisor
Richard Keeling	Partner, Arthur Young, New York
Don Kirk	Former FASB Chairman
Ray Lauver	Former FASB Board member
David Mosso	FASB staff member and former Board member
Tim Lucas	Current FASB Director of RTA
Reed Storey	FASB Assistant Director of RTA
Halsey Bullen	FASB Project Manager
Len Tatore	FASB Manager, Project Administration
Caroline Linn	Documentation Specialist, FAF

Without the help of each of the above, I could not have gathered as much information as I did, nor done so in such an enjoyable manner.

Back in Lancaster, others helped in a variety of ways. Brian Kirtley conducted computer data-base searches remarkably quickly, and the academic staff did their best to keep me on the straight and narrow. Special mention should be made of Robert Yaansah, my 'cell-mate' for three years, for his efforts to keep me cheerful.

Last, and certainly not least, I wish to thank my wife Michela who has put up with me whilst effort became thesis and, eventually, book.

In addition to these personal thanks, formal acknowledgement must be given to the publishers who have allowed some of the diagrams included in this work to be reproduced. These are: Australian Accounting Research Foundation, for Figure 17; Basil Blackwell, for Figure 13; and Financial Accounting Standards Board, for Figures 6, 7, 9, 11, 12 and 18. Copyright by Financial Accounting Standards Board, 401 Merritt 7, PO Box 5116, Norwalk, Connecticut 06856-5116, USA. Reproduced with permission. Copies of the complete documents are available from the FASB.

Lancaster
October 1991

Figures

Appendices

Abbreviations

AAA	American Accounting Association
AIA	American Institute of Accountants
AICPA	American Institute of Certified Public Accountants
APB	Accounting Principles Board
ARS	Accounting Research Studies
ASR	Accounting Series Releases
CAP	Committee on Accounting Procedure
CPA	Certified Public Accountant
FAF	Financial Accounting Foundation
FASAC	Financial Accounting Standards Advisory Committee
FASB	Financial Accounting Standards Board
FEI	Financial Executives Institute
FRB	Federal Reserve Board
FTC	Federal Trade Commission
GAAP	Generally Accepted Accounting Principles
GASAC	Governmental Accounting Standards Advisory Committee
GASB	Governmental Accounting Standards Board
SAS	Substantive Authoritative Support
SEC	Securities and Exchange Commission
SFAC	Statement of Financial Accounting Concepts
SFAS	Statement of Financial Accounting Standards

In addition, this study makes reference to a large number of documents produced by the FASB during its Conceptual Framework project. To avoid repetition of the long and often cumbersome titles of these documents, a system of abbreviations has been used. Each document has a unique abbreviation, mostly based upon the following categories of documents:

	Abbreviation
Discussion Memorandum	DM
Research Report	RR
Invitation to Comment	ITC
Exposure Draft	ED
Statement of Financial Accounting Concepts	SFAC

A full list of these documents is provided in Appendix 2 of the study and hence is not repeated here.

Introduction

In 1973 the newly-formed Financial Accounting Standards Board (FASB) embarked upon a project to produce a conceptual framework for financial accounting. It was to be a key element in the FASB's future work, providing the constitution that was to govern the Board's setting of accounting standards.

Destined not to end until 1985, the project touched upon most of the major theoretical issues in financial accounting. In so doing it stimulated wide-ranging debate and caused much controversy. It consumed resources, in terms both of money and personnel, on a colossal scale.

In short, the Conceptual Framework project was the longest, most expensive, and arguably the most important formally-constituted research programme in the history of accounting. It has not, however, come to be regarded as the most successful: superlatives have been applied to its inputs, but not to its outputs. For example, Anthony [1987, p. 75] felt able to state: 'There are only a few fundamental issues in financial accounting. The FASB ducked them all.' This was not an isolated view. For the most part, comment on the project has been critical, ranging from disappointment to disparagement, e.g. Solomons [1986b]. It has been claimed (by, for example, Agrawal [1987]) that the end products of the formulation process (Statements of Financial Accounting Concepts or SFACs) were ambiguous, incoherent and internally inconsistent, and that the framework as a whole was incomplete. The view most commonly expressed has been that the project failed to live up to expectations. But how could this come about? How could a well funded programme conducted by the elite of the American accountancy world apparently produce such an unsatisfactory result?

This study seeks to answer questions such as these, but it also considers whether these are the most appropriate questions. In addition to

the above, perhaps one should also ask whether the result really was so unsatisfactory; was the criticism justified? Have the adverse comments, which arose largely due to unfulfilled expectations, really considered the most important aspects of the project? Surely there is more to be gained from examining the project than a simple 'proof' of its failings?

To find answers to these questions, this study widens the perspective normally adopted in this area by following an historical, even an archaeological, approach. It takes as a premise that, like any other artefact, the conceptual framework may be studied in (at least) two ways. Firstly, one may ask if it is intrinsically a good piece of work: is it technically satisfactory and successful in its own terms? Secondly, one can assess what it can tell us about the people involved in its production, the societal circumstances that brought it about, and the formulation process. In this particular case, the former involves a study and analysis of the conceptual framework in theoretical terms. The latter is approached by assessing relevant evidence in terms of models of individual and social behaviour. This second objective, of seeking to understand the process, ultimately promises to be more rewarding. Whilst, as with (say) a flint tool, technical aspects may of themselves be interesting, the social implications are more profound.

In addition, much may be learnt of value to a project such as this in a context other than the USA, for example in the UK. Important issues may be identified from the American work, the resolution of which could lead to more successful future attempts to produce a CF.

Sources of evidence

As noted above, this study involves, in part, the assessment of relevant evidence utilising behavioural models. Obviously before these models may be applied, evidence must be gathered, sifted and organised. For this study, much of the collection of evidence took the form of an historical investigation in which great use was made of the literature surrounding the topic. Not surprisingly, given the epic scale of the American CF project, no existing single piece of work provided a complete picture of the FASB's effort. Thus it was necessary to construct such a picture (although it is not claimed that this study provides a 'full' picture: even a study such as this is too small to encompass the FASB's project).

Two main procedures were adopted in order to produce the necessary picture. Firstly, extensive use was made of documentary evidence. This

took a number of forms, including articles in academic journals, news stories in practitioner-oriented magazines, the news releases (Status Reports) of the FASB itself, the FASB Board Minutes, and books by those either involved in the events surrounding the project or observers of it. In addition and even more importantly, the actual documents produced as part of the CF project were all read, analysed and assessed.

Secondly, a series of fifteen interviews was conducted in the USA in September and October 1988 with people who had either been involved in the project, had been close observers of it, or were involved in its initiation. The interviewees included past and present Board members and FASB staff, and academics and practitioners with an interest in the topic.

The interviews were semi-structured. For each interview, a series of questions had been prepared in advance, and the answers to these formed the core of each interview. However, when the interviewee deviated from the intended subject of questioning, he was allowed to continue so that new insights might be gained. (On a number of occasions this led to new lines of questioning which were pursued further in later interviews.) In such circumstances, both open and closed questioning techniques were utilised, in order to obtain maximum information in the most efficient manner.

A caveat is necessary here. As in interpreting the results of any interview, one is to a major extent reliant upon the openness and honesty of the interviewee. It is possible to argue that, in describing the circumstances surrounding the production of the CF, some of the interviewees would have reason to colour their description to favour their own point of view. Whilst possible, no substantial evidence was found to support such a contention. When describing particular events, even those with widely differing viewpoints agreed on the main points. No major discrepancies were found in the course of the interviews. This cross-checking of information lends weight to the results obtained.

In addition, where matters considered too sensitive to discuss were raised, interviewees simply declined to answer questions. This suggests that they were prepared to be open within certain bounds. Such behaviour, unless part of a well-prepared 'cover story', seems inconsistent with a desire to mislead.

Thus it is felt that the information gathered by the interviews may be relied upon. This is not to say that it is free from subjectivity; clearly it cannot be, but this bias is unlikely to be worse than that found in other sources. Indeed, subjectivity is a topic that recurs throughout this study: subjectivity in the information gathered, subjectivity inherent in

the process of writing history,[1] and subjectivity in the procedures adopted in trying to detect influence. Whilst subjectivity may be recognised as undesirable, it cannot be eliminated in any of these contexts. Caveat lector!

Outline of the study

The study is structured as follows. Chapter 1 provides context and background: it describes and analyses the circumstances of the conceptual framework project's birth. Noting the institutional structure underlying the key events, the chapter concentrates on the conditions that initiated the project. It considers why, when the profession was faced with major problems, the solution that led to the development of a conceptual framework was chosen.

Consideration is given in Chapter 2 to the issues underlying the way in which the FASB approached its CF project. The Board's original intention is discussed and this is then put into context. Alternative approaches to the production of a CF are also considered. Finally, the reasons why the FASB project might have been expected to fail are covered: philosophical, theoretical, political, and expectational factors are assessed, as is past experience of such attempts.

Chapter 3 examines the reality of the CF project. Starting with background information about the FASB and the start of the CF project, details of the inputs (resources, money and personnel) and outputs (mainly documentation) follow and the latter are analysed in terms of timing, volume, etc. The output is categorised into 'families' according to subject matter. The results of a detailed textual analysis of the output of the project are then presented. The coherence, completeness and clarity of the documents are discussed, and the various textual changes that occurred in the resulting documents are noted and possible reasons for these changes are suggested.

Chapter 4 describes various models that may shed further light on the formulation process, and consider whether they offer, individually or together, an explanation for the events previously noted. These models relate the reasons why particular individuals or groups might wish to influence the outcome of the CF project to the ways in which they could exert such influence. The possibility of the 'capture' of the process by particular interest groups is considered, as is the influence of individual personalities on the outcome of the work.

Chapter 5 considers the influence of the conceptual framework on

developments both inside and outside the USA. Within the USA, the effects on communication with the financial community, and changes to accounting education and to accounting standards are considered. Outside the USA, the influence of the CF on other conceptual framework projects is assessed.

Finally, a summary is offered of the study, and conclusions drawn from it. An assessment of the conceptual framework produced by the FASB is given, questioning whether the project was beneficial to the US accounting profession. The appropriateness of such a project for other countries is also considered.

Note

1 See Chapter 1 for a discussion of subjectivity in historical research.

1 Background and Origins

Introduction

The Conceptual Framework (CF) project was a child of the sixties. It developed from the chosen response of the American accounting establishment to a crisis: a crisis caused by a series of problems that had rumbled on for most of that turbulent decade. Centring on various aspects of the setting and enforcement of accounting standards, these problems had their origins in earlier years. However, it was in the sixties that they finally came to a head. As Briloff [1972, p. 16] put it: 'the accounting profession is in a serious state of disarray – involved in litigation of new seriousness and magnitude, with its principles seriously challenged . . . and its function confronting a credibility crisis.' Understanding the direction taken by the CF project involves appreciating firstly, the origins of the crisis itself, and secondly, why the selected response was in fact chosen. This chapter considers these questions and shows how the crisis and the chosen option were causally linked by events that had occurred previously in the development of accounting principles.

A major consideration that permeates all of the following is the tension that exists in the USA between the accounting profession and the government. The regulation of financial reporting has involved, for the most part, a delicate balancing of the desire of the profession, in the form of the American Institute (AICPA or, pre-1957, AIA), to be responsible for matters pertaining to accounting, and the Damoclean threat of government (state or federal), through its various agencies, to take over control of rule-making.[1]

The chapter is structured as follows. Firstly, the problems causing the crisis of the 1960s are examined and their origins sought. In the course of this, reference will be made to a number of previous crises that in many ways parallel that of the sixties. Having discussed the problems,

the options available as a solution are considered and an explanation given of the choice made. It is suggested that, at the time, an undertaking such as that chosen was the only viable response open to an accounting establishment wishing to retain both credibility and a major say in the regulatory process. The way the selected option led to the CF project is also considered. Finally, a summary and reflection upon the foregoing are given.

A digression: the writing of history

Before commencing this exposition, some reference must be made to the view of history underlying the work, for in substance this chapter is largely an historical analysis. Many differing views have been expressed on the way in which history may (or should) be written. Various associated problems have been tackled. For example, Collingwood [1946], following Dilthey and Croce, stressed the need for empathetic 're-enactment' by the writer with the participants in the historical events he describes. Additionally some writers, Collingwood amongst them, have argued that writers should seek to interpret history in a way that would be acceptable to those very participants, or (per Lovejoy [1959]) that only those events seemingly important to the participants should be selected for examination.

A simple reply to both arguments is that they place unrealistically narrow limits on the method of writing history. Whilst both arguments have merit in suggesting useful perspectives from which to view historical events, they should not be the only ones. Gardiner [1974, p. 11], summarising Walsh [1967] neatly puts this point of view, as follows:

> history is commonly presumed to have aims that reach further than the explanation of why men behaved as they did, the eliciting of their intentions, policies, or principles. It also typically concerns itself with the outcome – whether anticipated by them or not – of their actions and (more generally) with such things as processes of development . . . to which they often contribute without being aware of doing so. There is, in other words, a clear sense in which the historian's retrospective vantage point enables him to discriminate pervasive patterns or themes in the past and thereby accord to events a significance not the less real for having been unenvisaged, and possibly unenvisageable, by contemporary participants or observers.

In addition, both of the above arguments involve a view of objectivity, a goal towards which writers of history are generally believed (however wrongly) to be striving. However, 'pure' history is not possible. Carr [1961, p. 23] summed up this as: 'History means interpretation.' He

went on to describe (p. 30) the method that is (inevitably) used in this study:

> The historian starts with a provisional selection of facts and a provisional interpretation in the light of which that selection has been made – by others as well as by himself. As he works, both the interpretation and the selection of facts undergoes subtle and perhaps partly unconscious changes, through the reciprocal action of one or the other . . .

Thus a picture is built up. It is not objective. Facts, selected subjectively, and hence impure, are presented to the reader. Making the reader aware of the limitation is all that the writer can do.

One further comment is appropriate. In writing this chapter, great use was made of two works on the history of US accounting and standard setting. These were Carey's [1969] and [1970] chronicle of the AICPA, and Zeff's analysis of the profession's forging of accounting principles [1972]. Thus, in large part, secondary sources have been used. However, in addition, information gathered in the series of interviews referred to in the introduction was used to check and confirm the matters covered.

The crisis of the 1960s

The matters that together led to the crisis of the late 1960s may be split into those that formed its substance:

(a) the setting of accounting standards;
(b) flexibility of permitted accounting methods;
(c) fraud and the auditors' role in its detection.

and those that eventually precipitated it, being actions taken by:

(d) the American Accounting Association (AAA);
(e) Robert Trueblood of Touche Ross & Co.

Each of these will now be considered in turn.

The substance of the crisis

The Setting of Accounting Standards
The main substantive reason for the credibility crisis of the late 1960s was difficulties experienced in the setting of accounting standards. This

section considers those difficulties in terms of the institutions and people involved, the view taken of the nature of standards, and the eventual crisis-generating events.

Institutions and their interaction

To understand the events of the 1960s, it is necessary to have some appreciation of the way in which the American accounting profession was organised and the way in which it interacted with other bodies. The following is a summarised history of the institutions involved in the development of accounting standards in the USA. More detailed accounts are to be found in Storey [1964], Carey [1969 and 1970], Zeff [1972], Skousen [1976] and Sprouse [1983].

The determination of accounting standards and disclosure rules in the USA has involved both government and private sector institutions. Of the government bodies, the two most important in this respect have been the Federal Trade Commission (FTC) and the Securities and Exchange Commission (SEC), the latter more so in recent years.

Both of these organisations were set up in response to crises in the financial markets, and in turn stimulated responses by the accounting profession. The FTC was instituted by the Clayton Antitrust Act of 1914 which was a belated response to the credit crisis of 1907. The SEC was formed under the Securities Exchange Act of 1934 that constituted, with the Securities Act of 1933, the Roosevelt government's response to the Great Crash of 1929.

The profession, not responsible for either crisis, on each occasion found itself dealing with a new organisation that might usurp its authoritative position in accounting and reporting matters. In response, it was forced to make more coherent its position on what were then termed accounting principles in order to placate the newcomer. This involved, respectively, an agreement in 1916 with the FTC and the Federal Reserve Board (FRB) on uniform accounting and auditing methods, and in 1936 the restructuring of an existing AIA committee into the Committee on Accounting Procedure (CAP), the first formal 'standard setting' body. In the latter case even this was insufficient: further enhancement of the CAP's role and resources was necessary before the SEC ceased, for a time, to drop hints about stepping in and formulating rules itself, as it was entitled in law to do.

The CAP itself had about twenty members (the number varying over time), all of whom were members of the AIA. Most members were in public practice, and all served on the committee in a part-time, unpaid capacity. Initially there was no research support for the CAP within the

AIA, and so committee members made use of staff in their own firms for this purpose. Not surprisingly, these facts led to criticisms of the CAP on the grounds of lack of independence and susceptibility to outside influence.

The output of the CAP consisted of Accounting Research Bulletins (ARBs) which catalogued 'accepted' practices, without seeking to prescribe or proscribe. Thus no underlying philosophy was apparent. However, the methods described by ARBs were accepted by the SEC for use in filed accounts.

The role of determining accounting principles was carried on by the CAP until 1959 when it was replaced by the Accounting Principles Board (APB). The change was initiated by concerns over the number of accepted practices and the vagueness of the term Generally Accepted Accounting Principles (GAAP). Symptomatic of these feelings was the intervention of Leonard Spacek, managing partner of Arthur Andersen & Co. In the mid-1950s he launched a series of hard-hitting attacks on the quality of financial reporting. As an example of his style, Carey [1970, p. 77] quotes a speech Spacek gave in Milwaukee: 'There is only one reason for misleading financial statements. It is the failure or the unwillingness of the public accounting profession to square its so-called principles of accounting with its professional responsibility to the public.' The uproar that not surprisingly ensued was widely reported, and the AICPA found itself with an internally generated crisis of confidence: its credibility was in doubt.

The response was led by the 1957 president of the AICPA, Alvin R. Jennings. An advocate of greater emphasis on accounting research, his proposals for reform resulted in more resources being devoted to that end. With a new organisation and structure, the APB was born to replace the CAP.

Despite the changes, Carey [1970, p. 95] states that: 'The [APB] itself, however, was not much different from [CAP], which it succeeded', it too being a committee of the AICPA. Again, committee members were all members of the AICPA, part-time and unpaid: the old criticisms could still be levelled. However, on the APB the 'Big Eight' accounting firms were guaranteed representation, often in the form of their senior partners. This was to ensure Big Eight support for APB pronouncements: in fact, it opened the way for accusations of undue influence by these firms.

Another change made in the transition from CAP to APB was to give seats to academics and Certified Public Accountants (CPAs) from industry and commerce, the first move towards wider representation in

standard setting. The new emphasis on research was exemplified by the creation of a Research Division within the AICPA with its own director. This replaced the Research Department, which dated from 1939. The new Division provided support for the APB, with research output taking the form of Accounting Research Studies (ARS's), and APB Statements. Accounting principles were formalised and, to a degree, prescribed in APB Opinions.

The APB was the body that was responsible for determining accounting principles right through the 1960s with, in 1965, major changes made to its structure and working methods. Initiated by the new AICPA chairman, Clifford V. Heimbucher, these changes included revised drafting procedures, a new planning committee, and the streamlining of administrative functions. Also at that time, most Big Eight firms ceased to nominate their senior partners to the APB, although the domination of these firms continued (see Zeff [1972, pp. 192–3]). Thus it was a much revised APB that found itself under attack when the crisis broke.

The government body that had the greatest effect on accounting matters from the 1930s onwards was the SEC. As noted, this was set up under the 1934 Securities Exchange Act. Its powers were, and are, considerable: for example, companies wishing to issue shares or have their shares traded must register with the SEC and abide by its requirements. Additionally, and more significantly from the standard setting point of view, the Commission was given the right to control the form and content of financial statements and other reports of companies registering with it.

This might have been expected to mean an end to the profession's authoritative position in determining accounting practice. However, from the start the SEC was largely content for the Institute to continue doing this, provided the results were considered satisfactory. Initially, 'everything seemed to be going well, so far as the accounting profession was concerned. The SEC seemed friendly, tolerant and flexible' (Carey [1969, p. 200]). This did not last, however. In 1936–7, speeches by the chairman of the SEC, James Landis, and the Commission's Chief Accountant, Carmen Blough, indicating dissatisfaction with the GAAP of the time, stimulated the changes made to the CAP noted above. From then on the tension referred to earlier developed. Carey [1969, p. 202] summed up the position as follows:

> In the years ahead SEC spokesmen alternated between praise of the profession's substantive contributions to improvement of corporate reporting, and frank criticism of the profession's failures of omission and commission. The criticism was sometimes mingled with thinly veiled threats that the

Commission might exercise its latent powers to prescribe accounting principles and methods if the profession did not move forward more rapidly.

Thus, to summarise the above, there occurred over time within the profession a gradual increase in the appreciation of real research effort in the determination of accounting principles. Additionally there was a broadening of the membership of the committee responsible. However, these changes occurred within a context of largely unchanged basic organisation and structure, and a continuing uneasy relationship between the profession and the SEC. Also, the manner in which accounting principles were approached changed: initially they were merely catalogued, but later they were prescribed. This aspect is now considered in more detail.

The Nature of Accounting Standards
It has been noted that at its inception the SEC was content to let the AICPA deal with matters of accounting principle. Whilst true, this is not the whole story.

In 1938, the SEC set out its position:

> In cases where financial statements filed with this Commission [per the Securities Acts 1933–4] are prepared in accordance with accounting principles for which there is no substantial authoritative support, such financial statements will be presumed to be misleading or inaccurate . . . In cases where there is a difference of opinion between the Commission and the registrant as to the proper principles of accounting to be followed, disclosure will be accepted in lieu of correction of the financial statements themselves only if the points involved are such that there is substantial authoritative support for the practices followed by the registrant and the position of the Commission has not previously been expressed in rule, regulation or other official release of the Commission . . . (ASR No. 4 [1938])

A number of points arise from this:

(a) the Commission's views, if publicly expressed in documents such as Accounting Series Releases (ASRs), dominate;
(b) if no such view has been published, accounting principles used must have 'substantial authoritative support' (SAS); and
(c) the possibility of disagreement admits of a number of possible principles having SAS.

This last point is the key to many of the later problems. GAAP, a concept arising in the 1930s, may consist of any number of possible

accounting treatments of a given transaction. Provided a practice has SAS, it is acceptable to the SEC. But what is SAS?[2]

The SEC recognised the pronouncements of CAP/APB as constituting SAS, and thus were seen to back up these pronouncements. (This is sometimes described, rather loosely, as the accounting profession determining the principles and the SEC enforcing them. Given the voluntary status of such pronouncements until Rule 203 of the AICPA's Code of Ethics was changed in 1971, there was a degree of truth in this at the time.) These may not, however, be the only accounting principles with SAS. What, then, if a clash occurs? This question long bothered American accountants, and was the subject of much debate. It came to the fore in 1957–64 when the status of APB Opinions in particular was questioned.

At the start of the debate, 'the authority of Opinions rested on their general acceptability' (Carey [1970, p. 96]) and departures had to be disclosed. However, in 1964 it was proposed that Opinions 'shall be considered as constituting the only GAAP(s) in the subject area for purposes of expressing an opinion on financial statements' (Carey [1970, pp. 111–12]). Thus, from being a preferred alternative, an Opinion-sanctioned method would become the compulsory method.

The eventual outcome backed away from this view, turning to the formula that GAAP were principles with SAS: Opinions constituted SAS, but other SAS-supported principles could exist, i.e. a restatement of the SEC view. This end result smacked of compromise and left the room necessary for the later controversies to develop. However, the debate revealed various views on the status of accounting principles that are of interest.

Firstly, principles were originally seen almost as the culmination of a contest between competing methods: a Darwinian view that the fittest method would dominate. Accountants were not prepared to wait the requisite number of generations to see if this were so: variation of method was felt undesirable, and this influenced the change of view to principles as standards, i.e. a selection of one (or more) method(s) from many.[3]

Secondly, some have questioned whether this implicitly inductive method of deriving standards is appropriate, a more deductive, conceptually-based approach being advocated. In this respect, a split between the AICPA and the American Accounting Association (AAA), the educators' body, has always been evident, the latter favouring deduction (see AAA [1977]).

This latter point also reveals a disagreement over the 'tactics' of

standard setting. Concomitant with the inductive approach is a tendency for the standard setting body to indulge in 'fire-fighting', that may (and usually does) lead to inconsistent standards. The deductive approach requires a more conceptual view, a basis from which to deduce. The perceived failure in the 1960s of the dominant fire-fighting approach gave weight to a more conceptual approach as a preferable option.

Crisis-generating events in standard setting
The institutional structure and interrelationships and approaches to standard setting outlined above provided the framework not only for development, but also within which problems could arise. Specific accounting issues triggered the eventual crisis in the 1960s. The first of these was the investment credit fiasco. This came about as a result of the 1962 Revenue Act that included a clause seeking to promote investment by businesses. Allowance would be given for tax purposes of up to 7 per cent of the cost of certain designated assets.

Two main possible accounting treatments were apparent:

(a) deferral i.e. the tax saving to be allocated over the life of the asset, say by reducing its book cost and therefore subsequent depreciation charges, thereby allocating the benefit derived over the related accounting periods;
(b) flow through i.e. taking the whole saving obtained in the year of acquisition.[4]

The initial APB vote on the issue was 12-2 in favour of deferral. Responses to the subsequent exposure draft were, however, evenly split, and the SEC seemed to favour flow through (Carey [1970, p. 100], Zeff [1972, p. 179]). The final vote on APB Opinion No. 2 was 14-6 in favour of the deferral method, with the six dissenters stating that either method should be allowed. (Zeff also reported that the Big Eight accounting firms were split 4-4.)

Such was the dissent on the topic and such the concern that the SEC might not support the position adopted that a meeting between the AICPA and the SEC was organised in December 1962. On 10 January 1963, however, the SEC issued ASR No. 96 that stated that for filing purposes the Commission would accept either the deferral or the flow-through method, there being SAS for both. Without SEC support, APB Opinion No. 2 was left high and dry. The APB admitted as much two years later by issuing Opinion No. 4, which adopted the SEC position of allowing either method.

Although one can see that in part the failure of Opinion No. 2 derived

from the belief then held that accounting standards must rest on general acceptability, the result was nevertheless a severe jolt to the APB's prestige and credibility. Indeed, the moves in 1964 to change the status of Opinions can be seen to have been influenced by these events.

As Carey added, there was a 'field day for the press' ([1970, p. 104]). Talk of 'splits in the profession', 'squabbles', and 'clear defiance' by three of the Big Eight firms (who had stated that they would not expect their clients to follow Opinion No. 2) clearly undermined any hopes of presenting a united front to the watching world. Similar problems seemed likely to erupt later, in 1967, over APB Opinion No. 11 on deferred taxes and again, in 1968, over Opinion Nos. 13 and 14 relating to banks. Internal disagreement was on each occasion made public.

However, the straws that broke the camel's back were the interrelated topics of business combinations and goodwill. Both, but particularly the former, were of considerable public interest, thanks in part to the press comment of Abraham Briloff and others (see Briloff [1972]). Also, the SEC again seemed ready to step in should the APB fail to act swiftly (Zeff [1972, p. 213]).

Merger accounting (or pooling of interest) was then (1968–9) flourishing. The debate that the APB had to resolve was whether this particular accounting treatment was acceptable and should be permitted in future. The initial draft Opinion of July 1969 was that pooling should not be permitted, a position favoured by the FTC (Zeff [1972, pp. 214]).

As a parallel topic, the treatment of goodwill (the level of which is in large part dependent on the form of business combination accounting adopted) had to be decided. Effectively the choice was between writing off and not writing off the goodwill to the income statement, thereby reducing reported profit. The initial position was to write off, over not more than forty years.

When these initial positions became known publicly, a campaign was launched by many in business against the Opinion. This seemingly succeeded, for the next draft approved of pooling under certain defined conditions.

From that point on, the debate degenerated into a squabble over the specific rules (on size tests, previous levels of ownership, rights of the shareholders, etc.) that should hold when pooling was permissible. However, the shades of opinion held made obtaining a decisive vote on the Opinion difficult. Eventually, in July 1970, a compromise was achieved and APB Opinion No. 16 on business combinations and No. 17 on goodwill were passed.

These events had exasperated many and revealed the process of deter-

mining accounting principles to be as much a matter of argument and politics as refining the best practice of the day. The whole affair had tried the patience of many beyond endurance. As Zeff [1972, p. 216] put it: 'These two Opinions, perhaps more than any other factor, seem to have been responsible for a movement to undertake a comprehensive review of the procedures for establishing accounting principles.' It would seem that this in itself would have been sufficient to precipitate the crisis. However, there were other, connected factors that also played a part.

Flexibility of permitted accounting methods
The existence of more than one recognised accounting treatment for a given transaction type has for a long time given rise to disquiet. This may in part derive from the belief of some that there is one 'right' way to account for each transaction. Such a view was to some extent supported by early attempts to establish accounting principles (the 'Darwinian' view noted above).

An additional fear is that the availability of a number of methods can be manipulated by preparers of financial statements. By changing accounting methods at appropriate moments, a rosier view of the company's financial position may be presented. (This has given rise to a vast literature on the efficacy of such procedures. For reviews of the efficient market/naive investor hypotheses literature, see Dyckman and Morse [1986] and Watts and Zimmerman [1986].)

However, the main concern is that even the legitimate use of different methods reduces the comparability of company financial statements. Such comparability is considered important by those involved in investment analysis and similar functions, facilitating the assessment of companies within, and between, market sectors.

The problems that can arise when accounting standard setters try to resolve such divergencies have been discussed above. Their involvement, though, is indicative of the desire to reduce the options open to preparers and hence promote comparability. James J. Needham, SEC Commissioner, in a 1970 speech stated it simply as: 'The [APB] is the acknowledged body responsible for reducing the number of alternative ways of reporting seemingly identical events' (Zeff [1972, p. 215]). However, flexibility can cause problems not just for accounting standards. In a number of instances, *causes célèbres* resulted from the use of accounting policies that, whilst having a degree of SAS, were other than might have been expected in the circumstances.

Prime amongst the cases that occurred in the 1960s was the sale in

1962 of the Ethyl Corporation, a company jointly owned by General Motors Corporation and Standard Oil of New Jersey. The two companies treated their proportion of the gain resulting from the sale differently: one took the gain direct to reserves, the other through the income statement. Not surprisingly, the financial press commented adversely on the difference in treatment.

Worse was to follow. In August 1966 Westec Corporation went into voluntary bankruptcy. This occurred shortly after healthy profit reports. The discrepancy of actual economic ill-health and reported fitness was attributed to 'management's choice of liberal accounting practices' (*Wall Street Journal*, 6 September 1966, quoted in Zeff [1972 p. 190]). The Forbes editorial for 15 October 1966 was scathing:

> It's past time [CPAs] were called to account for practices that are so loose that they can be used to conceal rather than reveal a company's true financial picture. . . . [Auditors'] certificates usually bear the phrase 'according to generally accepted accounting practices', a phrase which is now coming to be generally accepted as damned meaningless. (Quoted in Zeff [1972, p. 190])

Further, an element of some of the frauds noted in the next section was the use of such 'liberal' accounting practices. For example, the use of front-end loading of income occurred in a number of the cases in order to create an overly optimistic view of the reporting company.

Fraud and the auditor's role in detection

Fraud, like death and taxes, is forever with us. On a small scale it may cause distress to those affected: when large and well publicised, it can generate tremors to shake the foundations of even revered institutions, including the accounting establishment. For, although in the words of the English legal dictum, 'an auditor is a watchdog, not a bloodhound' (Re Kingston Cotton Mills (No. 2) [1896] 2 Ch. 279 at p. 288), it is difficult to convince a newly-ruined investor of the adequacy of this view.

The United States, like most countries, has had its share of major frauds. In the 1930s for example, a number of massive defalcations were discovered, adding to public concerns over the advisability of investing in big business engendered by the Great Crash. The Kruger and Toll collapse of 1932 revealed falsification, forgeries and concealed thefts. Press comment was extensive and unflattering towards accountants and accounting. Consequently, suggestions were made that accounting rules for corporations should be prescribed so as to help avoid such

occurrences. Such action was headed off by the AIA, but the threat was clear.

Six years later, the McKesson & Robbins case, where 22 per cent of a major company's total assets per the audited accounts were later found to be fictitious, led to investigations by the SEC, the New York Attorney General and the Ethics Committee of the AIA. As Carey [1970, p. 25] put it: 'The entire accounting profession was, in effect, on trial.' Again the question was raised of why the auditors had failed to detect the fraud.

The AIA enquiry led to significant changes in recommended auditing practice and the commencement of a series of 'Statements of Auditing Procedure'. These changes pre-empted and seemingly appeased the SEC, for when its report on the affair was published it stated: 'Until experience should prove to the contrary, we feel that this [AIA] program is preferable to its alternative – the detailed prescription of the scope of and procedures to be followed in the audit for various types of issuers of securities who file statements with us' (quoted in Carey [1970, p. 37]). However, the implicit threat had been made of future SEC action if matters did not improve.

Despite the changes made and the progressive development of auditing method, such *causes célèbres* did not disappear: the 1960s produced ample evidence of this fact. The 'Great Salad Oil swindle' of 1963 (see Woolf [1976]) revealed deficiencies in auditing approach of alarming proportions. And the decade came to a rousing conclusion with the exposure of National Student Marketing Corporation, Tally Industries, Penn. Central, and Continental Vending (see Stamp, Dean and Wolnizer [1980]), all of which involved elements of (at best) sharp practice. The last two were frauds showing varying degrees of sophistication, each of which had for a period managed to slip past the auditors.

Such consistent incompetence, as perceived by the investing public (whatever the SEC reports might say), fanned by withering press attacks by Abraham Briloff and others, undermined further any remaining faith in the ability of accountants. And a profession of questionable credibility has problems indeed. Again, the situation described seemed sufficient to require action.

Crisis precipitation

The substance of crisis now existed: all that was required was something to precipitate it. In the event, actions were taken by two bodies, either

of which might have been sufficient to do so: together they certainly were.

American Accounting Association

In August 1970, the AAA constituted a special committee to make recommendations regarding the setting up of an 'accounting commission'. As part of its report (see *Accounting Review* [July 1971, pp. 611–13]), seven main areas of dissatisfaction with the APB were identified. These were:

(a) its use of a fire-fighting, not a conceptual, approach, i.e. the lack of a philosophy underlying the determination of accounting principles;
(b) its being unrepresentative, CPA-dominated, and with little concern for users of financial statements;
(c) the lack of independence of APB members, many being partners in large accounting firms and thus open to influence by clients and fellow partners;
(d) the fact that many Opinions were compromises rather than coherent positions;
(e) its playing too restricted a role, i.e. the APB dealt with only financial reporting, not accounting as a whole;
(f) the lack of research of a satisfactory quality;
(g) poor enforcement of principles by the AICPA.

With the exception of (e), the complaints were those that had surfaced and resurfaced frequently since the 1930s.

An independent Commission of Inquiry was recommended, and this was endorsed by the AAA Executive Committee in February 1971. However, action by the AICPA overtook the AAA, and thus the academics deferred to the Institute's actions.

Touche Ross & Co.

As has been noted before, a number of the Big Eight accounting firms had been unhappy about certain decisions of the APB, for example with APB Opinion No. 2. Further, in November 1970, Arthur Andersen & Co. went further and expressed to AICPA president Marshall Armstrong its general disquiet over standard setting. However it was Touche Ross & Co. and in particular its chairman, Robert M. Trueblood, who took decisive action. An article by H. Erich Heinemann in the *New York Times* of 4 January 1972 (quoted in Briloff [1972, p. 319]) summarised the event:

just a little over a year ago, Robert M. Trueblood, chairman of Touche, Ross & Co., and a former president of the [AICPA], in effect threatened that his

firm – one of the largest and fastest growing of the 'Big Eight' national accounting firms – would bolt the [APB] and deal directly with the [SEC] in the setting of accounting ground rules . . .

Mr. Trueblood charged that the business of establishing accounting principles was 'dragging seriously,' that there was a large question in his mind whether the present organization of the board was 'efficient or even viable,' and he said that Touche, Ross was reconsidering 'its entire participation in the affairs of the board.'

'Under the circumstances', he said, 'I am sure you will understand that, as a practising firm of some consequence, we will maintain our right of freedom with respect to direct contact with the SEC on this and all other professional matters.'

Public comment on APB decisions was one thing; dissociation from its workings was another. The prospect of a Big Eight firm 'opting out' of the established process, even if doing so whilst restating its allegiance to the SEC, could have spelt the end of the APB. This was a bigger threat even than the defiance over Opinion No. 2.

The AICPA, already feeling the pressures described above, set up a special conference in December 1970. Thirty-five CPAs representing twenty-one major accounting firms participated. The objectives of the conference were:

(1) to unite the accounting profession in re-examining how accounting principles should be established;
(2) to isolate the principal issues or questions which would need to be considered in any such re-appraisal; and
(3) to explore the various alternative approaches to the conduct of such a study.

Reference was made at the start of the conference to the belief that more thought needed to be given to making the establishing of accounting principles 'responsive to the needs of those who rely upon financial statements'. This was not a new idea, having been discussed in, for example, ARS Nos. 1 and 3 and A Statement of Basic Accounting Theory (ASOBAT) (AAA [1966]). It was later developed in the FASB CF project itself.

The conference report recommended the setting up of two committees or study groups, one 'to review the operation of the [APB]', and the other to 'seek to refine the objectives of financial statements' (quotes from *Journal of Accountancy* [February 1971 p. 11]).

In February 1971 the AICPA's Board of Directors discussed and approved the recommendations. It even broadened the scope of the first

study group: it was no longer to be confined by presuming the continuance of the APB. Action was being taken.

The options and the choice

The AICPA conference recommended the setting up of two study groups. Other options had been open to it but were not taken. It is worth considering those options and seeking to explain why the study group path was chosen.

The options

A number of options would have been open to the conference participants. Amongst these were to:

(a) cease to set accounting standards;
(b) admit defeat, and let the government take over the setting of standards;
(c) admit defeat, and let the SEC take over the setting of standards;
(d) maintain the status quo;
(e) maintain the status quo, but with additional funding, greater research, revised procedures, etc.;
(f) form a new standard setting body;
(g) set up an advisory/investigatory committee (or committees).

Examining each of these in turn reveals why the last was chosen.

Cease setting accounting standards
At first sight this seems a strange option, but in the light of the character of the debate, it has a respectable pedigree. After all, it was only in the 1930s that principles were formally determined, and in the 1960s that standards had taken on their rule book, rather than general acceptance, connotations. The case made for a 'free market' in accounting disclosures was and remains a serious one (see Benston [1981]). However, to adopt this option would not only have voluntarily removed the AICPA from one of its primary roles, but would also have left the field open to the SEC. This, as suggested below, was unacceptable.

Government control
This of course was the unthinkable, the option that no-one in the private sector wanted. To accept this would have removed from the profession one of its main functions, thereby diminishing still further its

credibility. But it was a serious possibility, as recognised by many commentators. For example, in 1969 Leonard M. Savoie, the AICPA Executive Vice-President, stated: 'Abuses in the area [of merger accounting] have become so prevalent that prompt, corrective action will be taken – whether by the profession or by government' (Briloff [1972, p. 88]). It was quite feasible that the Federal Government could have introduced legislation to set up a new regulatory body, as it had done after the crises of 1907 and 1929. However the conference participants were not likely to suggest this option; rather, they probably sought to avoid it. In their favour was the fact that the new government bodies (FTC and SEC) resulted from major financial crises, and no new crisis of such a magnitude had occurred in the late 1960s. A negative point was the fact that the SEC was already in place and had the powers to step in.[5]

SEC control

Reference has already been made to the latent power of the SEC. The activation of those powers had been threatened on many occasions by, for example, Carmen Blough early on and Manuel Cohen (the then Chief Accountant) in the mid-1960s. Others clearly felt such action to be a possibility: for example, Anthony [1963, p. 99] summed up the situation as: 'If the [AICPA] fails in its present program for developing accounting principles, the [SEC] will act to develop these principles.' (Anthony had added, 'The AICPA effort is likely to fail.')

All was not gloom, however. Despite the many threats in the past, the SEC had not actually taken over control of standard setting. Certainly it had, by issuing ASRs or making public its views, determined the outcome of individual issues, but it had not gone further. Perhaps the reason for this was, in part, revealed by James J. Needham in 1970. He stated: 'I must inform you that, in my opinion, were the responsibility for rule making lodged elsewhere, for example at the SEC, the results would not be any different' (Zeff [1972, p. 215]).

Horngren [1972. p. 39], arguing that the APB and SEC should be viewed together, suggested that in fact the APB acted as a useful shield for the Commission, i.e. the SEC needed the APB to continue. Additionally, besides lacking the will to set standards, Burton [1973, p. 57], the then Chief Accountant at the Commission, stated that it was simply unable to do the job: 'The SEC is not in a position to establish accounting principles, even though we have the statutory authority to do so. The [accounting profession] can devote more hours and financial resources to this area than can the Commission' (quoted in Kripke [1979], reprinted in Zeff and Keller [1985]). Also, as Solomons [1986b,

p. 28] pointed out, the SEC's jurisdiction is limited. Were it to have taken control, a separate body would have been needed to set standards for non-SEC-regulated companies, and this could have led to divergent rules, an unattractive possibility.

However, such was the situation that the SEC must have been close to feeling itself compelled to act. The conference participants had to find a way of avoiding this.

The status quo

This too was an unacceptable option. This was the regime that had created the crisis: there was no reason to believe that it would be able to improve matters to any significant extent. Also, the situation had reached the stage where the AICPA had to be seen to act: inaction would have been equated with failure.

Additional funding, etc.

This too was a dead option. The same writ large was unlikely to win support. Additionally, such a 'mid-life facelift' had been tried in 1965, with demonstrable lack of success. In effect, the AICPA had played this card earlier in the game: it could not, with any degree of conviction, be played again.

Form a new standard setting body

This was the end result of the path chosen. However, to have adopted this route immediately would have been:

(a) to admit defeat; and
(b) a high risk option. Apart from being a step into the unknown, such a step would not have been feasible without much discussion and thought. Although this move seemed likely eventually, the committee option would give time for reflection.

Set up a committee

The chosen option, it bought the AICPA a breathing space needed for sober reflection; it did not make an irrevocable commitment; and it seemed likely to satisfy critics insomuch as action was seen to be being taken.

The choice: two study groups

The chosen response to the crisis was the setting up of two study groups. These came to be known by the names of their chairmen, Francis Wheat and Robert Trueblood.

The Wheat Study Group

The first study group was to consider the 'establishment of accounting principles' and was appointed in March 1971. Its ambit was wide, the first paragraph of its terms of reference stating: 'The main purpose of the study is to find ways for the [AICPA] to improve its function of establishing accounting principles. The study should consider how the Institute's standard-setting role can be made more responsive to the needs of those who rely on financial statements.' Note the use of the word 'standard' rather than principle, and also the immediate prominence given to the needs of the users of financial reports. The following points about the Study Group's terms of reference are worthy of further comment.

(a) Reference was made to a full-time body to replace the part-time APB, thereby suggesting obviating the criticisms of lack of independence, etc.
(b) Similarly, mention was made of a court-like mechanism. A harking back to Leonard Spacek's campaign in the 1950s and 60s (see Carey [1970, p. 124 *et seq.*]), but not taken up.
(c) Reference to 'elements in society', i.e. wider representation was contemplated from the outset (see the AAA criticisms and the comments made during the AICPA conference above).

The Study Group held public hearings on 3–4 November, and on 29 March 1972, only a year after its inception, its final report was sent to the AICPA Board of Directors.

Its main recommendations were:

(a) standard setting should continue in the private sector;
(b) since a part-time body is open to criticism on grounds of personal interest and lack of commitment, the standard setting body should be full-time;[6]
(c) a wider range of opinion should be represented than was the case in the APB; and
(d) more substantial research with continuous direction was required.

On 10–11 April 1972, the AICPA Board of Directors met and recommended to the Council that the report be accepted and implemented. The meeting of the Council on 1–3 May considered the report and reactions to it that had been received: the report was accepted by 'nearly unanimous vote' (Arthur Andersen & Co. [1972]). Trustees of the Financial Accounting Foundation (FAF), the body to oversee the new FASB, were appointed on 30 June 1972, and the FASB started work in June 1973. Its first Chairman was Marshall Armstrong, the AICPA president who had taken the decision to set up the study groups.

The Trueblood Study Group

One of the first tasks the FASB had was to deal with the report produced by the second of the two study groups. This was charged with looking at the 'objectives of financial statements' and was chaired by Robert M. Trueblood. That he, who through his actions had in large part necessitated the creation of the study groups, should be appointed the chairman of one of them was not as surprising as it might at first appear. In 1958, he had been appointed a member of the AICPA committee on long-range objectives, and in 1961 he became chairman of this committee, a post he held for the next four years until he became president of the AICPA.

During his chairmanship of the committee, a working paper entitled 'Profile of the Profession: 1975' was produced. This reflected Trueblood's concern with the future of the profession, a concern that was further exemplified when, whilst president, he set up a three-man 'committee on structure'. Concerned specifically with the AICPA's organisation and its suitability to the future, its report led to changes that were enacted by 1969.

Set up at the same time as the Wheat group, the Trueblood committee did not report until October 1973, the time lag reflecting difficulties in achieving the desired end-result. At the time many of the group's recommendations were seen as radical, particularly those relating to social goals and not-for-profit organisations. In many ways no less radical were the introduction of predictive ability and earnings cycles as important concepts, and the emphasis on user needs.

Summary of the two study groups

To sum up the two study groups and their output, one can see the Wheat group as responsible for the structure within which the Trueblood report could be used in the development of the conceptual framework. Indeed, to do this was an ideal strategy for the new body to follow: it would be seen to be tackling a major topic of importance and gain a breathing space.

Summary

Writing in 1964, Reed Storey suggested that accounting was at a crossroads. He offered two alternative views of the future:

> The period of the 1960's may hopefully be remembered by future generations of accountants as a time during which progress made earlier in the

improvement of accounting and reporting was consolidated, continued, and even accelerated, a time during which real and lasting solutions became discernible for some of the major problems. Accountants of the future may, however, point to the present as the time in which it became clear that the accounting profession was unable to put its own house in order, and that the function of determining accounting principles was taken over by some other group, perhaps by a legislative or regulatory agency of government. . . . This is a critical period in the history of accounting. (Storey [1964, p. 59])

Unfortunately the latter view was the more accurate: the 1960s proved to be a time of crisis. It is, however, interesting that Storey foresaw such tempestuous times: that he could have done so should not be a surprise though, for as has been noted, the underlying reasons were there for all to see.

This chapter has traced a number of interconnected themes, the implications arising from which led to the crisis of the 1960s. The determination of accounting principles, perceived to be a major role for the profession and hence worthy of defence, came under threat due to a series of fundamental problems. The source of these was the previous failure to clarify the role of the standard setting body and the nature of accounting principles.

In its response to the crisis, the profession was handicapped: it had effectively painted itself into a corner. To overcome earlier criticism, it had undertaken certain limited reforms, but having done these it could not repeat them. To retain its role in standard setting, the profession had to face the issues it had previously ducked. This forced it down the path that led to the CF project undertaken by the FASB.

Notes

1 For contrasting views of this relationship and the desirability of government involvement see Horngren [1972] and Burton [1982].
2 For detailed consideration of this topic, see ARS No. 7 (AICPA [1965], especially p. 52) and Armstrong [1969].
3 This later developed into a debate over the basis (normative or positive) of standards (see Chapter 2).
4 Carey [1970, p. 98] added a third option, treating the saving as a contribution to capital. A similar argument was later used in the UK in relation to deferred taxes – see Burns [1977, p. 84].
5 Note that the idea of greater government involvement in standard setting did not die at this point: in the mid-1970s, both the Moss and Metcalf Congressional subcommittees considered this possibility very seriously, and in the 1980s so did the Dingell committee.

6 The details of the formal structure suggested are given in Appendix 1. The implications of this structure on the development of the CF are discussed in Chapter 4.

2 Conceptual Frameworks in Theory

Introduction

Chapter 1 traced the origins and development of the US accounting profession's credibility crisis. The accounting establishment was shown to have unwittingly manoeuvred itself into a position such that a radical face-saving solution was necessary: the setting up of the Wheat and Trueblood study groups was the only viable option available.

That analysis may be extended and used to trace the path followed by the FASB once the decision had been taken to construct a conceptual framework based, in part, on the Trueblood Report. As with the decision on what response to make to the crisis, a number of options were available to the Board in choosing how to produce a CF. These options are considered here and an explanation offered for the choice made.

The method adopted is as follows. Firstly, possible approaches to the production of a CF are discussed. Then the FASB project is placed in context, by identifying the approach the Board chose in the light of those discussed. Next, to help assess why the Board chose as it did, the advantages of their approach are considered, and then the disadvantages. The latter section includes reasons why the CF might have been expected to fail.

The conclusion of the chapter parallels that of Chapter 1 in suggesting that there was a large degree of inevitability in the decision process. Further it is maintained that it should have been clear from the start that the project was likely to produce the results it did. Rather than leading to the production of a widely accepted conceptual framework, and thus solving once and for all the credibility crisis, the project gave an opportunity for differences between interest groups to crystallise: existing power struggles were institutionalised.

Conceptual frameworks

The term 'conceptual framework' is now well enough established in accounting for all academics and the majority of practitioners to have at least a vague understanding of what is meant by it. Of itself, this is testimony to the impact of the FASB's project, for the term was not widely used in the discipline prior to the project's start. This is not to say that such constructs did not previously exist, but rather that the term itself was comparatively novel, having previously been used only in such documents as ASOBAT (AAA [1966]).

But what does it mean? What constitutes a CF, and what variations exist? To consider these questions, and hence set forth the options open to the FASB at the outset of the project, a general definition is needed from which a number of variants may be derived.

As a starting point one may utilise Miller and Redding's [1988, p. 109] suggestion for a definition of a CF of 'a collection of broad rules, guidelines, accepted truths, and other basic ideas about the field'. This is not intended as a complete definition, nor is it beyond criticism. Nevertheless it does admit of a wide range of interpretations, including purely theoretical frameworks, those based on practice, and many falling somewhere in between. As such it covers most, if not all, of the discussions of the topic in the literature.

A number of writers have sought to distinguish types of CF, sometimes to contrast their own 'superior' view with lesser ones. In so doing, each has presented a (partial) taxonomy of possibilities. The differences between writers reflects the many perspectives from which one may view accounting.[1] Some of these reflections on CFs are now considered.

Miller and Redding [1988, p. 109] give three reasons for, and thus approaches to, creating a CF. These are:

(a) description of existing practice;
(b) prescription of future practice;
(c) definition of commonly used terms.

In discussing these, they identify description with a bottom-up, inductive approach and prescription to a deductive, normative one. Previous CFs exemplifying each of these are given, shown here in Figure 1 below. (The definitional CF is discussed, but no examples are proffered.)

The 1977 report of the AAA Committee on Concepts and Standards for External Financial Reporting 'Statement on Accounting Theory and Theory Acceptance' (SOATATA) recognised the distinction between

description and prescription, but subsumed it within a different structure. Although not explicitly discussing CFs, but rather accounting theory generally, this structure is directly relevant. It was:

(a) classical – normative, deductive
 – inductive;
(b) decision usefulness based – decision model
 – decision maker;
(c) information economics based.

To expand on these, category (a) is intended to represent the view of writers who based their work on the concept of 'true income' or sought to derive structured order from the 'chaos' of practice. Category (b) refers to those who approach the subject not from the point of view of the existence of one true method, but from the extent to which the information provided is useful. The last category takes a different slant by treating information as a commodity like any other in the economy, subject to the constraints of supply and demand.

This view of accounting theory is broader and more analytical than that suggested by Miller and Redding. Note in particular that an overall development from eternal truth to user needs to user and preparer needs is apparent. To support this classification, past works were cited (see Figure 1). The end product has not, however, been free of criticism: for example Peasnell [1978, pp. 221-4] points out that many authors' work may not fit conveniently into one specific category but, rather, may justifiably be included in a number.[2]

In a variation on the SOATATA classification, Kelly-Newton [1980, p. 14] re-titled the three approaches as:

(a) attempts to reflect 'economic reality';
(b) user oriented; and
(c) giving consideration to preparers of information.

These she then identified with the 'old-fashioned' CAP/APB approach, the FASB approach, and her own 'sociological' approach respectively, i.e. a progression through time, implying that the FASB approach was already out of date.

A different perspective was adopted by Ijiri [1975 and 1982]. In the latter, without defining a CF, he stated that it may be decision based or accountability based. These he distinguished as follows. A decision based framework is user-oriented and uni-directional (from accounts preparer to accounts user); an accountability-based framework recog-

(1) MILLER AND REDDING

Descriptive	*Prescriptive*
Paton & Littleton	ARS No. 1
ARS No. 7	ARS No. 3
APB St. 4	ASOBAT
	Trueblood

(2) SOATATA

(a) Classical

Deductive	*Inductive*
Paton	Hatfield
Canning	Gilman
Sweeney	Littleton
MacNeal	Ijiri
Alexander	
Edwards & Bell	
ARS No. 1	
ARS No. 3	

(b) Decision usefulness

Models	*Makers*
Trueblood	Devine
1936 AAA	Hofstedt
Saunders, Hatfield & Moore	BAR studies generally
May	
Vatter	
Chambers	
ASOBAT	

(c) Information economics
Marschak
Arrow

Figure 1 Classification of previous CFs by source

nises a relationship between users and preparers, and hence is bi-directional. Ijiri favours the latter, and went on to develop his argument along these lines. (This is also advocated by Archer [1981], discussed later.)

Ijiri's conception is axiomatic in nature, and is inductive in approach. Stamp, in his many writings on the subject of conceptual frameworks (for example [1980, 1981, and 1982]) was very critical of an axiomatic approach, albeit concentrating on those using a deductive approach. He contrasted this approach unfavourably with a jurisprudential approach in which a CF would develop in a similar manner to the law (see Power [1984] and Zeff and Keller [1985, p. 79] for discussion).

It should be clear from the above sample of views that there are as many views on what constitutes a CF as there are writers. To attempt to 'classify the classifications' would probably simply add another layer of confusion. A few points may, however, be drawn out.

(a) Discussion of CFs may vary from the general inductive versus deductive
 split to the more detailed user orientation versus accountability type.
(b) A number of the points of view put forward are not incompatible. Indeed,
 it may be possible to construct a multi-dimensional taxonomy. For
 example, a deductive CF may or may not be accountability based.
(c) More recent writings on CFs and accounting theory have recognised a
 greater variety of CF types. This of itself has added to understanding of
 the subject.
(d) A degree of agreement is evident, regardless of perspective. Whereas
 earlier writers sought to find one right answer, more recently the focus has
 been firstly on one or more groups interested in financial reporting, and
 then on the relationships between them: the problem has been recognised
 as being more complex.

The FASB's conceptual framework in context

What form, then, did the FASB's CF take? How does it fit into the
above categories? In this section only the avowed intent of the FASB
before the work progressed very far will be considered. (The actual out-
come is described, and contrasted with the intent, in the next chapter.)

The CF was defined in 'Scope and Implications of the Conceptual
Framework Project' (FASB [1976b, p. 2]) as: 'a constitution, a coherent
system of inter-related objectives and fundamentals that can lead to
consistent standards and that prescribe the nature, function, and
limits of financial accounting and financial statements.' The paragraph
continues:

> The objectives identify the goals and purposes of accounting. The funda-
> mentals are the underlying concepts of accounting, concepts that guide the
> selection of events to be accounted for, the measurement of those events, and
> the process of summarizing and communicating them to interested parties.
> Concepts of that type are fundamental in the sense that other concepts flow
> from them and repeated reference to them will be necessary in establishing,
> interpreting, and applying accounting and reporting standards.

Perhaps the first thing to strike one about the actual definition is that
it seems very purposeful; it is not the sort of general definition one
might expect. Instead it rather clearly derives from the main task facing
the FASB, namely to provide a basis for the recovery of credibility.
How, though, does it tie in with the categories noted above? Here a
difficulty is apparent. Although purposeful, the definition is sufficiently
vague to allow a number of interpretations. It obviously suggests a
normative, prescriptive approach, but there is no clear indication of a

view on decision usefulness, information economics, accountability or jurisprudential types. In fact, the definition as given avoids such issues.

Further evidence exists in Section III (H) (2) of the FASB's Rules of Procedure. This helps clarify the goals of the SFACs, which together constitute the CF, as being

> to establish the objectives and concepts that the FASB will use in developing standards of financial accounting and reporting; provide guidance in resolving problems of financial accounting and reporting that are not addressed in authoritative pronouncements; and enhance the assessment by users of the content and limitations of information provided by financial accounting and reporting and thereby further the ability to use that information effectively. (FASB [1987, p. 19]).

In their own terms, Miller and Redding [1988, p. 115] describe the first two goals as indicating prescription and the last as definitional. The intended prescriptive nature of the CF is again clear.

To characterise fully the FASB project, however, one must look further. From Trueblood onwards, each document in the CF project on objectives stated clearly that decision usefulness was to be the cornerstone of the project. The final version was in SFAC No. 1 (FASB [1978e, para. 34]): 'Financial reporting should provide information that is useful to present and potential investors and creditors and other users in making rational investment, credit, and similar decisions.' Thus, it is evident that the FASB intended to produce a normative, deductive CF of the decision usefulness type. This was borne out by the early stages of the project. As will be seen, however, it is equally evident that this was not carried through – the end product (e.g. SFAC No. 5) did not match the original intent.

It is also worth noting that the FASB attempted to subsume the accountability or stewardship approach into the adopted decision usefulness approach. An argument running through most of the documents considering objectives was that accountability involved a decision to buy, hold, or sell shares based on the performance of the entity and its management as reported. As such it forms a sub-set of the decision usefulness approach.[3]

Advantages of the FASB approach

Having characterised the FASB approach to producing a CF, one may ask why they chose as they did. What, for instance, were its advantages? A number are evident.

Firstly, the new 'constitution' or 'coherent system of inter-related objectives and fundamentals' would go a long way towards restoring the credibility of standard setting (and, by association, that of the accounting profession). As Peasnell [1982, p. 254] put it: 'It is not surprising that the FASB places so much emphasis on the importance of developing a CF; by doing so the FASB provides a (partial) answer to its critics: all will be well when the 'objectives and elements' of financial statements are determined.' The particular path chosen, that of a rigorous, deductive framework, would in particular impress. So logical and scientific an approach must surely be sound. (As will be seen later, this view was not universally held.)

In particular, a deductive approach was in sharp contrast to the 'failed' or unsatisfactory attempts to catalogue accounting techniques that had gone before. Works such as ARS No. 7 and APB St. 4 were effectively descriptive CFs, yet neither had made the impact necessary to convince observers that they would solve the profession's problems. By adopting the 'opposite' approach, the Board was at the same time distancing itself from what had gone before and adopting a 'new' approach.

Secondly, undertaking what was clearly going to be a major project bought a breathing space for the Board. Stamp [1985, p. 120] made such a point: 'Often . . . a committee is established merely as a cosmetic exercise to show that "something is being done". In times of great controversy a move of this kind may be politically very astute; the general debate can be postponed, or at least muffled, in the hope that by the time the committee report the heat in the controversy will have died away.'

Ravetz [1971, p. 384] sums up both of the above points in his discussion of 'immature disciplines', of which accountancy would seem to be one:

Those who must take the decisions on practical problems will welcome research, for their own reasons. If nothing else, it imposes a delay on the decision; and in the meantime the problem may dry up and go away, or they themselves may shift to a less exposed position. Also, the conclusion of a research project, in which the categories are tidily defined and recommendations neatly listed, seem more amenable to translation into the terms of a technical project, and the articulation of routine tasks, than the aphoristic generalisation of an informal study. And, to be sure, if other things were equal (although in the case of immature disciplines they are not) a scientific argument provides a more secure foundation for its conclusion than an impressionistic essay.

A third benefit was that the adoption of a user-oriented, decision usefulness approach answered one of the major criticisms of the APB's working methods noted previously, that users of financial statements had too little say in the setting of standards. By specifically targeting the user group, that basis of criticism was removed. To other groups though, notably the preparers of accounts, it seemed that the pendulum had swung too far. They gradually sought to assert their point of view as the project went on, as will be seen in Chapter 4.

The main advantages to the profession of the project undertaken by the FASB were thus that it went a long way towards satisfying critics of the previous approach and restoring credibility to the profession. As a short-term measure, the CF seemed likely to succeed in its face-saving role. However, other negative aspects existed which would come to the fore in the longer term.

Disadvantages of the FASB's approach: why might the CF project have been expected to fail?

Just as points may be made in favour of the FASB's idea of and approach to a CF, so many arguments may be advanced against it. Such arguments fall into a number of distinct categories as follows:

(a) past experience;
(b) parallels with standard setting;
(c) basic approach;
(d) expectations.

Each will be dealt with in turn.

Past experience

The first and most obvious point to be made is that no previous attempt at developing what might be termed a CF had ever succeeded to the extent of becoming the accepted basis of accounting. Individual ideas from a number of such frameworks had been implemented, but none in its entirety.

It was noted above that previous works e.g. ARS No. 7 (AICPA [1965]) and APB St. 4 (AICPA [1970]), constituted descriptive CFs, but that none had found acceptance as satisfactory answers to the problems of the profession (the latter despite being issued at the height of the crisis and being seen by its preparers as a basis for solving the obvious

problems (Weston [1988])). The point was made that a deductive CF was in contrast to these and hence might be expected to fare better.

It should not be forgotten, however, that there had been a previous attempt to produce a deductive CF, this being made up of ARS Nos.1 and 3, issued in 1961 and 1962 respectively. The two studies were written by Moonitz, and Sprouse and Moonitz respectively, and were part of a research drive undertaken by the then newly formed APB in order to gain credibility.

Of particular interest is that, when issued, ARS No. 1 did not meet strong resistance. It was only on the publication of ARS No. 3, which constituted the operationalisation of the first study and pointed towards current value accounting, that opposition was voiced. Indeed, so intense was this opposition that the APB decided not to pursue the project; it was too hot to handle, too radical (see Zeff [1982]). As will be seen, the parallels with the FASB's CF are striking.

Anthony [1983, p. 12], however, dismisses this past experience line of reasoning as 'defeatist', in effect accusing it of the fallacy of induction: past experience does not determine future prospects.

As problematic as standard setting

A second reason why the CF project might have been expected to fail was its similarity to the actual setting of accounting standards, the problems of which were highlighted in Chapter 1. The derivation or construction of a CF may be viewed as no more than an aspect of the standard setting process, albeit at one stage removed. A number of parallels may therefore be drawn.

Firstly, the setting of accounting standards without the use of an explicit CF involves those responsible utilising, consciously or unconsciously, their own implicit CFs, subject to influence, argument and persuasion by others and the need to compromise in order to achieve a result. The derivation of a CF involves the same factors, and as such may result in a shifting of the debate to the 'earlier' stage (Stamp [1982, p. 124]).

Secondly, in this particular case, the actual procedures used by the FASB were the same as for the setting of standards, i.e. the same 'due process' was adopted. Indeed, the CF project utilised the process to the fullest extent: few short cuts were taken. This, of course, meant that the same strengths and weaknesses applied. (See Appendix 1 of this study.)

Thirdly, standard setting is an activity beset by pressures, both internal and external: some examples of this were noted in Chapter 1. It is now widely accepted that, far from being a simple case of selecting the

best technical solution to a problem, the setting of accounting standards is a political process. The best known writings on this are by Solomons ([1978, 1983 and 1986b]), but others had previously commented on this, e.g. Gerboth [1972] and Horngren ([1972 and 1973]). A view from 'within' was graphically provided by Stamp [1985].

In this sense, political influence can stem from personal animosity, manoeuvring to ensure the adoption of genuinely held theoretical views, or vested interests. The most commonly considered reason for politicking, however, is the effects that accounting regulation or changes thereto has on wealth distribution. These are generally termed the 'economic consequences' of the change. Specifically, this term refers to changes in an entity's economic position that result from changes to accounting or reporting requirements. These may be real (e.g. a rise or fall in share price attributable to higher or lower profits resulting from a new reporting method), or perceived (e.g. a change of currency hedging policy as a result of a desire to maintain an existing picture under new foreign currency translation requirements. See Rappaport [1977, p. 92]).

Some of these consequences are unfavourable, and hence stimulate opposition in the form of formal submissions or informal lobbying against the change proposed. (Few objections to change are received from those who perceive the economic consequences to be beneficial.) The FASB recognised the importance of the topic and organised a conference on it (FASB [1978d]). Other have considered its effects, notably Wyatt [1977] and Zeff [1978].[4]

The CF project was intended to form the basis for the setting of accounting standards. One might reasonably suppose therefore that both outsiders and insiders would treat the development of the project in the same way as they would the setting of standards: if an aspect was politically, economically or theoretically unacceptable to them, they would work against it and, if advantageous, for it. As will be seen in Chapter 4, such overt lobbying only became a major force in connection with the stages of the project dealing with 'specifics'. This may be viewed as reflecting greater awareness of the implications of the project once nitty-gritty issues had to be faced: all can agree on ethereal generalised objectives, but once the course of the project seemed likely to result in unwanted accounting and reporting measures, opposition surfaced (see comments on ARS Nos. 1 and 3 above).

Criticisms of the approach

Much was made above of the adoption by the FASB of a normative, deductive approach with a decision usefulness slant. Although a num-

ber of advantages were seen, the adoption of this method is open to
criticism. The bases of such criticism vary, covering assertions that to
do so is attempting the impossible, to it being philosophically unsound.
A number of writers, from slightly different perspectives, have argued
that the purely 'scientific' manner of the CF was unsound, this tying in
with the need to recognise political influences. Each of these will be
considered in turn.

Normative standards are impossible
As was noted above, the FASB's basic approach as originally intended
was to produce a prescriptive, normative framework. A body of litera-
ture exists, however, that contends that it is impossible to create norma-
tive standards and, one may infer, a normative CF.

The basis of this contention is the welfare economics work of Arrow
[1963]. This was applied to accounting by Demski [1973, 1974, and
1976] and Beaver and Demski [1974]. The basic point made by Demski
was that, in a multi-person setting, a consistent ranking of preferences
from a number of options, such as alternative accounting treatments, is
impossible to obtain. Indeed, it may be impossible even in the case of an
individual.

Cushing [1977] considered the points raised by Demski, and sug-
gested that some of the assumptions underlying Arrow's theorem were
suspect and that the 'no normative standards' conclusion was untenable.
Bromwich [1980] extended the discussion, and Johnson and Solomons
[1984] finally sought to deal with Demski's argument by showing the
irrelevance of the impossibility theorem in an accounting context.

It is important to note also that Demski's derivation of impossibility is
from an information economics base, whilst his opponents (e.g. see
Chambers [1976]) utilised a classical or decision usefulness perspec-
tive. One might not, therefore, be too surprised to find a degree of
incommensurability (Feyerabend [1975, Ch. 17]).[5]

FASB's approach philosophically misconceived
In a number of papers, Hines (e.g. [1986] [undated]) has examined the
philosophical underpinnings of the way in which accounting theory is
produced. Of fundamental concern here is her contention that the CF
project is misconceived. She argues that the FASB is perpetuating the
fallacy that economic reality, which it asserts financial reporting should
reflect (SFAC No. 2 [1980c, para. 63]), is independent of that reporting.
She points out that the two are linked, in the sense that financial
reporting of 'reality' affects that very reality. For example, consider a

financially troubled company on the brink of bankruptcy. A financial report revealing this could actually precipitate that bankruptcy.

This view seems to suggest that reality changes directly as a result of financial reports. However, this is not so: users must take action (buy or sell shares, etc.). Thus one may liken the process to looking in a mirror. If one does not like what one sees, one may seek to change it (through, for example, dieting or surgery). But the act of seeing reality does not necessarily imply a change to that reality.[6]

Accounting is not a science

The status of accounting as a discipline has been a point of contention between some academic accountants. Some, such as Sterling [1979], have advocated 'making' it a science. Others, notably Stamp [1981] reject this as ignoring the true nature of the subject (see Power [1984] and Lyas [1984]). It follows from this, if one wholeheartedly accepts Stamp's view, that the original FASB approach was indeed misconceived, for it sought to impose rigorous 'scientific' method on a subject ill suited to accept it.[7]

Further, Stamp [1982, p. 124] argues that the FASB approach is dependent upon the creation of a set of axioms, disguised as definitions (of elements of financial statements). Thus, he made his argument more specific, stating that the CF was bound to fail, accounting not being 'like geometry, with conclusions flowing logically from predetermined axioms and definitions'.

One need not agree with this rather strong conclusion to accept that an axiomatic approach is likely to fail. While accounting possibly could be made like geometry, the result would be unacceptable to those accountants to whom 'cook book' standards are anathema. Thus an axiomatic approach, if that is what it was, was likely not to succeed.

Comprehensive v. incremental approach

Gerboth [1972] was another writer to reject the approach to accounting theory formulation that above was termed 'scientific', but which he termed 'comprehensive'. (This is also sometimes termed 'rationalist'.) Writing at the time of the change-over from the APB (upon which he served) to the FASB, he argued that the comprehensive approach, which was then in vogue and seemed likely to be adopted by the FASB, should be ignored and the 'incremental' approach of the APB, which he characterised as 'muddling through', be retained. He noted that the expectations of outsiders would probably make this impossible, but that this would simply lead to later disappointment.

The incrementalist approach advocated by Gerboth (and noted by Horngren [1973, p. 64] to be the one 'most accountants probably prefer') was expounded as a philosophy of decision making under uncertainty by Lindblom [1959] and discussed by Etzioni [1968, pp. 268–73].

A synthesis

Archer [1981] draws together much of the above argument and combines it with new elements. Drawing on jurisprudence (as advocated by Stamp) and on an accountability-based framework (per Ijiri), he rejects the normative, scientific or 'hard systems' approach, preferring the 'soft systems' methods of Checkland [1981], which may be viewed as an operationalised form of Lindblom's work. In rejecting the hard systems approach, Archer also rejects the FASB's approach to the CF.

Summary

The five main protagonists cited above all reject the normative approach as used by the FASB for the CF. Demski believes that meaningful results will be impossible, whilst the others, for differing reasons, do not admit even that such an approach is appropriate. It is interesting that it is the normative, deductive aspect of the approach that has been undermined: little has been said of the decision usefulness view (although Ijiri and Archer both prefer accountability as a base).

Note also that none of the writers in rejecting the scientific method advocated the production of a positive CF: as noted previously, such attempts have not been successful. Interest in positive theory has risen in recent years, however, in particular based on the work of Watts and Zimmerman [1978, 1979 and 1986]. This has been subject to criticism by Christenson [1983], Hines [undated], and Whittington [1987]. See also Tinker, Merino, and Neimark [1982].

Implicit in the advocacy of the incremental approach is the recognition that in order actually to gain acceptance for a conceptual framework, some form of trade-off of individual values is necessary. In other words, CF construction, like standard setting itself, is a political process. It is all the more surprising, therefore, given that the political nature of standard setting was already well established (e.g. Gerboth [1972] and Horngren [1972, 1973]) that this approach was not taken into account when setting up the CF project. Indeed it can be argued that this error was the most significant one made during the CF project. Had greater care been taken to consider the pros and cons of conducting a project such as CF production – the methods available and the likely

pressures – many of the later problems could have been avoided or overcome.

Expectations

The final factor that militated against the success of the CF project was the expectations that it raised in the various interested parties. To initiate a CF project would clearly lead these parties (financial statement preparers, users, commentators, etc.) to hope that their own particular view of the world would be adopted as the 'official line'.

Were the outcome not to match expectations, disappointment would result. If extreme, and founded on strongly held beliefs, the parties could reject the FASB's CF and thus undermine its credibility. Thus the success of the CF project depended not only on satisfactory internal coherence and completeness, but also on external acceptability.

A simple model will show how the raising of expectations could work against the acceptance of a project such as the FASB's CF.

Let I = the intention of the CF formulators
P = the intention as perceived by outsiders
A = the achieved result

Assume initially that these are fixed (a static model). The possibilities are as follows:

	Situation	Resulting comment
If	$P = I$, and $A = I$	Praise
	$P = I$, and $A \neq I$	Criticism, justified
	$P \neq I$, and $A = I$	Criticism, unjustified
	$P \neq I$, and $A \neq I$	Indeterminate, leading to:
	$P \neq I$, and $A = P$	Praise, unjustified
	$P \neq I$, and $A \neq P$	Criticism, justified/unjustified

Of the six outcomes, only two lead to praise (of which one would be regarded as a failure by the formulators), whilst three result in criticism.

One must recognise however that I, P and A may all change over time. Intentions may be firm to start with, but can alter, for example as a way of 'cutting losses'. Perceptions may change, due to a number of factors including clarification of actual intentions. Achieved results do not change as such, but may be built upon, and thus A at any given time can later be seen merely as an intermediate position. The introduction of such a dynamic element complicates the analysis of likely

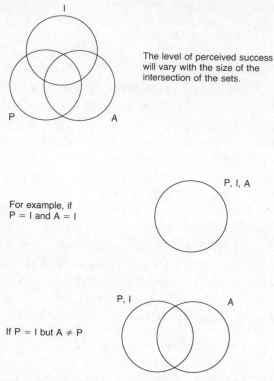

Figure 2 Expectations model

responses to the achievements of a project such as the CF – the results become uncertain.

Three other further complicating factors exist. Firstly, P can vary from observer to observer, as indeed can perceptions of A, i.e. achieved results may be interpreted differently. Thus one observer may be content with a result (i.e. $P_1 = I$, and $A = I$) whilst another may perceive the same outcome differently (i.e. $P_2 = I$, and $A \neq I$ or $A = I$). Secondly, the interrelationship of the various perceived views can lead to the application of pressures (e.g. lobbying) from different quarters at different times. The dominant view (if any) may itself vary over time. And thirdly, there is a feedback element; I may be influenced by P and hence change, this itself altering the acceptability to observers of results.

Note that the model may also be represented as a Venn diagram, in a similar manner to the approach to objectives used by Cyert and Ijiri [1974] in their discussion of the Trueblood report. Various levels of congruity are shown in Figure 2. Thus expectations, particularly if not

met, may stimulate adverse comment and actions at best disruptive to the CF formulation process, and at worse be damaging.

Summary and conclusions

This chapter started by introducing various alternative approaches to constructing a CF and then placed the FASB's attempt in context. Advantages and disadvantages of this approach were noted, these indicating that benefits arising were largely short-term, but that they might lead to longer-term problems. In particular the following points arose.

(a) The normative approach adopted by the FASB has been the subject of grave misgivings by many writers. A number feel that such an approach is unsuited to accounting.
(b) CF production, like standard setting, is a political process and should be recognised as such. Previous experience, in the form of ARS Nos. 1 and 3, supported this. Such a view was put forward before the start of the project, yet the normative, scientific style likely to result in just such problems was adopted.

Why then did the CF go ahead in the manner it did? Why did the FASB adopt that particular approach?

The general arguments of placating the critics and buying time have already been advanced, but these of themselves do not seem sufficient to justify the FASB's method; other factors are necessary. The two most likely points are:

(a) the previous and relatively recent failures of descriptive frameworks (ARS 7 and APB Statement 4) to satisfy the critics and hence the 'need' for a deductive, prescriptive framework;
(b) the fact that one of the major criticisms of the APB, as noted in Chapter 1, was a lack of user involvement. Given this, a user based, decision usefulness model was likely from the start.

An alternative possibility exists. This is simply that the project was not planned properly. Possible alternative approaches may not have been considered in sufficient depth before the project commenced. Rigorous scientific method seems attractive to laymen such as accountants, and one must remember that the debate over the nature of the accounting discipline as a non-science was not as widely acknowledged in the early 1970s as it is today.

In other words, it was perhaps not a conscious decision to ignore the sociological aspects and the political implications of the structure of the project, but rather a simple lack of awareness of the alternatives. The FASB had eventually to face the reality it had avoided for, as will be seen, the nature of the project changed as it went on.

As in the events described in Chapter 1, the impression remains that the events described took on a life of their own, and that those in authority were ill prepared to deal with them; a fire-fighting approach to framework formulation was adopted, just as it had been for standard setting. The next chapter considers the actual course of the CF and the changes that occurred during development.

Notes

1 For surveys of some of these perspectives, see Davis, Menon and Morgan [1982] and Belkaoui [1985].
2 It is interesting to note that Peasnell himself later defined a CF as 'a statement of financial reporting objectives' [1982, p. 243] – of somewhat more limited scope than many definitions.
3 This will be discussed in more detail in Chapter 3.
4 See also Chapter 4.
5 As the Reverend Sydney Smith remarked on seeing two women arguing from their houses on opposite sides of the street, 'They can never agree for they are arguing from different premises' (quoted in Medawar [1984, p. 103]).
6 This point is also made by Solomons ([1978, p. 71] and [1983, p. 114]).
7 Here one is accepting deduction as 'the' scientific method. This is very much open to debate, somewhat beyond the scope of this study. See Popper [1959], Kuhn [1970], Lakatos [1970] and Feyerabend [1975] for various views on this topic.

3 The Conceptual Framework Project in practice

Introduction

In any aspect of human endeavour, intentions are not always matched by results. For a variety of reasons, what is proposed is not followed through and the end product does not live up to the plan. Such thoughts are truly apposite when considering the development of the FASB's CF. Whereas the foregoing discussed the Board's intentions as it embarked upon its self-imposed task, this chapter describes the actual development and the resulting output. In so doing, it reveals that the end product differed markedly from the initial ideas and intentions.

The chapter is structured as follows. The first main section gives basic details of the project, its structure, and the output that resulted. Next, a broad assessment of the project *vis-à-vis* the Board's aims is given that supports the intentions–results dichotomy. Then constant themes and major trends in the project are described. Following that, the results of a detailed analysis of the documentary output are given. These support assertions that the CF was not the coherent statement expected by many. Indeed, many anomalies appear that may even give support to suggestions of external influence over the process. Finally, an assessment is given of the output of the CF in terms of its own targets and those of others.

The FASB's CF project in outline

Description

When the FASB began work in June 1973 its initial technical agenda, chosen from thirty topics suggested by the Financial Accounting Standards Advisory Committee (FASAC) and others, including some

passed on by the APB, consisted of seven items. Each item was to be tackled by a task force led by one Board member. The topics were:

(a) accounting for foreign currency translation;
(b) reporting by diversified companies;
(c) criteria for determining materiality;
(d) accounting for leases by lessees and lessors;
(e) accounting for future losses;
(f) accounting for research and development, start-up and relocation costs; and
(g) broad qualitative standards for financial reporting.

The last of these was the embryonic CF project. The importance ascribed to it may be judged from the fact that, despite nominally being of equal priority to the other projects, it was the only one to involve all Board members. Also, it was initially under the direction of the FASB chairman, Marshall Armstrong.

At the time it was stated that:

> In undertaking this [broad qualitative standards] project, the Board recognizes that as it develops specific standards, and others apply them, there will be a need in certain cases for guidelines in the selection of the most appropriate reporting. FASB expects that the report of the special AICPA committee on objectives of financial statements chaired by Robert Trueblood will be of substantial help in this project. (FASB Status Report No. 1 [18 June 1973, pp. 1 & 4])

Thus, despite the title given to the agenda item, one could gain the impression that from the very beginning the Trueblood Report was seen as the starting point for the project. This, however, was only part of the story. Whilst it is true that the Trueblood Report gave shape and impetus to the CF, the project's initiation can be credited to Donald Kirk, then a Board member and later the Chairman of the FASB. It was he, influenced in his professional development by Carl Tietjen, a partner in Price Waterhouse (Kirk's former firm), who saw the need for the ethically-based, broad qualitative standards the initial project called for (Sprouse [1988], Kirk [1988]). His suggestion that a project to produce such standards be undertaken received fulsome support from the other Board members. Of course this was, at least in part, attributable to the circumstances undermining the credibility of standard setting described in Chapter 1. Thus the project was accepted on to the agenda and begun: the Trueblood Report provided added stimulus.

The Trueblood Report itself did not appear until October 1973

(AICPA [1973]). It was seen by many to be a radical report, covering such areas as social reporting and not-for-profit organisations, areas not normally covered by mainstream, 'establishment' committees considering financial statements. The FASB's response, published in June 1974, was a discussion memorandum. Entitled 'Considerations of the Report of the Study Group on the Objectives of Financial Statements' (FASB [1974]), it was brief and did little more than restate the majority of the Trueblood conclusions and ask for comments. The responses to this document by interested parties, together with further discussion within the Board, led to 'Tentative Conclusions on the Objectives of Financial Statements' (FASB [1976a]). A further series of documents on objectives leading to Statement of Financial Accounting Concepts (SFAC) No. 1 (FASB [1978e]), followed.

Objectives, however, were not the only topic pursued. As early as October 1973 when the FASB met the Trueblood study group, other aspects were envisaged: 'Once objectives are agreed upon, the Board intends to address itself to the entire hierarchy of financial accounting theory, including qualitative characteristics, the types of information needed by users of financial statements, and basic accounting concepts' (FASB Status Report No. 6 [28 November 1973]). Thus, the project was clearly seen to be a comprehensive undertaking, and in December 1973 the overall title was changed to 'Conceptual Framework for Financial Accounting and Reporting'. A twelve-man Task Force was formed to advance its development, reflecting the importance of the project (FASB Status Report No. 10 [28 February 1974]). As if to formalise and clarify for itself the true measure of its self-imposed task, the Board published in December 1976 a document, 'Scope and Implications of the Conceptual Framework Project' (FASB [1976b]) (S & I). This set the project in context and discussed its basis and intentions.

At the same time as Scope and Implications, a discussion memorandum on 'Elements of Financial Statements and Their Measurement' (FASB [1976c]) was issued, signalling that the project was well under way. From then on, it broadened and developed to encompass most areas of financial accounting theory. Not all of the avenues explored, however, resulted in the final documents of the formulation process, Statements of Financial Accounting Concepts (SFACs).[1] Only six SFACs were eventually produced, the subjects being:

(a) Objectives of Financial Reporting by Business Enterprises;
(b) Qualitative Characteristics of Accounting Information;

(c) Elements of Financial Statements of Business Enterprises;
(d) Objectives of Financial Reporting by Nonbusiness Organizations;
(e) Recognition and Measurement in Financial Statements of Business Enterprises;
(f) Elements of Financial Statements (revised to take account of Nonbusiness Organizations).

These documents were published over the period 1978 to 1985 and represent the culmination of the whole research programme. In addition to these, a series of documents dealing with accounting for one of the most serious problems of the 1970s, inflation, was produced. This may be regarded as a branch of the CF project. Indeed it was seen as such by the FASB, for it addressed many practical aspects of the main conceptual problems under consideration, including capital maintenance concepts and measurement units.[2]

Summary information helps to bring home the size of the project. Output, in the form of Research Reports (RR), Discussion Memoranda (DM), Invitations to Comment (ITC), Exposure Drafts (ED) and Statements of Financial Accounting Concepts (SFAC), for each of the series of documents, was as follows. (Note that some documents dealt with more than one topic: whilst the number of documents refers to all that are relevant to a given topic (and thus there is some double counting), double counting of pages has been avoided by giving the number per family topic).

Documents leading to:	No. of docs.	Pages
SFAC No. 1	4	147
SFAC No. 2	5	168
SFAC No. 3	4	499
SFAC No. 4	6	400
SFAC No. 5	10	984
SFAC No. 6	3	290
GPLA/CCA	26	1,523*
Others	2	302
Total	60	4,313

* Details of one document unavailable, thus omitted from total.

As well as the sheer size of the project, the structure is also of interest. This is shown in Figures 3 and 4. The former gives an overview of the project, the latter more detail of the timing of production of documents. Whilst it must be recognised that due to lead times, published output does not necessarily accurately reflect the amount of work being done at any given point, the number of documents produced indicates that after

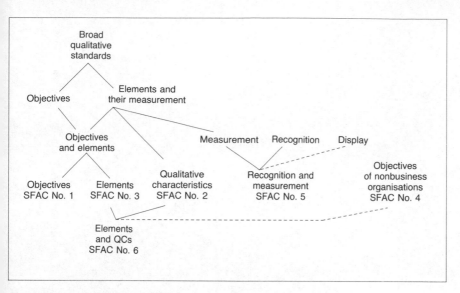

Figure 3 FASB CF by document family

a slow start, the project reached a peak of activity in 1980 and then declined until its completion in December 1985. This is shown clearly in Figure 5. In addition to the output, the documentation supporting the positions of those commenting on DMs, EDs, etc. was even more voluminous, consisting of many thousands of pages.

Summary

In the Introduction to this study the CF project was described as 'the longest, most expensive, and, arguably, the most important formally-constituted research programme in the history of accounting' (p. 00). The time it took to achieve a defensible final position – thirteen years – and the cost, running to tens of millions of dollars, support this contention. The sheer volume of documentation reinforces the point.

Clearly the project was a vast undertaking, and of great importance to the accounting establishment. It was intended to be the intellectual masterpiece (in the original sense) that would have done much to quieten the critics of the standard setting process by providing the basis for sound standard setting. Did it, however, meet its targets? Were intentions matched by results? The following sections examine the CF's development and lead to an assessment of the success (or otherwise) of the CF in terms of the FASB's stated intentions.

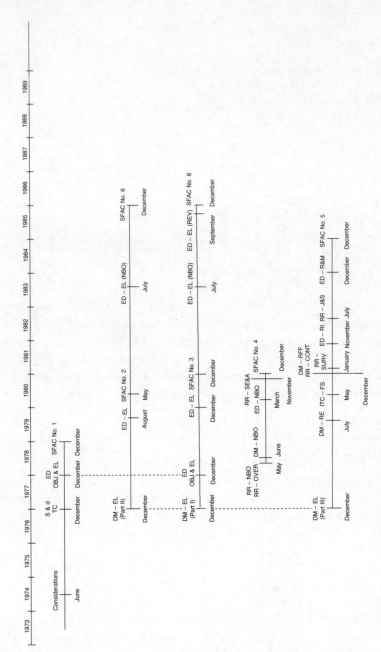

Figure 4 FASB CF documents by time of issue

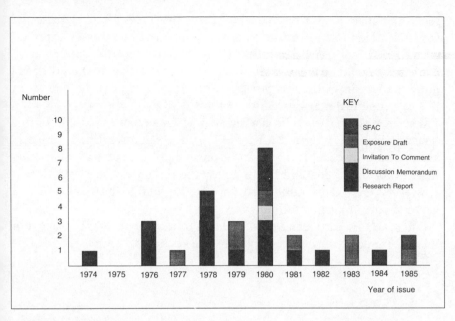

Figure 5 FASB CF documents by frequency of issue

Criteria for assessing the conceptual framework

The most obvious way of assessing the FASB's CF is by judging it against the Board's originally stated aim. One must establish just what constitutes this benchmark. This has already been quoted in Chapter 2, where the relevant paragraphs from S & I were given. Thus one may see that the Board was looking for:

(a) a constitution;
(b) coherence in its system of objectives and fundamentals;
(c) a prescriptive framework; and
(d) specifically, for objectives, recognition criteria, a measurement system, and display guidelines.

The attainment of each of these may be assessed as follows.

A constitution

The Concise Oxford English Dictionary defines a constitution as: 'mode in which State is organised; body of fundamental principles according to which a State or organisation is governed. Can the CF claim to fulfil this

role? The answer must be 'No'. However, this is hardly to criticise the CF itself. This role is outside that which might reasonably be expected of it. A CF can, if prescriptive, form a basis for the derivation of accounting standards. It seems strange to suggest that it should determine the way in which this process is organised – that is the role of, in this case, the Rules of Procedure of the FASB.

The nearest that the CF can be said to have come to fulfilling this unattainable role was in SFAC No. 2 on Qualitative Characteristics. Here, the cost-benefit threshold given might be seen as restricting matters for discussion and hence governing the operation of the Board. However, this seems rather too specific a point to be regarded as a genuine part of a constitution.

Thus, in this particular, the CF failed to meet the goal set for it, but this failure derives from an impossible target having been set.

Coherence

The coherence of the 'system of inter-related objectives and fundamentals' (S&I, p. 2) may be assessed on a number of levels. The consideration of detail will be deferred until later in this chapter, but the evidence regarding coherence in a broader sense may be dealt with here.

In setting out on a project such as the CF, the FASB might have been expected to have had a clear idea of the subjects it was to cover. Certainly it is apparent from public statements, such as those quoted above, that the Board knew from an early stage that objectives, qualitative characteristics, and information needs of investors would form part of the project. But it is less clear that the Board had structured its work. Thus despite diagrams such as Figure 6 and Figure 7, dating from the late 1970s, there is evidence of some confusion.

A good example of this confusion is the manner in which topics were added to and/or dropped from the Board's agenda. Fewer final statements (six) were issued than the number of topics initiated might have led one to expect. Also, some topics were combined in an unexpected manner. Thus, the final SFACs, although constituting the CF, did not fully represent the extent of the work carried out. Although SFAC No. 5 was used to collect together many aspects of the project that would otherwise have been lost, even this ignored the whole issue of display, one of the major items referred to in S&I (see also below).

The admission of items to the Board's agenda is quite revealing and is given as Figure 8. Points of particular interest are:

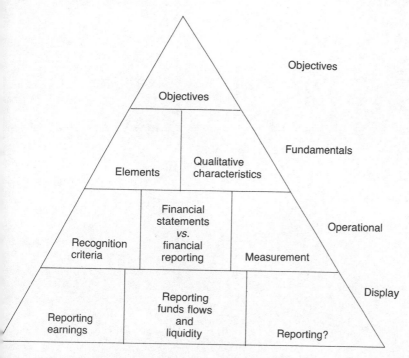

Source: minutes of a meeting of the task force on accounting recognition criteria, 27 September 1979

Figure 6 Structure of FASB CF project

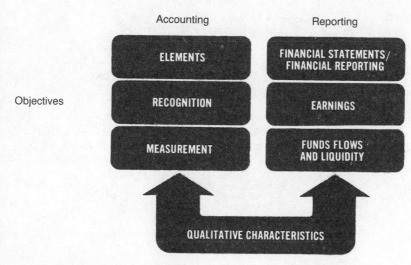

Figure 7 Approach to FASB CF project

Topic

Topic	Staff agenda	Board agenda
Broad qualitative standards = Objectives Qualitative characteristics Elements		July 1973 } (Name changed Dec. 1973) Part of elements } Dec. 1973
Measurement*/financial reporting and changing prices		
Recognition*	Oct. 1977	2 April 1979
NBO objectives	Aug. 1977	July 1978
Financial reporting and financial statements	Aug. 1977	July 1978
Earnings presentation/reporting earnings**	Oct. 1977	April 1978
Funds flow and liquidity***	Oct. 1978	First quarter 1979
Financial reporting by NBOs	Apr. 1980	March 1981
Update of SFAC Nos. 2 and 3 re. NBOs	Apr. 1980	March 1981
Reporting performance of NBOs		March 1981
Financial reporting by private and small publicly owned companies		October 1981

* Combined 1982
** Including cash flows
*** Including financial position

Source: Status reports of the FASB (various dates)

(a) the way in which the initial Broad Qualitative Standards project expanded to cover a variety of topics. Indeed, it is ironic that a project initially conceptually at odds with an evolutionary approach to accounting standards itself became an evolutionary process.

(b) the way in which projects grew out of each other, e.g. 'Financial Reporting by Private and Small Publicly Owned Companies' from 'Financial Statements and Other Means of Reporting', 'Financial Reporting by Nonbusiness Organizations' from 'Objectives of Reporting by Nonbusiness Organizations', 'Measurement' from 'Elements'.

(c) the intertwining of some projects, e.g. Elements and Measurement; Measurement and Recognition; Income, Cash Flow and Financial Position with Reporting Earnings and Funds Flow and Liquidity.

(d) the removal of some topics from the CF, e.g. 'Financial Reporting by Private and Small Publicly Owned Companies', and most aspects of 'Financial Statements and Other Means of Financial Reporting'.

Clearly the structuring of the FASB's CF project does not seem to have been as rigorous as, say, the Australian effort currently under way (see Chapter 5). This view is confirmed by Gellein [1988] who admitted that whilst the need to include objectives, qualitative characteristics and elements was clear from the start, beyond that plans were somewhat uncertain. The general areas of, for example, recognition and measurement were known, but the way in which they were to be fitted together was imprecise. (Indeed, Figure 6 above represents a rationalisation of what was already under way, rather than an *ex ante* plan.)

Thus, not only can it be argued (as by Archer, Hines and others in Chapter 2) that the FASB's approach to its CF project was methodologically unsound, but also that its planning within the chosen approach lacked rigour. Whilst it is true that the issues covered by the CF were of great importance, the task of seeking satisfactorily to resolve many of them cannot have been helped by the evident lack of coherence in its completion.

A prescriptive framework

As was noted, the FASB set out to produce a prescriptive, or normative, deductive framework that was to be decision-usefulness based. This approach was advantageous in terms of distancing the FASB from the failures of the past (CFs that had been descriptive or inductive). However, although the CF started out on this route, it strayed as it went on.

Miller and Redding [1988] point out the prescriptive approach was not sustained for the life of the project (even if the decision usefulness base was nominally adhered to). They argue (pp. 115-16) that in fact the

FASB moved 'back and forth between the prescriptive and descriptive approaches', and cite paragraphs from SFAC No. 1 to support this. One may similarly cite examples from later documents such as the plainly descriptive Research Report by Jaenicke (RR – SURV). However it was the final substantive SFAC issued, No. 5 (FASB [1984]), that revealed how total the change of approach was. It made no attempt to be anything other than descriptive of the main areas of interest. For example: 'Items currently reported in financial statements are measured by different attributes depending on the nature of the item and the relevance and reliability of the attribute measured. The Board *expects* the use of different attributes to continue.' (SFAC No. 5, para. 66, emphasis added.) If this was not clear enough, paragraph 2 of the same document had set out the Board's position (again, emphasis added): 'The recognition criteria and guidelines in this Statement are generally consistent with current practice and do not imply radical change. Nor do they foreclose the possibility of future changes in practice. The Board *intends* future changes to occur in the gradual, evolutionary way that has characterised past change.' Contrast these with the Scope and Implications intention for a prescriptive framework.

This change from the avowedly normative intent to the final descriptive result was probably the biggest turnaround in the whole project. Many interpretations may be placed on this, ranging from the suggestion that the Board could not agree on one course of action and hence tried to produce a compromise, to the Board bowing to outside pressure not to follow through the radical changes it was perceived to have embarked upon. (It is speculations such as these that will be examined in more depth in Chapter 4.)

Underlying this, though, was the problem noted previously that the FASB's CF project was not the result of a carefully thought out and logically reasoned approach to the production of a CF. The lack of detailed consideration given to the best way to go about the project might lead one to expect problems. The apparent incoherence of the project over time bears this out.

The production of specified components

An assessment of the successful production of objectives, recognition criteria, a measurement system, and display rules is again a two-stage process. Firstly, one may assess whether each was actually produced at all. Secondly, one may assess each in detail. As with coherence, the

detail will be considered later: this section will concentrate on the broader picture.

Objectives was the subject of the first series of documents in the CF and followed on directly from the Trueblood Report. An SFAC was produced in 1978, two years after the initial substantive document. (As will be seen, this was speedy in comparison with some statements.) It was consistent with the decision usefulness basis of the CF and, although causing some adverse comment, was generally considered a success (but see the detail section below).

Both recognition and measurement were dealt with in SFAC No. 5. However, unlike objectives, neither aspect of this document was considered successful. Although recognition criteria were specified, they were somewhat hazy. They were:

(a) meeting the definition of an element;
(b) having a relevant attribute measurable with sufficient reliability;
(c) being relevant information; and
(d) being reliable information.

Points (c) and (d) stemmed from SFAC No. 2 on Qualitative Characteristics, and point (a) from SFAC No. 3 on Elements of Financial Statements. Point (b), although novel, was not clarified further and hence was left open to interpretation.

The treatment of measurement was even less satisfactory. Whilst recognition criteria were at least specified, measurement was discussed rather than defined (see quote above). Thus, a reader had no clearer idea of the likely eventual outcome in this topic area, reading the CF, than before.

The treatment of display was again unsatisfactory. Although it had been added to the Board's technical agenda and some discussion documents produced (e.g., ITC – FS), it did not result in an SFAC, nor even in a section in SFAC No. 5. Display, quite simply, was quietly forgotten at the end of the project.

Once again, in this regard, the CF failed to meet its intentions. Topics were either dealt with unsatisfactorily or not at all.

Summary

Of the four points noted as being the Board's intention for the CF, it has been shown that one (being a constitution) was unrealistic and thus not attainable. The second (coherence) could be, even at the general

level, questioned, and the third (prescription) was lost sight of. The fourth (production of specific fundamentals) was at best only partially successful. That this leads to the conclusion that the CF largely failed to meet the intentions set out for it is self-evident. Both observers and those involved felt a great sense of disappointment.

However, to say that the Board failed to meet its self-imposed targets is not, however, the same as saying that no good came out of the CF. As the model in Chapter 2 showed, a project such as the CF could be judged a success by others even if it did not meet the intended targets. The next section identifies major themes evident in the project and considers whether they may be represented as a positive contribution of the CF.

Themes emerging during the CF process

Throughout the CF project, a number of themes persist. Some of these were present in the CF from the start, whilst others emerged as it progressed. All are relevant to an assessment of the project, in determining whether it made a positive contribution to accounting and financial reporting.

The importance of cash flows

Cash flows and their usefulness to users of accounts were themes picked up from the Trueblood Report. The FASB accepted that cash flows were important and refined the idea in the documents leading to SFAC No. 1. Cash flows to the firm were differentiated from those to the investor, and past cash flows were differentiated from future cash flows (SFAC No. 1 paras. 37–9).

However, this emphasis on what had not previously been seen as a central topic of financial reporting troubled some commentators for it seemingly implied a radical shift away from 'traditional' accruals accounting. This worry was soon recognised by the FASB and answered in a number of documents, e.g. SFAC No. 1 para. 44, SFAC No. 3 paras. 74–82. In these documents, the dominance of accruals accounting was reiterated. Further support for accruals accounting was provided by DM – RE (para. 8) which suggested that users of accounts use past earnings to predict future earnings and that the latter are then used to predict future cash flows. It was argued (para. 9) that this is preferable to a direct prediction from past cash flow information because 'the

earning statement provides a more comprehensive picture than a cash statement of the results of transactions of a period and of the relationships between them'.[3] Whether or not one agrees with this view, one can see that FASB was unlikely to pursue this topic further. Tradition, in the form of accruals accounting, was to remain.

The likelihood of current value accounting

Another spectre raised by the CF was that of some form of current value accounting. The American financial community is traditionally conservative in its approach to reporting. A project perceived as radical, such as a CF promising a fundamental review, started the alarm bells ringing: current values might be on the way.

As with cash flows and accrual accounting, the FASB felt the need to calm the waters and in the 1976 S&I, a whole section was devoted to 'Is Current Value Accounting A Foregone Conclusion?'. The answer given was 'No', but this seems to have been insufficient, as evidenced by the Mautz campaign of 1977 (see Chapter 4). Indeed, the worry, particularly amongst preparers of accounts, about some form of current value accounting carried on for the life of the CF project, right up to the issuance of SFAC No. 5. This though, by failing to prescribe a specific measurement basis, placated the worried preparers.

Note that both of the above problems resulted from a lack of congruence between the FASB's intentions and the preparer group's perception of them. This is in accordance with the predictions of the model developed in Chapter 2.

Income smoothing and the bottom line

Allied to the current value point made above was the concern of many in the financial reporting community that moves by the FASB towards an asset and liability (A&L) view might lead to standards resulting in less smooth income figures.[4] Again preparers did not like this, but on this issue the FASB did not respond directly. The Board in its later pronouncements (e.g., SFAC No. 5 para. 35) did, however, reveal that it had taken notice of these fears. It did so, not by deferring to the 'income smoothers', but by making clear that it felt that too much attention was being paid to 'the bottom line'. More emphasis, it felt, should be placed on the components of income, the sources and sustainability of revenues, rather than the final net figure. This theme, one being taken up in the United Kingdom by the Accounting Standards

Board (ASB), may yet come to be regarded as one of the major advances arising out of the CF.

The broadening of the FASB's role

A wider aspect of change that may be detected in the CF output was the role that the FASB saw for itself. There is some evidence that the Board wished to enable itself to broaden the scope of its jurisdiction. However, having achieved this position, it has been reluctant to use it.

There are two main pieces of evidence to support this belief. Firstly, within the sphere of business enterprises, the Board changed its search for objectives from those relating to financial statements to those for financial reporting, e.g. whereas Trueblood referred to 'Objectives of Financial Statements', SFAC No. 1 referred to Objectives of Financial Reporting'.[5] The Board also issued the ITC 'Financial Statements and Other Means of Financial Reporting' which again indicated that financial statements were no longer perceived by the FASB as its only responsibility. In that document, the overall scope of the Board's involvement was made clear in a diagram, reprinted in SFAC No. 5 and reproduced as Figure 9.

The other aspect of the FASB expanding its role is its involvement in accounting for governmental institutions. Whilst dealing with not-

Figure 9 Scope of accounting authorities

for-profit (or nonbusiness) organisations in the private sector is fully understandable, involvement in the governmental sector is less so. By becoming involved, the Board initiated a process that led to the important 1989 report on structure (FAF [1989]).

As previously noted, the original nonbusiness organisation (NBO) objectives project was initiated in August 1977 and became a full Board topic in July 1978. This covered all NBOs including governmental organisations.[6] This wide scope was quickly trimmed to exclude federal governmental organisations, but state and local governments were still covered. However, representatives of these bodies objected to the FASB's 'interference', and after a long period of discussion, the FAF trustees bowed to the pressure and set up the separate Governmental Accounting Standards Board (GASB). GASB was given jurisdiction over state and local governmental accounting, and its standards regulate that area. If, however, GASB had not issued a standard on a particular topic, relevant FASB rules were presumed to hold good. This led directly to a clash between GASB and FASB over the issue of depreciation by not-for-profit organisations.

FASB's SFAS No. 93, issued in August 1987, required depreciation to be charged on long-lived assets held by not-for-profit organisations in its jurisdiction. GASB responded in June 1988 by saying that public colleges and universities and certain other governmental agencies should not change their accounting treatment to comply with SFAS No. 93. Thus organisations such as colleges, operating in the two sectors, would produce accounts on differing bases. This obvious anomaly led to much press comment and a deferral of the implementation of SFAS No. 93 (by means of SFAS No. 99). A detailed review of the situation was initiated and this in turn resulted in a recommendation for a further review (FAF [1989]). Eventually, a compromise was reached whereby colleges and universities, and health care entities would fall under FASB jurisdiction unless the governing board of such a government-owned entity opted to be guided by GASB.

In addition, GASB has itself started a CF project, paralleling the FASB one, with the final objectives document already published. Its basis is not decision usefulness but accountability and stewardship. (The argument in SFAC No. 1 that decision usefulness encompasses stewardship clearly was not accepted by GASB.) Further clashes of a fundamental nature cannot be ruled out. The situation is thus as shown in Figure 10.

Thus, to summarise, FASB succeeded in one area in broadening its role and did so temporarily in another (governmental accounting). How-

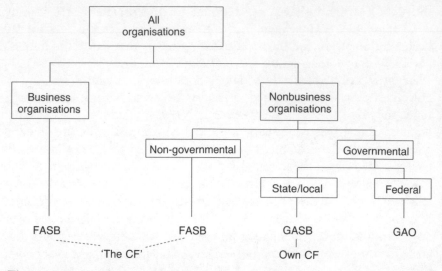

Figure 10 Split of Jurisdiction

ever, this latter success led to a forceful backlash and subsequent limiting of FASB authority. These moves were reflected in CF output, and foreshadowed developments later in the 1980's (see Chapter 4).

Time taken to complete the project

At the outset, the FASB realised that the CF project was a major undertaking. It was therefore likely to take longer than a 'normal' project to develop a Statement of Financial Accounting Standards (SFAS). However no-one envisaged that it would take the twelve-and-a-half years it eventually did (Sprouse [1988], Kirk [1988], Storey [1988]). The sheer length of the project itself became a problem in that the composition of the FASB changed during the period concerned.[7] Changes in Board membership could and did lead to changes in the balance of opinion on specific matters and also made the Board hesitant to take decisions around the time of membership change. Some of the inconsistencies noted in this study may also be attributable to this factor.

If one considers the time taken by each project within the CF, one may see a distinct trend towards taking longer to resolve issues. Taking the time between the issuance of the first and last substantive contributions on each topic, the following position is revealed.

	First	*Last*	*Time*
Objectives	Dec. 1976	Nov. 1978	2 years
QCs	Dec. 1976	Mays 1980	$3\frac{1}{2}$ years
Elements	Dec. 1976	Dec. 1980	4 years
NBO Obj.	May 1978	Dec. 1980	$2\frac{1}{2}$ years
R&M	Dec. 1976	Dec. 1984	8 years
NBO Elements	Jul. 1983	Dec. 1985	$2\frac{1}{2}$ years

With the exception of the last project, to update SFAC No. 3 for not-for-profit organisations, one can see a trend of increasing time per project. The extreme case was Recognition and Measurement. Possible reasons for this are many, with increasing difficulty in achieving solutions acceptable to the Board (and others) ranking highly. This was complicated further by the inclusion in R&M of many aspects of other projects such as Income and Cash Flows. In fact, the final substantive document (SFAC No. 5) was used to wrap up the remaining major issues of the CF.

Innovation

As has been hinted at, in many respects the CF was eventually revealed to be supportive of the status quo. Change would be evolutionary, not revolutionary. It did, however, contain a number of innovative aspects. Although many of these were not developed to their full extent, they are worthy of consideration for they reveal a constant and notable willingness on the part of the Board to be innovative, at least within certain bounds.

Decision usefulness

As already mentioned, the FASB adopted decision usefulness as the basis of the CF project. This contrasted with the previous assumption of the primacy of stewardship. Admittedly the Trueblood Report had emphasised this line of thought, but whereas Trueblood was a report to be accepted or dismissed, the CF was intended to guide the future setting of accounting standards. Thus the adoption of decision usefulness was a significant step that should not be ignored.

Prediction

The time and space (e.g., SFAC No. 1 para. 48, SFAC No. 2 para. 53) devoted to prediction based on accounting numbers was novel. Previously accounting had been largely seen as rooted in the past. Indeed, it is often still is. One hears that accountants should deal with

the past and leave the future to analysts. The CF explicitly allowed a view to be taken of the future. In this, however, it backed away from the Trueblood Report's idea of including forecasts in the financial statements, a feature of Trueblood widely seen as very, or perhaps too, radical.

Comprehensive income
Much has been written in the accounting literature on the subject of income and the ways in which it should be measured. The CF, in SFAC No. 3, introduced a clear and explicit view of this concept, and expressed it in a way that was novel. It defined a type of income, representing a return on financial capital, new to many non-academic readers. This was comprehensive income. So radical were the implications of this (including the possibility, already noted, of allowing current value accounting) that it was felt necessary to explain it thoroughly in diagram form (see Figure 11). It was made clear that this was a concept separate from earnings, the term commonly used in American business, albeit one that the FASB has never defined.

By introducing the concept of Comprehensive Income, the Board hoped to make clear its thinking and smooth the way for future developments. It is a moot point whether it succeeded in this, for most commentators seemed somewhat nonplussed by the concept. Anthony [1987, p. 76], in typical style, commented, 'Comprehensive income is a meaningless term. I have not seen it before and I doubt that I will see it again.'

Diagrams used in exposition
One facet of the CF in particular that is to be applauded was the use of diagrams to help explain difficult concepts or problems. The diagram on CI (Figure 11) is a good example. Others include the extension of the same basic diagram to cover not-for-profit organisations,[8] the description of FASB jurisdiction in SFAC No. 5 (see Figure 9), the hierarchy of Qualitative Characteristics in SFAC No. 2 (see Figure 12) and the explanation of the types of nonbusiness organisations (RR – NBO). Such diagrams not only make dry texts somewhat easier to follow, they also form useful aids to learning and teaching.

Summary

Of the themes noted, the first three raised doubts in the minds of observers as to the intentions of the CF producers and led to resistance,

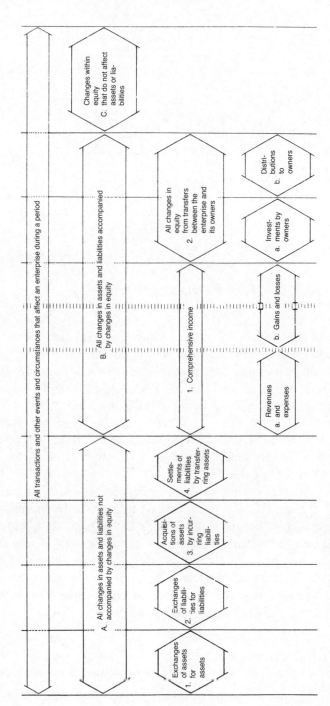

Figure 11 Comprehensive income

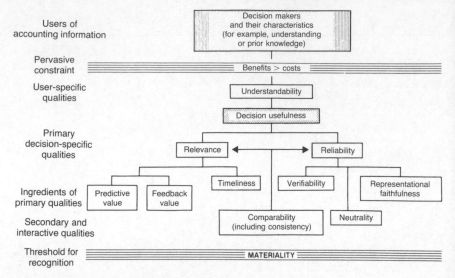

Figure 12 Hierarchy of qualitative characteristics

i.e. in terms of the model described in Chapter 2, expectations were not met by actual events, with unfortunate consequences. This needlessly hindered the Board's work, time and resources having to be devoted to correcting the false impressions gained. The point on jurisdiction, whilst being concerned more with procedures than content, again diverted Board's attention from its main task. The increasingly slow completion of individual projects by and large reflected rather than caused problems. The last topic discussed – innovation – showed some of the major positive contributions of the CF.

On balance though, even assessing the CF against criteria other than those set by the FASB, one finds it hard to be overwhelmingly positive. The many good points to flow from the project seem somewhat lost amid the problems that arose in getting across the ideas. This is crucially important and must be recognised by those following in the FASB's footsteps. Even good ideas will fail if they are not presented properly. The next section considers more detailed aspects of the CF to see if this negative view is further supported.

Specific aspects of the CF

Just as one may gain interesting insights into the process of CF formulation by examining the broad issues, consideration of the detailed output

can also be quite revealing. Indeed, a detailed review of the documentary output of the CF project raises many points. Some of these may be, after further investigation, found merely to be drafting changes with no deeper meaning. Other are of more interest. To this end, each series of documents may be examined in turn to elicit developing themes, to note changes that occurred over time and to identify anomalies arising.

Many small changes can be identified by such work. These include changes to arguments put forward in support of a position, alteration to the order of documents, and variations of wording. Many of these can be attributed to stylistic or editorial reasons. Some, however, were clearly more significant and thus are considered here.[9]

Confused exposition

In an earlier section it was indicated that a degree of muddle was apparent in the FASB's general approach. This is also apparent in the actual documents produced. Seven examples are worthy of particular comment:

(a) the documents produced intertwine topics to an extraordinary extent, e.g.,
 e.g., DM on Elements and Measurement
 ED on Objectives and Elements
 ED on Recognition and Measurement
 Such merging and breaking up of topics raises questions as to how clear a picture FASB had of its task. It also makes following the arguments harder for a reader of the output.
(b) in the family of documents leading to SFAC No. 1, the discussion of the role of stewardship or accountability became confused. Accountability was used in the Trueblood Report to mean something more than stewardship. Accountability was taken to imply a duty to use the assets of the company to their best advantage, whereas stewardship simply meant to maintain them. In capital maintenance terms, stewardship led to consideration of return of capital, accountability to return on capital. As Skinner [1973, p. 141] said, 'The parable of the talents . . . had the same idea and explained it rather better'. Accountability was adopted by the FASB in Tentative Conclusions (TC) (para. 17), but later on in ED – OBJ & EL the word stewardship replaced it, even though the discussion of the concept under consideration remained constant. Thus, the meaning of stewardship was either being silently broadened or the issues confused.
 It is also relevant to note that later work in the NBO series on Successful Efforts and Accomplishments was not integrated with this. SE&A covered the attainment of what is now termed (at least in United Kingdom local government circles) Value-for-Money, and thus offered the prospect of deriving ways of assessing accountability. This, however, was not fed back to the business enterprises section of the CF. This in itself indicates a lack of co-ordination of the various aspects of the whole project.

(c) the list of users put forward in the documents leading to SFAC No. 1
 changed and grew over time. However, it is in the paragraph dealing with
 the main users, the information provided to whom (it was stated) would
 suffice for all, that a major change occurred. At the SFAC stage the
 previous 'investors and creditors' became 'investors, creditors and others'
 (para. 34). Not only were the 'others' unspecified, but the other objectives
 and the arguments put forward did not change radically. Thus, even
 though the groups at whom the information was aimed were altered, the
 justifications of why they were targeted did not. This leads one to question
 what, if anything, would have been necessary to result in changes to the
 objectives previously decided upon.

(d) there is a discussion in SFAC No. 2, paras. 16–18, on the Board's
 responsibility (regarding information qualities) to various user groups.
 Although forming a coherent discussion in itself, this seems to have been
 somewhat superfluous since the identity of the dominant user groups, the
 satisfaction of whose needs would satisfy all, had been decided in SFAC
 No. 1.

(e) there is a reference in SFAC No. 2 to a 'reasonable person' in the dis-
 cussion of materiality (see para. 132). One would have expected, rather,
 that the user groups identified in SFAC No. 1 would form the basis for
 this assessment, i.e. if the users are the focus for the financial reports, it
 must surely be their view of materiality that is important, not that of an
 undefined 'reasonable person'. (It may be argued, of course, that the two
 are synonymous.)

(f) again in SFAC No. 2, the discussion of understandability *vis-à-vis* rel-
 evance is confusing. In the hierarchy of qualitative characteristics, repro-
 duced here as Figure 12, understandability is shown on a higher tier than
 relevance with the indication that it is a user-specific quality. However, the
 somewhat unexpected analogy of the vegetarian traveller in a foreign
 country (para. 39) seems inconsistent with this. If the traveller cannot read
 the menu, the information it contains cannot be understood by him. Thus,
 although the information is relevant to his decision of what to eat, it is not
 useful to him. Showing understandability as a hurdle (in a similar manner
 to cost/benefit and materiality) between decision usefulness and relevance
 would seem a more satisfactory exposition.

(g) in SFAC No. 3, the definition of assets and liabilities (paras. 19 and 28
 respectively) contain the word 'probable'. Thus, for example: 'Assets are
 probable future economic benefits obtained or controlled by a particular
 entity as a result of past transactions or events.' The use of the word
 'probable' is problematic. This was recognised by the Board for a footnote
 was provided for each definition (footnotes 9 and 13) stating that a usual,
 general meaning was implied, not a specific technical one.

 However, even given this, when is something probable? That this may
 be fiercely debated was made clear in a 1988 FASB staff training seminar
 when FASB staff found difficulty in agreeing on this. Whilst those taking
 part in the seminar (including Board members) stated that 'more than 50%
 likelihood' would constitute probable, those leading the seminar implied
 that the word should be interpreted as being 'less than but near to 100%

probable'. This latter had been the intention, it was claimed. Indeed, the word 'probable' had only been introduced into the text after comments that its omission implied that 100% certainty was required for an item to be an asset or liability.

Clearly such a degree of divergence of view within the FASB makes the presentation of a coherent view to outsiders even more difficult. Perhaps dealing with probability in the recognition phase of the project as has been done by others, e.g., AARF and CICA, would have been more appropriate.

Dropped topics and unfulfilled promises

Throughout the course of the CF, documents were issued that contained topics that were later omitted. Additionally, reference was often made to other topics to follow, some of which failed to materialise. Possible reasons for these events abound: a review of the topics concerned may give some ideas of the true reasons.

(a) although they were picked up by the FASB from the Trueblood Report, the topics of earnings cycles and forecasts did not survive to the final SFAC. The former originated with the 'Chicago school' members of the Trueblood group, the latter with particular individuals, e.g., Frank Weston, APB member and former Arthur Young partner. Their failure to survive has been attributed to pressure from the public accounting practitioners who felt that they, particularly the forecasts, would cause difficulties in signing an audit opinion (Weston [1988]).

(b) multicolumn reporting, mentioned in SFAC No. 4 (footnote 20) as being a possible future project, was never pursued. This again would have been a radical step. One can conceive of many arguments against it, including cost and provision of too much information, both in terms of confidentiality and overloading the reader, so its exclusion is not surprising.

(c) similarly footnote 23 of SFAC No. 4 indicated that recognition and measurement issues relating to nonbusiness organisations were outside the scope of the statement. This seemingly implied that further work in the area was envisaged, perhaps to form another document. This, however, never occurred.[10]

(d) again in the nonbusiness area, a research report on Successful Efforts and Accomplishments was not pursued. Indeed, it was issued only one month before SFAC No. 4 and, although referred to in footnote 24 of the later document, was never capitalised upon.

(e) a DM was scheduled to follow the Ijiri and Jaenicke research reports on recognition. This never appeared. Instead, a further research report by Johnson and Storey was published. This happened because it was decided that a DM was not the best answer; a document with more focus, a 'Tentative Conclusions' for Recognition, was needed. However the Board felt uneasy about committing themselves to this, and so Robert Sterling,

by then at the FASB, suggested a research report as an alternative, an educational device for Board members (Johnson [1988]).

(f) the split of Revenues and Gains, Expenses and Losses was never resolved. It was suggested (SFAC No. 6, para. 88) that this split, depended upon the circumstances of individual companies, and was a display or reporting matter. This seems strange given that each item mentioned was identified as an element, 'a building block' of financial statements (SFAC No. 3 Highlights).

(g) earnings was never defined. Although promised on a number of occasions, this income measure, forming a component part of comprehensive income (SFAC No. 3, para. 58), and perhaps being based on physical capital, was never finalised. (It was, however, described more fully in SFAC No. 5, para. 34 as excluding the cumulative effects of certain accounting adjustments of earlier periods from the current period results.)

(h) the statement in ED – EL (para. 37) that capital maintenance was to be the subject of a separate project was never completely followed through. Discussion of capital maintenance concepts was restricted to other documents, particularly in the elements and recognition and measurement series.

(i) similarly, suggestions of a number of novel financial statements failed to come to fruition, even in SFAC No. 5, notably the statement of cash flows and the statement of transactions with owners. This may be attributed to the fact that SFAC No. 5 did not pick up all of the strands of the documents that preceded it, particularly those relating to display. Alternatively, it may be that it was recognised that matters such as cash flow statements were too specific for an SFAC and were better dealt with in an SFAS.

(j) on a smaller scale, one may note that the reference to 'operating profit' present in a worked example in ED – R&M was missing from SFAS No. 5 (para. 44). It seems likely that this was removed when the Board realised that it was introducing an undefined term into its argument, one that might lead to dispute later.

Summary

A characteristic common to most of the above points is that they represented or promised radical changes from contemporary practice. The fact that they were not pursued might lead one to suspect that the Board backed off, fearing adverse comment. Further, one might suggest that the Board was subject to pressure not to continue with such topics. Considerations such as these will be covered in Chapter 4.

Unresolved problems

Anthony has said [1987], 'There are only a few fundamental issues in financial accounting. The FASB ducked them all.' Although this may be viewed as a little harsh, when one lists the problems or topics left

unresolved at the end of the CF, some credence must be given to this view. These are:

(a) REGAL, i.e. the distinction between revenues and expenses, gains and losses (see above).

(b) the unit of measurement. This was discussed in both mainstream CF documents (e.g., DM – EL), and the series on inflation accounting (e.g., DM – GPL, ED – GPP, RR – FT, ED – FR&CP, ED – CON.$, SFAS No. 33). Throughout this latter series in particular, it seemed certain that a constant dollar measuring unit would eventually be adopted. However, the issuance of SFAC No. 5 dispelled this idea. This noted that although the 'ideal' was a unit stable over time, the dollar was acceptable if inflation remained low, being familiar and easy to use. Thus, the Board expected that nominal units would continue to be used, although changed circumstances might lead the Board to select another, more stable unit (SFAC No. 5, paras. 71–2).

One wonders what would have been the outcome of this process had inflation in the USA remained high rather than declining. Also, one might ask when, if inflation again rises, distortions will be deemed to be intolerable.

(c) the attribute to be measured. The five attributes listed in SFAC No. 5 were historic cost, current replacement cost, current market value, net realisable value, and present value. This was a list broadly similar to that in the Trueblood Report that came out eleven years previously. Thus, despite a good deal of discussion (involving most of the inflation accounting documents plus several mainstream CF documents, e.g. DM – EL, ED – OBJ&EL), no new ideas were forthcoming and no progress was made in resolving how to use the attributes already acknowledged.

Interestingly, Sprouse [1988] states that he felt that the Board should have gone a stage further than it did. It should have suggested a hierarchy of the desirability of the attributes and given guidance as to when each should be used.

(d) the capital maintenance concept. In all the documents after DM – EL e.g. ED – FR&CP and SFAS No. 33, it was clear that financial capital maintenance (FCM) was favoured over physical capital maintenance (PCM) and it was this concept that was adopted in SFAC No. 3 as the basis for comprehensive income. However, PCM was not abandoned completely, for it was suggested that it may form the basis for earnings. (See (g) in the above section.)

(e) display issues generally. No display issues of note were ever decided upon in the CF project. Initial work on 'Financial Statements and Other Means of Financial Reporting', 'Reporting Earnings', and other topics came to nought. Even in the last stages of the CF, however, references were made to issues being display matters and thus having to be dealt with in that section.

(f) the status of Type A organisations in the nonbusiness area. RR – NBO (p. 162) shows this clearly. Three types of organisation were shown, being business enterprises, Type A and Type B nonbusiness organisations. The

term business enterprises is self-explanatory, whilst type B NBOs are totally dependent on donations. Type A NBOs are NBOs dependent upon trading for their income. Whilst the treatment of both business enterprises and Type B NBOs seems clear, the issue of how Type A NBOs should be dealt with was never satisfactorily resolved.

Summary and conclusions

This chapter has covered some aspects of what actually happened in the development of the CF. The scale of the project was described and the resources used noted. The structure of the project and the various series of documents were described. A broad assessment *vis-à-vis* the Board's own aims was given, showing that the CF failed to meet these goals. Whilst it would be difficult given the lack of congruence between intent and outcome to suggest that the CF succeeded as originally envisaged, it would be wrong, however, as has been widely suggested, to regard it as a total failure. Admittedly one must allow the goal posts to be moved in order to take such a positive view, but clearly many fundamental accounting issues were dealt with in the project and discussed more fully than anywhere else before in a public forum. Suggestions for innovative change were introduced. All these points indicate that much good came out of the CF: not perhaps the specific good that was intended, but still of no small value.

Did the CF please the critics? Only by default. Most critics were afraid of radical change. By failing to produce radical answers to many problems, particularly in the areas of recognition and measurement, the Board produced a document that satisfied these critics. Academics may bemoan the CF's failings, but preparers and others have been placated.

The original goals are not the only ones by which one may judge the CF's success or failure. The general trends that emerged were discussed and many positive points found. From this examination, however, it is the various anomalies in the development of the CF that are of particular interest. These, it has been noted, possibly indicate a degree of muddle or confusion in the minds of those developing the CF, and/or possibly that the Board was subjected to external pressures. This last point is taken up in the next chapter and pursued further.

Notes

1 The reasons for the dropping of subjects, or their incorporation into other projects, are of particular interest and will be considered later.

2 Appendices 2 and 3 give full details of the documents produced as part of the CF project, firstly by date of issue and then by 'family', i.e. the series of documents, by subject area, leading to an SFAC.

3 See DM – RE and DM – RFF for a detailed discussion of the linkage.

4 This refers to the 'conceptual primacy' afforded to the definitions of assets and liabilities rather than to revenues and expenses. Thus, if the A&L view is adopted, revenues and expenses would be defined in terms of assets and liabilities. If the R&E view is accepted, the definitional flow is reversed. See Chapter 4 for a description of the Mautz campaign on this topic.

5 It is possible to argue that this was simply clarifying a logical flaw in the previous documents: financial statements themselves cannot have objectives. The activity of reporting can have objectives; the documents cannot.

6 The New York City financial crisis and subsequent calls for order to be restored in governmental accounting had much to do with this, thus paralleling the crisis that led to the formation of the FASB itself.

7 Staff members and others refer to the first, second and third Boards, i.e. the Board that started the CF and completed the early stages, that which grappled with the problematic later stages, and the current Board.

8 It is worth noting that in the end the FASB had to produce separate diagrams for the income and equity concepts for business enterprises and not-for-profit organisations. This revealed the problem of the proprietary view implicit in the CF, for if the entity view had been adopted, the distinction of what constitutes equity or net assets would have been less crucial. See SFAC No. 6, paras. 49–65, 90–106.

9 A similar assessment of the CF is presented by Agrawal [1987]. He gives five headings to the anomalies he found in the CF, these being Incompleteness, Internal Inconsistency, Circular Reasoning, Unsubstantiated Assertions and Ambiguity. Under these headings he cites a number of examples, many of which (e.g., the move from a normative to a positive approach, the lack of a decision on a measurement attribute and a measurement unit) are valid. Others, however, are not (e.g., suggesting that SFAC No. 1's emphasis on earnings is inconsistent with SFAC No. 5's emphasis on asset definition, i.e. the type of argument put forward by Mautz in 1977).

10 There has been talk amongst FASB staff that the current consideration of recognition and measurement issues relating to financial instruments might lead to a document in 'green covers', i.e. a further SFAC.

4 Theoretical Consideration of the Conceptual Framework Formulation Process

Introduction

To seek a full understanding of the workings and results of a complex social system is an ambitious venture. In any sphere of study, complete theories are hard to find, universally accepted theories rare. However, compared with, say, understanding the community structure of a remote tribal people, an examination and explanation of the process governing the production of a CF by the FASB would seem a simple exercise. Data are readily available, communication with those involved is straightforward and the culture within which the process occurs is reasonably familiar. Producing a comprehensive description and then theory of the process, and hence being able to predict and explain its results, should not be insuperably difficult.

However, simply listing the factors to be taken into consideration in an examination of the FASB CF soon tempers such sanguine thoughts. Such factors include:

- the structure within which the process occurs
- the formal procedures adopted
- the manner in which the participants interact
- modes of acceptable behaviour
- the methods of influence open to participants
- the methods of influence open to others
- the motives underlying the decisions taken.

To understand these is a daunting task, but one that must at least be attempted in order to explain the changes, omissions and ambiguities within the CF noted in the preceding chapter. Without such a theoretical base, examination of the phenomena may become speculative and ill-focused.

This chapter does not offer a complete and universal theory of the behaviour and workings of modern US accounting standard setting. Nor can it unequivocally state that the changes noted in the previous chapter were solely due to a particular set of factors. What is offered here is a partial theoretical framework to highlight certain specific areas; a lens to focus attention on matters worthy of detailed consideration. When such matters are examined, some light is shed on the occurrences of interest.

The chapter is based on two main areas of the theory of regulation. The first of these concerns some of the relevant economic theories; the second is on aspects of the sociological and political science theory of power. Together they offer insights into why interest groups may wish to bring influence to bear, and how they can go about it. The validity of applying these theories to the particular case of the CF is established, and evidence is presented to test the theories. Finally an assessment is made of whether they offer a satisfactory explanation of the anomalies noted in the previous chapter.

Theories of regulation

Theories of regulation may be dichotomised across (at least) two dimensions. They may be split into those that are economics based and those derived from political science. (Obviously there is a degree of blurring between the two as politics is largely concerned with the division of wealth between members of society.) And, whether economics or politics based, these theories may be classed as public interest theories or interest group (or capture) theories (see Mitnick [1980]).

As intimated above, this chapter concentrates on the interest group theories, both economic and political. The reasons for this are:

(a) the public interest theories, that form the basis of much of the justification for regulation in the sphere of accounting, are well developed and have been examined elsewhere (see Mitnick [1980], Bromwich [1985], Watts and Zimmerman [1986]);

(b) the idea of the capture of the FASB process by a variety of groups, most notably the Big Six (formerly Big Eight) accounting firms and the preparers of accounts, has on many occasions been informally expressed and deserves closer examination; and

(c) the concepts and ideas involved in the interest group theories (particularly the politically based theories) have not been extensively applied to accounting and hence offer the prospect of novel insights.

Economic theories

A number of economic theories or insights help explain the desire by interest groups to influence accounting standard setting and hence, by extension, the production of a CF. These may be split into two groups:

(a) those explaining why interest groups may wish to bring influence to bear, and

(b) those describing the ways in which they may do so.

In the first group are functional fixation and agency/contracting theories, in the second economic consequences, lobbying and economic capture. Together they form a starting point for the more detailed consideration of how influence is brought to bear to be provided in the following section.

Functional fixation

This term describes the idea that shareholders, businessmen and others take the numbers in financial reports at face value. Thus, if an accounting rule is changed such that a company's reported profit falls, for example by requiring reducing balance rather than straight line depreciation, the readers of the report will change their behaviour accordingly (and sell their shares). Such behaviour is often cited as contradicting the idea of 'efficiency', where the market is supposed to 'see through' such changes (see Beaver [1989]).

Functional fixation rests on the idea of economic rationality, i.e. more money is preferred to less and actions will be taken to achieve this end. However, the learning process is slow and inhibited. Thus if reported profit falls, investors are assumed to sell their shares (or not buy more) and the market value of the firm falls. Fixated businessmen will thus seek to ensure no accounting standards are passed that lead to falls in reported profits.

Although seemingly logical in as much that it explains the observable concern of companies to be allowed standards that suit their interests, this idea is inadequate in that it does not provide a detailed mechanism to explain the actions taken. This is in part provided by agency/contracting theory.

Agency/contracting theory

Agency theory, derived from the work of Jensen and Meckling [1976], provides a tangible linkage between changes in accounting numbers and the behavioural response by businessmen and others. The core concept

is that capital-supplying principals (share- and debt-holders) wish to ensure that their risk- and labour-averse agents (corporate managers) act as they themselves would. Problems may arise in that agents may not devote the necessary effort, or may take out too much in the way of perks, unless monitored constantly. In other words, there are costs to the agency relationship that can cause the value of the firm to fall.

To counter this, contracts may be entered into, for example linking the managers' pay to the firm's performance. Indeed, it is probably in the managers' own interests to do this, for the market system, assuming efficiency, ensures that agency costs are ultimately borne by those who consume the perks (Watts and Zimmerman [1986], pp. 185–6). Watts and Zimmerman summarise the main points (on p. 199) in the following manner:

Accounting numbers are used in the firm's contracts that are designed to reduce agency costs. Ratios such as debt/equity ratios are used in debt contracts to restrict managers' actions that transfer wealth from debtholders. Accounting earnings are used in bonus plans, presumably to reduce manager shirking . . . If a contract's effect on agency costs varies with the procedures to calculate the accounting numbers used in the contract covenants, the firm's and/or manager's cash flows vary with the accounting procedures.

The use of accounting numbers, produced in accordance with GAAP, in these contracts, rather than information produced specifically for the purpose, reflects the fact that additional costs would be incurred if the latter path were to be followed. Hence one may understand company managers keeping a close check on potential accounting rule changes, for their own pockets may be affected. One may also note that the monitoring of the contracts is in large part perceived to be carried out by the annual audit, and thus accounting firms, too, have an interest in the rule changes and their clients' reactions to them.[1]

Economic consequences
As noted in Chapter 2, economic consequences is a phrase that came to prominence in the mid-1970s. It describes 'the impact of accounting reports on decision making behaviour of businesses, governments, unions, investors and creditors' (Zeff [1978]). In particular, it refers to examples of reactions to changes in reported profits caused by changes in accounting rules.

Although the discussions of economic consequences yielded no detailed explanatory theory (this being provided by functional fixation or agency theory), they did draw out many examples of modifications to behaviour in response to changes in the rules governing reported

accounting numbers. Amongst these were the various actions taken in response to SFAS No. 8 on foreign currency translation, such as changes in hedging policy, in order to maintain reported income at 'expected' levels. Companies involved in such changes included Philip Morris (see Rappaport [1977]), TRW, Woolworths and ITT (see Andrews and Smith [1977]), and various banks (Business Week [1976, 1977], cited in Watts and Zimmerman [1986]).

Not surprisingly, perhaps, the examples that were reported were all concerned with instances where the effects of the accounting standards were perceived to be negative: an aggrieved company tends to be more vocal than one benefiting from the change.

From this it might be expected that lobbying on accounting standards based on economic consequences would occur. Indeed, this had happened in the days of the APB when, for example, Monumental Corporation announced that it would change its investment portfolio if a standard were to be adopted causing unrealised gains and losses on securities to be included in income (Foster [1978], p. 536). The lobbying on APB Opinions 16 and 17, noted in Chapter 1, also falls under this heading.

The FASB's first major experience of this phenomenon was the response in 1976 of the American Banking Association to the discussion memorandum on accounting for the restructuring of debt. A number of proposals contained in the DM were viewed unfavourably by the president of the ABA who suggested to his members that they should lobby the FASB, which they duly did. Additionally, at the public hearing, a number of senior bankers stated that the proposals might lead them to re-examine their loan portfolios. Loans to (ethnic) minority business enterprises, friendly foreign governments and US local government might become harder to obtain. In other words, there would be severe economic consequences to the proposals. (This was the time of the New York City bankruptcy, so the impact of such comments is not hard to imagine.)

On this issue the Board backed down. They felt that they could not do what they felt to be 'right'. To challenge the ABA might threaten the FASB's very existence (even if they were justified in pointing out that changing the accounting rules did not alter the collectability of loans).

Such lobbying and its implications caused great concern to the Board and in particular its Technical Director, George J. Staubus. Their point of view was that accounting standards, although resulting in changed reported profits, rarely had direct cash flow implications and hence the economic consequences were not real.[2]

As a way of examining the validity of lobbying on these grounds, Staubus organised a conference on the topic. All relevant organisations were notified and invited to submit papers. A committee selected the best and these were presented at the conference. With modifications, they were published as a FASB Research Report (RR – EC) [1978]. Staubus has pointed out that the groups and companies that had been so vocal on the economic consequences issue all failed to produce papers for the conference, and were almost silent on the topic thereafter (Staubus [1988]). In effect, having failed to 'put up', they had to 'shut up'.

However, it remains clear that some corporate managers do modify their actions to compensate for accounting rule changes: company policies are changed. If accounting rule changes, such as those that could ultimately be derived from a novel CF, were perceived as particularly disadvantageous, lobbying to prevent the rule change is a logical course of action.

Lobbying
Sutton [1984] provides a more detailed and rigorous economic rationale for lobbying. Based upon the explanation of voting behaviour by Downs [1957], he asserts that interested parties will undertake lobbying if the benefits likely to be achieved exceed the costs of so doing. However, lobbying is likely to be of limited extent due to free-rider problems and perceptions of low probability of affecting the outcome.

Sutton also suggests that producers of accounting information are more likely to lobby than the users (due to wealth and diversification differences), and large producers are more likely to do so than small ones (again on wealth grounds). Another factor is the cost of non-compliance with the resulting regulation. This suggests that in the USA, with SEC-enforced compliance, the consequences of procedures becoming part of the 'rule book' give an incentive to challenge unpalatable proposed regulation before it is in place. Of course, a high level of lobbying does not necessarily lead to success, as will become apparent later.

As will be seen below, the ideas Sutton puts forward are in accordance with many aspects of power analysis and thus will be pursued later.

Economic capture theory
The branch of economic theory referred to here is that based largely upon the work of George Stigler and the Chicago school. (Note also the

work of Moore [1961] and Jordan [1972].) In an influential 1971 paper (drawing inspiration, as Posner [1974] points out, from the work of Downs [1957], Buchanan and Tullock [1962] and Olson [1965]), Stigler proposes the notion that firms in an industry will demand regulation.[3] Such regulation would provide benefits for the industry in the form of either direct subsidy, control over entry, control over substitutes and complements, and/or price fixing. The concomitant costs would consist of providing (political) campaign contributions, business connections, and the like. In addition, Stigler suggests that those demanding regulation would seek to capture the regulatory process so as to ensure acceptable or favoured regulation was passed (see Mitnick [1980] for a full discussion).

Further papers by Posner [1974] and Peltzman [1976] extended and refined the original idea. Posner introduced cartel theory whilst Peltzman suggested that politicians, determined to remain in office, will receive support (votes) to the extent that, by their actions, they secure net (financial) gains for their supporters, the companies.

A number of major problems exist in applying Stigler and Peltzman's ideas. Firstly, they both assume that the agency producing the regulation can enforce it: coercion can occur. This need not actually be the case, particularly for bodies such as the FASB which must rely on another body, the SEC, for enforcement. Secondly, they both assume that economic betterment flows directly from a political process, i.e. support is given to a politician in return for his work to secure favourable legislation. This, as Mitnick [1980, p. 114 *et seq.*] points out, is unrealistic (or at least incomplete). Politicians enact legislation, they do not administer it. Further, in the specific case of the FASB, board membership is not the product of a democratic process in which campaign contributions and the like can be directly influential: Board members are appointed by the trustees of the FAF (see below). Finally, the idea of capture as expressed by Stigler is restrictive. It allows only those regulated to capture the process – in this case, the preparers. As has been noted, other groups, e.g. the big accounting firms, have been suggested as 'captors'.

The above may explain why little attempt has been made explicitly to apply this theory to the accounting world. Exceptions exist in the work of Benston [1980] and Johnson and Messier [1982]. The former examined the market for public accounting services as a whole, the latter the possibility that the FASB was controlled by the (then) Big Eight accounting firms.[4]

Summary

In this section, two possible theoretical explanations, functional fixation and agency theory, of why companies and others might feel the need to influence the accounting standard setting process were given. Additionally, many examples of direct action taken by companies were presented, plus theoretical suggestions of what further action they might take. Sutton predicts that:

(a) preparers are more likely to lobby than users, and
(b) big preparers are more likely to do so than small ones, i.e. one might expect 'big business' to dominate.

The capture theorists also come to a similar conclusion, i.e. that those regulated, the preparers, will seek control of the process. These predictions will be assessed below after the relevant politically-based theory is set out.

Political theory

Unlike the preceding section which offered an array of relevant theories, this section focuses on one main area: the study of power. However, as will be seen, the simple word power has many nuances and the resultant literature is, if anything, more wide-ranging than the economic considerations above.

Power

Throughout history, power has fascinated great minds. Thinkers as diverse as Aristotle, Machiavelli, Hobbes, Russell and Michel Foucault all regarded the concept worthy of consideration. In recent years the study of power has been concentrated mainly in two areas of intellectual endeavour, namely sociology and political science. In each, various views of power have been developed, criticised and debated, and extensive cross-fertilisation between the two areas has occurred. This study, whilst not ignoring the input from sociology, draws heavily on developments flowing from political science, and seeks to show why it is appropriate to apply the concept to the sphere of accounting standard setting.

The section is structured as follows. The idea of power is considered. Then the ways in which power may be asserted are discussed, as are their applicability to the case of the FASB. The development of the

main views of power is outlined, and finally a linkage formed between the concepts discussed and the case in hand.

What is Power?

There are nearly as many definitions of power as there are writers on the subject. Not surprisingly, the definition of the subject is closely tied to the perspective (ideological, political, philosophical, methodological) from which it is viewed and this leads to differing results (or interpretations of results), as will become evident.[5]

Two of the most commonly repeated definitions of power are those of the sociologist Max Weber [1968] and the political scientist Robert Dahl [1957]. These are:

Weber the probability that one actor in a social relationship will . . . carry out his own will;

Dahl A has power over B to the extent that he can get B to do something that B would not otherwise do.

It is possible to criticise both definitions. For example, Wrong [1979] has found fault with Weber, Bachrach and Baratz [1962 and 1963] with Dahl. Clear differences between the definitions are apparent (for example, Dahl's restriction of the case to two actors, the degree to which power is viewed as actual rather than potential, etc.). However, the general idea of behaviour being changed at the behest of one (individual or group) participant in a process is common (but see Lukes below).

This central idea of causing a change in behaviour seems very pertinent to the theme of this study. However, before use can be made of it, consideration needs to be given to the forms that power may take, and to the ways, some more subtle or insidious than others, in which it may be expressed.

The forms of power have been categorised by Wrong [1979] (see Figure 13). Only some of these are relevant to the FASB, as the following indicates. Clearly, force is not a consideration. Manipulation (which Wrong [1979, p. 28] defines as when B is not aware of A's intention to influence him but A does in fact manage to get B to follow his wishes) is relevant to the FASB's situation. However, the FASB is very aware that it is likely to be the subject of attempts to influence it – after all, the emphasis on due process (see Appendix 1) is designed to formalise and make open such occurrences. As a result, manipulation is, on the face of it, unlikely to be prevalent (but see the discussion of two dimensional power below).

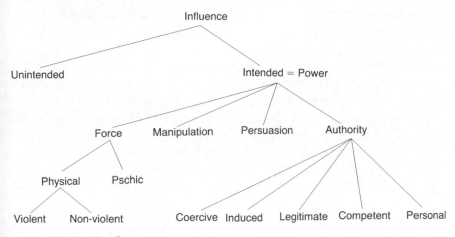

Figure 13 Types of power

The inclusion of persuasion, defined in the normal sense, in the chart of power is dubious, for it 'lacks the asymmetry of power relations' (Wrong, p. 32). However, it is worth mentioning as it matches the image that many have of standard setting – reasoned argument leading to the 'right' answer. Once again, the due process formalises this.

Authority may take many forms and it is here that one facet of power, often ignored, comes to the fore. It will have been noted that the comments above all implicitly take the object of the display of power to be the FASB, the subject being the interest group. However, authority in its various guises is a form of power that the FASB may have over other groups. Thus it can be seen that power is a two-way process, a relationship, not a simple one-way street.[6]

The FASB's own power is also worthy of further consideration. Taking each form of authority in turn, starting with coercion, Wrong [1979] p. 41 states: 'For A to obtain B's compliance by threatening him with force, B must be convinced of both A's capability and willingness to use force against him.' As was noted above, the FASB cannot enforce its own rules. For this it relies on the SEC. The direct application of coercion must therefore be ignored. Nor can the FASB offer inducements, so this too must be dismissed.

Legitimacy is at the heart of the FASB's ability to function (Johnson and Solomons [1984]). As was seen in Chapter 1, the Board was formed as a result of previous failures and organised in a way to answer widely expressed criticisms. Having been forged in the fires of necessity, with the approval of all interest groups, the legitimacy of the Board could not

be seriously challenged.[7] Competence is another area in which the FASB should be above criticism, and in the obvious sense it is. Being formed of knowledgeable and eminent persons, with a range of backgrounds, the Board has firm foundations. Yet criticised it has been. This has mainly taken the form of complaints of an ivory tower outlook. Finally, personal authority might not be expected to be a topic relevant to this study, but it is. Many Board members and others involved in the story of the CF were held in great respect: their views carried weight.

In order to appreciate the ways in which these forms of power may be expressed, and also to realise some of the problems of assessing the expression, a consideration of the origins of modern power theory is needed.

The community power debate

The starting point for most modern writing on the expression of power is the debate over community power. This is so called because it derives from an extensive literature on the way in which power is distributed within local (community) politics in the USA. The following brief outline of the debate highlights a number of important issues concerning the methods used to determine the existence of power.

Examining this field in detail, writers such as Floyd Hunter [1953] and C. Wright Mills [1956] produced work that indicated that a 'ruling elite' determined the way in which communities are run. In other words, despite the democratic process, a minority group actually controlled local politics. This view diverged from the previously held, and intuitively comforting, notion that the community (or public) interest dominated, that democracy operated well.

These ruling elite writers based their assertions on studies conducted in various local communities (and, in the case of Mills, on a broader, national basis). However their work was the subject of considerable criticism, most notably by Robert Dahl ([1958, 1961]) and Nelson Polsby [1963], who drew attention to the fact that the elitists' results were largely based on anecdote and reputation. Dahl in particular insisted that such methods were inadequate: hard facts were required to back up such serious claims.

In a series of studies, notably *Who Governs?* [1961] which examined local politics in New Haven (the home of Yale University at which he taught), Dahl sought to examine actual decisions taken on certain 'key' issues. Voting records were examined as a way of assessing instances of the use of power. Dahl's conclusion was that the ruling elite hypothesis could not be supported: a 'pluralistic' view was more satisfactory.

Dahl's work was, in turn, the subject of criticism. Writers such as Bachrach and Baratz ([1962, 1963, 1970]) claimed that to focus purely on formally-taken decisions in the way Dahl suggested was to miss much of the subtlety of the way things actually worked. Not only was the subjective identification of 'key' issues unsound; they also suggested that 'non-decisions' were as important as decisions and that research such as Dahl's, that ignored them, was at best inadequate, at worst misleading. By non-decisions, Bachrach and Baratz (B&B) were mainly referring to instances when matters, worthy of consideration, were not included in the agenda of items to be discussed, possibly as a result of a covert exercise of power.

Writers who took the B&B view were themselves not without critics, notably Merelman [1968] (who coined the term neo-Elitists to describe them) and Wolfinger [1971]. These critics pointed out that, whilst there was much of merit in B&B's arguments, their suggestions were themselves impractical to test and possibly misleading. Many valid reasons existed for non-decisions other than the covert exercise of power.

In 1974, Steven Lukes produced a monograph summarising the debate and adding to it (Lukes [1984]). He proposed an alternative taxonomy of the various views:

Pluralist = one dimensional
Neo-Elitist = two dimensional
Radical = three dimensional

The third dimension, which distinguished the 'radical' view he proposed, heavily criticised the behavioural focus of the other two views, extended the consideration of the suppression of potential issues to before the decision-making stage (i.e. to the environment within which decisions are taken), and made explicit the idea that latent conflict existed between 'those exercising power and the real interests of those they exclude' (Lukes, pp. 24–5).

Not surprisingly perhaps, Lukes too has been criticised, for example by Bradshaw [1976] and Clegg [1979] on a number of grounds. Most notably, his use of 'real interests' (felt not to be adequately defined) and his jump, like Dahl's, from considering the diadic (i.e. A and B only) to more complex collectives (i.e. groups) without adequate linkage were felt to be unsound.

Summary
The above indicates that power may take many forms, some of which are clearly relevant to a study of the FASB's due process and hence the

CF's production. These are manipulation, persuasion, and legitimate and competent authority. In addition a variety of structures within which to assess power exist, each of which may be criticised but each of which, by focusing on a particular aspect of power, may also shed light on the process and hence the anomalies previously noted. These were:

1 D (Dahl) = examining decisions
2 D (B & B) = examining non-decisions (i.e. agenda rigging)
3 D (Lukes) = examining latent conflict, structures, etc.

Before seeking to apply these ideas, it is necessary to show that they are appropriate to the consideration of accounting regulation.

Appropriateness to accounting regulation

Caution has often been advised before applying ideas from one area of study to another: in this context see Anderson [1982], Hope and Gray [1982] and Hope [1985]. However each of these writers accepted that it may well be valid to carry out such a transfer if care is taken. The linkages necessary for the application of power analysis to the FASB's process to be justified fall under three headings:

(a) accounting standard setting as a political process;
(b) appropriateness to polyadic situations; and
(c) influence of individual action.

These will be examined in turn.

Accounting standard setting as politics

That accounting standard setting is not a pure intellectual pursuit, resulting in standards agreed upon solely thanks to rational discussion, is now widely accepted. Many writers, from a variety of viewpoints, have written on the topic (e.g. Horngren [1973], Solomons [1978], Bromwich [1985], Stamp [1985], etc.), pointing out that standard setting is, in reality, very much a political process. It therefore seems reasonable that ideas from the field of political science, such as power analysis, should at least be considered in a study of this area.

Appropriateness to polyadic situations

It was noted above that Dahl and Lukes may be criticised for making a jump from diadic analysis to polyadic assertions, i.e. having con-

ceptualised in an A and B world, they assert their conclusions hold for a many-person setting. That they and others have done this, and that their work has not been totally discounted, may give some credibility to the method and its application to the indisputably polyadic situation of the FASB, but a stronger base is needed. This base is provided in differing ways by two writers. Harsanyi [1962] explicitly tackles this by applying n-person game theory, and in so doing forges a link between Dahl's diadic expression and the Shapley-Shubick voting index (see below). Approaching the matter somewhat differently, Debham [1984] puts forward the idea of 'collectivity of image'. By this, he means that individuals identify with the view put forward as that of their collective (groups), and thus the view of the collective is supported.

Influence of individuals
Even if polyadic situations were to be excluded, the influence of single actors with great personal authority cannot be ignored. Indeed, it is worth considering exactly what was achieved by certain key men during the CF process. As Hope and Gray [1982] state: 'there may still remain situations in which the role of 'crucially placed' individuals may be significant in policy formation.' They go on to suggest that some, at least, of the following must hold:

(a) the individual has a strong power base;
(b) the individual has personal authority;
(c) the individual acts as a spokesman for another group; and/or
(d) the individual expresses strong opinions on issues that evoke indifference or apathy in others, or on which there is a stalemate of opposing views.

Most of these are appropriate to the case in hand. Specifically, the influence of individuals will become apparent later in this chapter.

Summary of theory

Before progressing to the application and testing of these theories, it is worth summarising the main points made and assessing each set of theories in terms of the other.

Firstly, both main economic theories predict that the preparers of accounts are likely to be dominant in the process that seeks to regulate them. Others, such as auditors, will also have an interest. Secondly, power theory does not predict which group (if any) will seek influence, but it does give pointers to the main areas worthy of note when con-

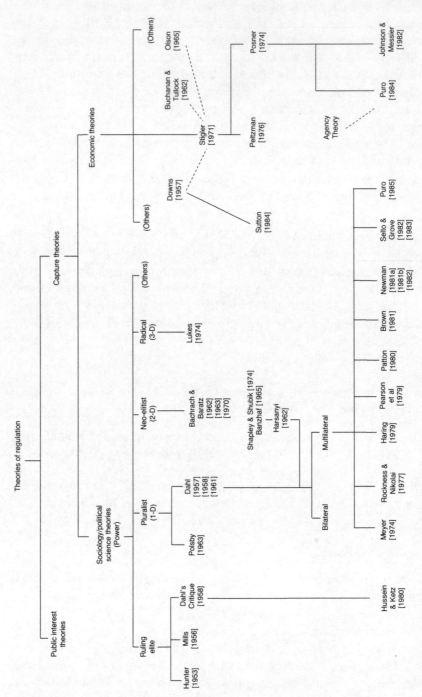

Figure 14 Theories of regulation: selected papers

sidering how influence is exerted. These are formal decisions taken, the topics on the agenda, and the structure and environment within which discussion occurs and decisions are taken. The former theory may be criticised in terms of the latter because it is implicitly one dimensional, the latter in terms of the former because it does not predict which group(s) should be the object(s) of focus. Together they provide insights into both.

The following section applies the above to the case of the FASB's CF project and tries to determine if any of the theories may be supported. Figure 14 is presented as an aid to understanding the studies noted.

The application of theory to the case of the FASB's CF project

In the preceding sections, the case has been made for applying various theories to the FASB's CF project. An attempt will now be made to apply the various theories, utilising the Lukesian dimensional taxonomy as a basis. Any theory having a degree of support in the context of accounting will then be applied to the anomalies noted in the previous chapter.

The one dimensional (Dahlian) view

In assessing the existence or otherwise of a ruling elite, Dahl emphasised the need to focus on actual decisions taken on key issues. In the context of the FASB's work, this leads one to examine votes taken by the Board in either accepting or rejecting statements. One may seek to avoid the criticism made of Dahl regarding subjectivity in choosing key issues by the simple expedient of examining all issues upon which the FASB voted. The rationale for this is that the Board would not vote on trivial matters. However, in so doing, one implicitly accepts the Board's assessment of importance, or worse may fail to detect deliberate 'smoke-screens'. In addition, when carrying out this work an outsider is handicapped by the fact that statements issued by the Board are biased in the sense that those matters rejected and hence not becoming statements are excluded from consideration. There is little that can be done about this, since information regarding those rejected, particularly at an early stage, is available only in insufficient detail.

Acknowledging these limitations, one may start by examining previous attempts to find influences at work in the FASB. Note that only one of these pieces of work (Hussein and Ketz [1980]) explicitly gave

	Author(s)	Date	Board?	Questions asked	Data	Techniques	Results
1	MEYER	1974	APB	Employment background determines voting? Dominance in APB?	(a) 42 issues from Opinions (b) 7 main (chosen) issues for each	(a) Chi² tests (b) Dissent rates	Background matters re. 42, not re. 7. APB NOT dominated by any group.
2	ROCKNESS & NIKOLAI	1977	APB	Employment background determines voting? Changes in member groups determines voting? Systematic lack of independence? Evidence of voting blocs?	All APB Opinions	MDS	No strong results. Evidence of there having been three distinct Boards.
3	HARING	1979	FASB	Association of accountancy firms and their clients? Association of the FASB and its Sponsors?	EDs re. SFAS Nos. 2, 5, 7, 8, 9, 12, 13, 15	Regression	Re. accountancy firms, results uncertain. FASB votes in the with its sponsors and the accounting firms, contrary to academics and big business.
4	PEARSON et al.	1979	AudSEC	Employment background determines voting?	SFAS Nos 2–20	(a) MDS (b) "Johnson hier-archical cluster programme" (c) ANOVA	No evidence of Big 8 cluster (In fact, quite dispersed).
5	PATTON	1980	FASB	Employment effects. Threat effects. Changes over time.	SFAS Nos. 134	(a) Chi² tests (b) Paired re blocs (c) MDS	No evidence of employment or threat effects. (Some slight evidence early on of a cautious approach to difficult problems).
6	HUSSEIN & KETZ	1980	FASB	Big 8 = ruling elite?	EDs re. SFAS Nos. 2, 5, 7, 8, 9, 12, 13, 14	(a) Correlations between Big 8 on issues (b) Dahl's power index	Potential for unity low. Potential for control of process low.
7	BROWN	1931	FASB	FASB follows lobbying groups?	DMs re. SFAS Nos. 2, 5, 8, 13, 14, 15, 19; ED re. SFAS No. 12	(a) MDS (b) Discriminant analysis	No such evidence. Split of attestor and preparer groups; CPA firm cluster evident. FASB follows no groups; closest to FAFed (users).

	Author	Year	Body	Research question	Opinions/SFAS	Methods	Findings
8	NEWMAN	1981a	APB FASB	Employment background determines voting?	APB Opinions 8–12, 14–29, 20–31; FASB SFAS Nos. 1–12, 16–20, 21–24	(a) Shapley–Shubik index (b) Banzhaf index	No change in Big 8 power over time; potential dominance remains. Dominance not actually used, i.e. Big 8 does not have more influence than non-Big 8.
9	NEWMAN	1981b	APB FASB	Test of size principle (= Minimum Winning Coalitions). Test of information effect. Test of threat effect.	APB Opinion 1–12, 13–31; SFAS Nos. 1–15, 16–34	(a) Probability tests (b) Cox–Stuart test	Size principle not supported. Some supported for threat effect re FASB.
10	NEWMAN	1982	APB FASB	Does SEC have power of veto over standard setting?	Composition of APB, FASB (FASB under both 4–3 and 5–2) voting rules	(a) Shapley–Shubik index (b) Banzhaf index	SEC power increased over time (only theoretical – not used).
11	SELTO & GROVE	1982	FASB	Coalitions exist? Test Shapley–Shubik and Banzhaf to see if they match reality	SFAS Nos. 1–25, 26–44	(a) z-tests (b) S–S and B indices	Found coalitions (not Big 8). S–S fits best in 2 of 3 tests, nominal index in other one. S–S always better than B index.
12	SELTO & GROVE	1983	FASB	Coalitions exist? Test Shapley–Shubik and Banzhaf to see if they match reality.	SFAS Nos. 45–69	(a) z-tests (b) S–S and B indices	Found one coalition. Nominal power index fits best i.e. better than S–S and B.
13	PURO	1984	FASB	Test of Economic Theory of Regulation and Agency Theory	EDs re. SFAS Nos. 8, 12, 13, 14, 19 + GPP	Probit analysis	Economic theory fits better re. decisions on disclosure rules, agency theory re. standardisation of accounting treatment.
14	PURO	1985	FASB	Does the Big 8 dominate?	EDs re. SFAS Nos. 2, 8, 12, 13, 14, 19 + GPP	(a) Simple comparisons (b) Chi2 tests	Big 8 participate more; Big 8 do not agree much amongst themselves, but more than with other groups; Big 8 view not accepted more re. standardisation; Big 8 view is accepted more re. disclosure; Big 8 influence does not disadvantage small firms; Big 8 follow corporate clients re. disclosure and some standardisation issues.

Figure 15 Statistical studies of power in an accounting context

power analysis as its basis, and only two (Johnson and Messier [1982] and Puro [1984]) employed economic capture theory. In fact, some writers admitted the lack of any theoretical underpinning as a weakness of their research (see, for example, Newman [1981b]). However, each of the pieces of work cited below may be viewed as falling within Dahl's idea of seeking the exercise of power through overt demonstration of it.

The fourteen studies located in the literature as having a bearing on this area sought answers to a variety of relevant questions (see Figure 15). These include two studies solely on the APB, and one on the AudSEC of the AICPA, which are included as they set the pattern for the techniques used. The concerns of the studies were with the following issues:

(a) did the employment background of a Board member systematically affect his voting behaviour?
(b) does a given group (usually the big accounting firms (the Big Eight) or an industry group) form a ruling elite *vis-à-vis* Board decisions?
(c) do voting blocs or coalitions exist within the Board?

In other words, the studies sought to detect influence by one or more interest groups. Figure 16 neatly encapsulates these areas of interest:

Other issues, such as SEC domination, whether the Big Eight firms followed their client's views, etc. were also tested in these studies, as was whether the potential existed for dominance of the Board (as opposed to it actually occurring).

The studies used a wide variety of statistical techniques and were based upon a number of differing groups of statements voted upon. Of particular interest from a power analysis point of view was that a number of studies (Newman [1981a, 1981b], Selto and Grove [1982, 1983]) made use of the Shapley and Shubik [1954] voting index (see also Bartholomew and Basset [1971]), which Harsanyi [1962] pointed out is simply a specific form of a power index.

The results obtained varied. Previous employment of the FASB members did not seem significant, a result no doubt pleasing to the Board and running counter to apparent attempts to influence the composition of the Board (see three dimensional view below). This suggests that the view expressed by Board member Robert Morgan that he was there to represent his preparers/industry constituency (Sterling [1988]) was not typical.

Those studies looking for a ruling elite or evidence of capture produced mixed results. Haring's [1979] results showed agreement be-

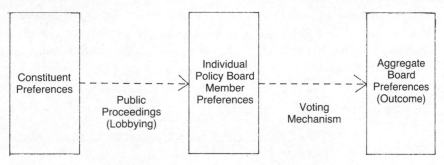

Figure 16 Lobbying model (Adapted from Newman [1981a].)

tween the FASB's view and that of its sponsoring groups and the large accounting firms, but not with academics and big business, i.e. accounts preparers. Hussein and Ketz [1980] found little evidence to support Big Eight control, a view agreed by Brown [1981] and Puro [1985].

Work on voting blocs also produced varied results, the most interesting being that by Selto and Grove. In their initial paper [1982] they identified three possible coalitions, but in extending their work [1983] they reduced this to one.[8] These results are of particular interest for the following reason. The three possible coalitions identified in the 1982 paper were:

> the second CPA + the financial analyst
> " " " + " " " + the preparer
> " " " + " " " + the academic

(The 'second CPA' was used to identify which of the three CPA members of the Board was being referred to.) Only the first of these groups was identified in the second study.

Those working at the FASB during the difficult years leading up to the issuance of SFAC No. 5 were very much aware of a loose voting bloc on a number of issues. According to Miller [1988], Johnson [1988], Kirk [1988] and Sterling [1988], the bloc consisted of John March, a CPA; Frank Block, the financial analyst; and Robert Morgan, the preparer. That the insights of such well-placed observers match Selto and Groves's results adds credibility to the use of such statistical methods.

The studies conducted generally provide little in the way of strong results, notwithstanding the comment in the previous paragraph. In some ways this was to be expected, for, as in any good conspiracy theory, if detection of the influencing of the process were so easy, it would be unsafe to attempt it.

The end result of looking at studies falling within the one dimensional view is that little substantial support is provided for any of the main theories, but that the technique may have something to offer studies of the FASB procedures.

The two dimensional (B&B) view

The main thrust of the B&B view was that exercises of power would occur as a way of ensuring control over the agenda of topics for discussion. Once again, this appears a plausible idea in the context of the FASB's process, but before examining the evidence, one general and two specific points must be made.

It must be recognised that research in this area is underdeveloped, even in the original political science literature. It is far easier to point out weaknesses in methods used than it is to correct them. For example, the choice of non-decisions selected is inevitably subjective – importance is in the eye of the researcher (see Wolfinger [1971]). Despite this, it is felt that this is worth attempting as the insights seem likely to be novel.[9]

The first specific point is that it is the Board itself that decides which topics it accepts on to its agenda. Advice may be given by FASAC, the technical staff and indeed outsiders, but ultimately the Board decides. Those wishing to influence the agenda must influence or persuade the Board. The second point is that it is the chairman of the Board who in large measure controls the allocation of resources to individual projects. If he decides a project needs to expand and/or speed up, he may ensure that this occurs. Outsiders must therefore influence him in order to bring this about.

What evidence exists for there having been attempts to change the agenda to the CF project? The first, and perhaps most open, instance related to the 1976 DM 'Elements of Financial Statements and their Measurement'. As will be recalled from Chapter 3 this, among other things, set out two main views of accounting, the Asset and Liability (A&L) view and the Revenue and Expenditure (R&E) view. Responses to this issue, as to others, were invited.

Professor Robert Mautz, an Illinois-educated academic, who had been on the CF Task Force in its early stages, was at that time representing Ernst and Ernst at the FASB. He saw the DM as an attempt to bring about a fundamental change in accounting from the (as he saw it) dominant R&E view to the A&L view. This 'balance sheet' view would lead ultimately to current value accounting, something he vehemently opposed.

Having convinced Ernst and Ernst of his case, he produced a lecture on the topic and offered it to the Financial Executives' Institute (FEI). With their approval, he toured 65-70 FEI chapters presenting his view, roundly criticising the DM and urging rejection of the A&L view, thereby seeking to limit Board discussion of the CF to the R&E view. By his own admission (Mautz [1988]) and that of those inside the FASB at the time (Kirk [1988], Storey [1988]), the Board and staff were furious. The FASB staff felt that Mautz was misrepresenting the DM, making it appear that the A&L view had already been selected; further, it was claimed that his assertion that the A&L view led necessarily to a current value model was simply not true. They attempted to correct this impression by themselves giving talks and making their points clear in various publications (see, for example, FASB Status Report No. 49 [June 1977]). However, Mautz did his work well, and the responses the FASB received on the issue were heavily coloured by his intervention. Ultimately he failed, for the A&L view was not rejected; indeed, it became the dominant view within the CF. But Mautz had stirred up businessmen and made them suspicious of the Board.[10] This attempt at agenda manipulation, the actions of an individual supported by a Big Eight firm (note one firm, not all as a group) plus a major interest group (FEI represents preparers), failed to suppress a major issue.

The other area where the Board were subjected to pressure to change their agenda was nonbusiness organisations (NBOs). The pressure in this case came from another academic with strong views, Professor Robert Anthony. He had been responsible for the 1978 Research Report on NBOs and had been involved in the statement ultimately produced on objectives of NBOs. A review of his archive materials carried out by the author and discussions with both him (Anthony [1988]) and FASB staff (Storey [1988]) make it clear that Professor Anthony saw the objectives statement merely as a first step in a process leading to further concepts statements for NBOs plus accounting standards derived therefrom. He pressed the Board to carry on in this way, but the Board did not wish to do so. (In Professor Anthony's view, certain of the staff did not want the Board to continue (Anthony [1988]).) In this case, Professor Anthony failed to have his proposals accepted: the Board did not pick up his points. This was probably due not to deliberate deflection by the staff, but more to the need for care in negotiation in the creation of the GASB resulting from the 'turf dispute' described in Chapter 3.

In each of the two cases cited, an attempt was clearly made to influence the FASB's agenda, providing some support for each of the

main theories under consideration. A two dimensional view may thus be
regarded as providing a legitimate focus on the process.

The three dimensional (Lukesian) view

The major point raised by Lukes was the need to consider wider,
structural issues, and not simply to focus on behavioural matters (e.g.,
votes). Also, latent conflict is at least as important as that which finds
expression. To implement this idea in the context of the FASB one may
examine various matters surrounding and impinging upon the operation
of the Board. These include:

(a) the appointment and composition of the Board, and
(b) attempts to limit Board action.

The appointment and composition of the Board

It was noted in a previous section that members of the FASB are not
elected democratically: they are appointed by the trustees of the FAF
(see Appendix 1). This has many implications for the way in which the
Board operates and the decisions it produces. Such is the seriousness of
these implications that many, including former Board members, have
expressed concern over them (Sprouse [1988]).

What is the cause of this apprehension? Put simply, by having the
power to appoint the members of the Board, the trustees have the ability
to put in place persons they feel will come up with the 'right' answers.
In effect, the trustees have the ability to rig the game.

The trustees clearly have the ability to shape the way the Board
operates: but what evidence is there that this has actually occurred?
Three 'windows' exist to shed light on this. The first concerns the
appointment of a successor to Don Kirk as chairman of the Board. Kirk
was one of the original members of the Board, had become chairman in
1978 and was due to serve until the end of 1986. He was an element of
continuity on the Board, equalled in this only by Robert Sprouse. The
choice of his replacement was a major issue.

Two main front runners were apparent: James Leisenring, then
Director of Research and Technical Activities (RTA) at the FASB, and
Arthur Wyatt, formerly a partner with Arthur Andersen and then
a Board member. However, neither was appointed. Instead, Dennis
Beresford, a partner in Ernst and Whinney, became chairman. Loomis
[1988] suggests that he was a compromise candidate. Miller and
Redding [1988] note that he was nominated by the NAA (a preparer

group) and suggest that this reflects preparer domination (see below). However, discussion with Miller (Miller [1988]) and others indicates that both Leisenring and Wyatt were 'carrying too much baggage' to be acceptable to the trustees: their views on major issues were well known and their appointment could not be contemplated.[11]

The second insight to the trustees' actions is offered by the shift over time in the make-up of the Board. Although, as noted in the One Dimensional section above, no evidence could be found to indicate that the background of the Board members systematically affected their voting patterns,[12] this does not necessarily imply that those appointing Board members will expect this to continue. Whether this is due simply to misplaced expectations is a moot point.

If one examines the background of Board members, a shift is apparent. The original Board was made up of:

4 CPAs in public practice	(Armstrong, Queenan, Kirk, Schuetze)
1 preparer	(Mays)
1 user	(Litke)
1 academic	(Sprouse)

The current Board consists of:

3 CPAs from public practice	(Beresford, Leisenring, Anania)
2 preparers	(Brown, Northrop)
1 user	(Sampson)
1 academic	(Swieringa)

Points of note are:

(a) the reduction in the number of accountants from public practice from four to three;
(b) the increase in industry (preparer) representation; and
(c) the fact that the 'user' today is Clarence Sampson, ex Chief Accountant at the SEC. One cannot but help feel that it is stretching a point somewhat to classify him as a user.

This last point is particularly notable given that:

(a) the users of accounts are not as well organised as preparers and thus have less of a voice; and
(b) the CF is aimed at being useful for the decisions of users.

Clearly there has been a shift towards preparers, a point raised by Miller

and Redding [1988] and others (e.g., Wyatt [1987], Sprouse [1988]).[13]

The final window on the trustees appointment policy is provided by the people they appointed to the Board. One may gather some insight into the type of people appointed by a review of the views they expressed in print. To this end, one may examine the published work of Board members. Such articles may be examined to establish whether they indicate any strongly held views on major issues in accounting theory and the process of producing standards. Also, submissions made by Board members prior to their appointment when working for companies, accounting firms, etc. are of interest. It should be noted that many of the articles written by Board members have been explanations of new accounting standards, procedural matters, ethical rules and the like. As such they do not reveal anything of the writers' views on the topics of interest. Additionally, of the articles that contain relevant subject matter, most are written in language such that it is difficult to detect any strongly-held conceptual views. However, some writers have revealed preferences and these are summarised below:

Kirk	Most of Kirk's published writings are concerned with the process of producing standards (and the CF) and then with getting over the meaning of the resulting documents to various interest groups. He viewed the Board's responsibilities to its sponsors very seriously, and he realised that business liked certainty and stability in the field of accounting standards: radical change would be unpopular.
Sprouse	As one of the authors of ARS No. 3, Sprouse's advocacy of current values was certainly well known prior to his appointment to the Board.
Mosso	Mosso's writings reveal a thoughtful approach to conceptual matters, far more so than is evident from the work of many other Board members. In a 1983 article written with Paul Miller, Mosso suggests that the CF is not purely deductive (or as he puts it, 'top down'), but a mixture of deductive and inductive ('bottom up'), thereby showing that he realised what had happened to the project. On specifics, though, Mosso is hard to pin down.
Morgan	A conservative approach, linked strongly to historic costs, is evident from Morgan's writings published after he left the Board. His publications prior to that date reveal no strongly-held conceptual views.
Brown	In a number of submissions to the Board on various documents (e.g., ED – OBJ&EL, DM – RE, ITC – FS), Brown revealed that he approached matters in a very concrete, and not a conceptual, manner. For example, he often urged caution, suggested that more examples be given, and advocated

	that flexibility be allowed. It is also notable that in his submission on ED -- OBJ&EL, Brown followed the 'Mautz line' and argued that the A&L view was incompatible with an emphasis on earnings. Brown's writings exhibit a concern with objectivity and verifiability, and he also sees comparability as important.
Beresford	In 1980 he expressed strongly views that the FASB should utilise fewer resources on the CF and more on major accounting issues. Additionally he saw the need better to communicate the results of the Board's work.
Northrop	In rather a similar manner to Brown, Northrop, when responding to FASB documents for his previous employer, IBM, suggested that more concrete examples were needed. He clearly dislikes ambiguity, and hints at favouring an A&L view.

The above shows the difficulties in attempting to gain insights to the selection of Board members by considering the published writings of possible candidates (even if the articles considered were published long before the authors were such candidates). Of the few writers to exhibit clearly-held belief, Sprouse (pro-current values) was appointed to the original Board at a time when the need for a fresh new approach was perceived. Morgan (a 'second Board' member) was clearly of a differing school. Brown and Northrop (current Board members) both expressed the desire for concrete examples to be more widely used. This may be interpreted as displaying a less conceptual approach. Beresford's 1980 declaration, although unequivocal, was made seven years before his appointment as chairman and thus should be viewed with caution.

Attempting to show that these views are congruent with any particular change in Board direction is even more tenuous. Certainly the inclusion of Sprouse in the first Board seems in tune with the times. However, the appointment of Morgan may be interpreted in many ways. The views of Brown and Northrop do seem to match the idea that a move away from the CF was needed: conceptual matters had had their time.

The above three windows do not provide direct evidence of trustee manipulation of the Board's composition. There is, however, an indication of a possible tendency towards preparer domination. In this connection, it is also worth pointing out that the FAF trustees have sought to replace Board members with people from the same background. This seems on a few occasions to have been taken to extremes. For example, John March, formerly of Arthur Andersen, was replaced by Arthur Wyatt, also of Arthur Andersen. In a similar manner, Price Waterhouse

have always had a 'representative' on the Board, with Don Kirk and then Ray Lauver, these two having overlapped (see Appendix 4). With Lauver's departure, another ex-Price Waterhouse man, Joseph Anania, was appointed. This does not necessarily indicate a desire for influence by the two firms: it was even rumoured that March was 'sent to the Board' so as to ensure he did not rise too far in the Arthur Andersen hierarchy.

One obvious question arising from this is who appoints the appointers? The history of this is given in Appendix 1 but the main points are summarised here:

(a) trustees are nominated by a number of sponsoring bodies. A nominee may be refused, but in practice this does not occur.
(b) originally the trustees numbered nine, with five CPAs and two preparers, whilst today they total sixteen, five being preparers – a distinct shift towards the preparers.

If one equates, as seems reasonable, preparers with the businessmen who are concerned with accounting changes (see functional fixation and agency theory sections above), one can see why preparer domination is viewed with concern.

One may also point to a number of key personalities who originate in the same corporations, e.g., Walter Stern and Edus Warren (successive treasurers of the FAF) both from the Capital Research Co., William Franklin and Robert Morgan (Board member) from Caterpillar Tractor. However, these possible indications of influence could also be explained by the simple suggestion that the trustees and their appointees are form a closed, self-selecting group: what may be viewed with suspicion or fear may simply be innocent.

Attempts to limit Board action
In the Two Dimensional section above, it was noted that the Mautz campaign resulted in widespread distrust of the FASB's intentions. The torch of taming the FASB was later taken up by the Business Roundtable, an organisation of large US companies (preparers). It, under the guidance of various well-known businessmen, notably Roger Smith of General Motors (1985–7) and John Reed of Citicorp (from 1987), has campaigned on many issues and ultimately sought openly to limit the FASB's abilities to set standards.

The power of the Business Roundtable (BR) is perceived to be great. Representing large companies, it is reputed to be able to ensure its will

is done. Indeed, it has even been suggested that the final hurried wrapping-up of the CF itself was as a result of Don Kirk attending a dinner given by the BR and having 'the facts of life' explained to him. Such a story seems far-fetched, but the very fact that it circulates is indicative of the BR's perceived abilities.

The BR's attempts to influence the Board go back a long way. Like many organisations, it lobbied on most of the major issues in the CF (see their responses on documents such as ED – RI and ED – R&M) and influenced the responses of its members. A number of changes to the FASB brought about by the 1977 FAF Structure Committee report were attributed to BR pressure. In 1985, Roger Smith called for a 'blue ribbon committee' to examine the workings of the FASB (Miller and Redding [1988]). More recently, the BR's criticism of the FASB has been open and serious. Despite public commendations of the Board by Ed Coulson, Chief Accountant of the SEC (Coulson [1988]) and by John Dingell, chairman of a Congressional committee that examined the Board (Dingell [1988]), a BR campaign continued through 1988 seeking to overhaul the way in which the FASB carried out its responsibilities. In September 1988 John Reed sent a memorandum to the FAF. In this he proposed a committee to control the FASB's agenda, deciding what should and should not be discussed (Loomis [1988]). The committee would consist of two Chief Executive Officers (CEOs), two Big Eight senior partners, the AICPA president, an SEC commissioner, and the FASB chairman. The proposal was also sent to David Ruder, chairman of the SEC who, in his reply, whilst accepting that some FASB procedures may need fine tuning, made it very clear that oversight of the FASB was the SEC's responsibility, not that of a new committee (*Wall Street Journal* [Jan. 1989]). Reed was not deflected by this. His response to the fine tuning offer was to suggest a twice-yearly meeting between the SEC and a new committee of CEOs and Big Eight partners to discuss the more fundamental reforms he wanted.

Whilst not succeeding at that time in obtaining his main wishes, Reed has since done so. The 1988–9 review of the FASB by the FAF suggested some changes, and stated:

> while the 1988-89 review was in progress, significant concerns about several aspects of FASB operations were expressed by certain constituents, particularly the Business Roundtable, and by the managing partners of major accounting firms (a reference to Joe Connor of Price Waterhouse). These concerns prompted the FAF to appoint a special advisory group of trustees and other knowledgeable people to examine the issues and provide recommendations to the trustees. (FASB Status Report No. 199)

This advisory group prepared, and the FAF implemented, a standing committee for the oversight of the standard setting activities of the FASB. This very clearly demonstrates the ability of the BR to influence the ground rules. Other attempts to influence the FAF and the Board have been less subtle even than this. Miller and Redding [1988] report (p. 149) the threat to withdraw funding from the FAF if the Board did not change certain proposals. One Board member, Frank Block, even went so far as to suggest that the wishes of disgruntled donors (mostly preparers) should be accommodated.

Thus, one may conclude the three dimensional view clearly offers insights, all of which point towards the preparer group having sought, and to some extent having obtained, dominance in the process. Thus support is given to the economic capture and lobbying theories.

Summary

The evidence presented above is mixed in its implications for the main theories advanced. The one dimensional (voting) studies were inconclusive. The attempt to influence the FASB's agenda could be viewed as supporting an attempt to capture the process, or as an exercise of power by an interest group, a Big Eight firm or by an individual. The three dimensional evidence is of most interest. It, perhaps most strongly, indicates a swing towards preparers in the control of the process and thus supports the lobbying and capture theories. But does this help explain the anomalies within the CF noted in the previous chapter?

Attempts to explain the anomalies in the CF

This section, as the one above, is structured around the Lukesian taxonomy.

One dimensional

It is difficult to assess the major changes that occurred in the CF documents in one dimensional terms because:

(a) many relevant votes occurred prior to meetings being held in the 'sunshine', i.e. in public, and hence no adequate public record exists; and

(b) even after 1978, the public record does not always give sufficient detail to allow assessment of individual votes on topics on interim documents.

Turning to the final CF documents themselves, one finds that there is no scope for the type of statistical analysis described above. Not only is the sample too small (only six documents), but of those, five were passed unanimously and one, No. 5, had but one dissent. This dissent is, however, of considerable interest. The dissenter was John March and his dissent consists of four main points (SFAC No. 5, para. 32):

(a) (the statement) does not adopt measurement concepts orientated towards what he believes is the most useful single attribute for recognition purposes, the cash equivalent of recognised transactions reduced by subsequent impairment or loss of service value – instead it suggests selecting from different attributes without sufficient guidance for the selection process;

(b) it identifies all non-owner changes in assets and liabilities as return on equity, thereby including in income, incorrectly in his view, capital inputs from nonowners, unrealised gains from price changes, amounts that should be deducted to maintain capital in real terms, and foreign currency translation adjustments;

(c) it uses a concept of income that is fundamentally based on measurement of assets, liabilities, and changes in them, rather than adopting the Statement's concept of earnings as the definition of income; and

(d) it fails to provide sufficient guidance for initial recognition and derecognition of assets and liabilities.

Although given in SFAC No. 5, the fact that parts clearly relate to SFAC No. 3 has led some to refer to it as the 'retrospective dissent' (Miller [1988]). For example, points (b) and (c) are grounded totally in the content of SFAC No. 3, and thus seem very much out of place. March even went so far as to argue for changing the definitions of the elements (SFAC No. 5, p. 33). That he could accept SFAC No. 3 at the time, yet effectively dissent from it later, may indicate that he did not realise the full implications of what he was doing at the time. Alternatively it could be argued that documents produced at the relevant time were full of 'Carsbergisms' (named by Robert Sterling after Bryan Carsberg, who was then working at the FASB). By this is meant a paragraph or phrase written in diplomatic language so as to be acceptable to those holding two diametrically opposed views.[14]

Two dimensional

One area where there seems to be a direct link between theory and actual events is that of agenda manipulation. In the previous chapter it was noted that certain topics simply failed to materialise in the CF. One

of the most notable omissions was social accounting. Was this the victim of agenda rigging?

Social accounting was dealt with in a separate chapter in the Trueblood Report. It might therefore have been expected to be found in the CF. It was not. It is not difficult to suggest a reason for this in terms of the economic theories previously noted. Discussion in academic circles of social accounting ranges widely and, in addition to the usual topics such as reporting to employees, can extend to considering accounting for, say, the costs attributable to industrial processes at present not recognised in the accounts of the companies concerned. Matters such as pollution, where society as a whole bears and therefore accounts for the costs, are good examples. Once discussion of these topics starts, it is easy to envisage that actually making industry bear the costs (and not simply accounting for them) might follow. Thus, any attempt to stifle at birth discussion of the topic seems economically rational from the corporate sector's point of view. (Reports suggest up to $100 billion, i.e. more than the total profit of the *Fortune* Top 500 companies, might be required to clean up certain toxic waste dumps in the USA: few, if any, accounting provisions have been made for such costs (*Environment Digest* [1988]).

Whether the dropping of discussion of social accounting was brought about by the exercise of power by the preparers of accounts is hard to determine. The FASB, in its first CF document (the 1974 DM 'Considerations . . .' (FASB [1974])), devoted little space to the topic. One question was asked: whether financial statements were the right place to present information on the social aspects of economic activities. Almost universally the responses received were negative. Even Touche Ross (Trueblood's own firm) concurred in this. In its next objectives document ('Tentative Conclusions' [1976a]), the topic was not discussed. Nor was it thereafter in the CF.

One must note that the phrasing of the question asked in the 1974 DM biased the issue. Because negative replies were received, the topic was dropped (Sprouse [1988]). But to say that financial statements are not the place for this information is not to say that the subject should not be discussed further (as some respondents suggested). Indeed, once the focus of the objectives series was changed from financial statements to financial reporting, one might have thought that the topic would surface again, but it did not. It had been killed off.

If one wishes to take a somewhat less conspiratorial view than the above may suggest, one may note that the inclusion of the topic in the Trueblood Report was at the behest of Robert Trueblood himself. He

had been moved by the sights he had seen in polluted mid-west steel towns and had realised that many obvious costs to society were not being accounted for. This led him to seek the inclusion of the topic in the report that bears his name (Streit [1988]). Add to this the fact that even today the topic is not commonly discussed amongst accountants, and one can view the raising of the topic as the result of one man being ahead of (or out of step with) his time, and its dropping as a reassertion of 'normality'. Or again, social accounting could be viewed as an early 1970s idea that had fallen from favour. To sum up, the case for suggesting that the dropping of social accounting from the CF resulted from an exercise of power by industry is not proven.

Other omissions from the final documents of the CF are also apparent. Indeed, one whole phase of the project, that dealing with display, was addressed only in preliminary documents such as DMs and ITC. The explanation for this is quite straightforward and follows on from the treatment of another topic, recognition and measurement, whose development involved a degree of agenda manipulation. These two areas will now be discussed in the order of their attempted resolution.

The later stages of the Conceptual Framework project

Recognition and measurement were ultimately covered in the same SFAC, No. 5. However, their prior history is of interest. The initial building-block approach foresaw objectives, elements and qualitative characteristics as the first three parts of the CF (Gellein [1988]). Measurement was included in the elements section (e.g., DM [1976c]) but it became apparent that this aspect was going to be a difficult one to resolve. By June 1977 there were calls to separate elements and measurement, and this was accepted by the Board in what Sterling [1988] refers to as a 'divide and defer' strategy. The public hearings on the DM were also split, with measurement being deferred until January 1978.

Recognition, on the other hand, was at this time only a staff agenda item: the technical staff were considering it and the Board would later decide whether to accept it on to their agenda. In fact, as was seen in Chapter 3, accepting the topic took a long time: it was not until April 1979 that Accounting Recognition Criteria became a full Board topic and formally part of the CF project. This may be interpreted as reflecting the difficulty the staff had in tackling the problem.

For some time thereafter the two topics were dealt with by the Board separately, much work in the field of measurement falling under the SFAS No. 33 heading. By January 1982, however, recognition and

measurement were beginning to be seen as strongly interlinked (see FASB Status Report No. 125) and were beginning to be discussed as such. Eventually they became wedded and hence the later documents produced.

This process of dividing and deferring has been strongly criticised by Robert Sterling (Sterling [1988]). He sees it as evidence of the inability of the Board to face up to problems, preferring to defer them in the hope that they will go away.[15] Sterling, of course, is in a very good position to comment: having gone to the FASB in July 1981, he was in the thick of things during this phase of the project. He strongly felt that measurement should be dealt with prior to resolving recognition – only once it is decided what is being measured, he argues, can appropriate recognition criteria be selected. However, some Board members, notably Robert Sprouse, wanted a further deferral of measurement. Sterling, wanting to 'make progress' on the project, accepted the Board's revised agenda and set about producing a series of case studies that sought to highlight recognition and measurement issues. For example, two cases involved the valuation of a corn crop, assuming firstly it was sold as a crop, secondly assuming it was fed to the farmer's own pigs (FASB Board Minutes, 9/16 June 1982). Other cases involved donations to a business, a lottery ticket and a simple barter. The objective was to get Board members to express their views on recognition and measurement in the simple cases and then gradually build up the complexity. (A similar approach is currently being used in the FASB's complex financial instruments project.)

Some Board members, however, quickly realised that committing themselves in public to a specific position might later result in them having to accept valuation bases they were intuitively unhappy with. They thus took to 'peeking', meaning giving the answer that fitted their held beliefs, even when this produced nonsensical results in the case under discussion. This, of course, defeated the whole point of the case study approach, and led to some heated exchanges.[16]

Part of the problem was Sterling himself, or rather his reputation. Knowing him to be a strong advocate of current exit value accounting, the more conservative Board members were suspicious of the case studies, expecting Sterling to have set 'traps' for them. In addition, Sterling used a very different approach to Bryan Carsberg who had preceded him. Whereas Carsberg diplomatically papered over cracks between positions, Sterling believed in exposing them and seeking to resolve them.

As a result of the various manouverings, the case study approach

stalled and little progress was made. By this stage (mid/late 1982) the Board was, as previously noted, more or less split into two groups. One, made up of March, Morgan and Block, generally favoured conservative views and historic costs as a measurement base (although their individual reasons for doing so differed). The other group, favouring a more flexible approach, consisted of Sprouse, Mosso and Walters. Don Kirk tended to side with the second group, although he often found himself somewhere between the positions of the two groups.

Matters came to a head in September 1982 when Kirk asked the Board members to state clearly their positions on this aspect of the CF (FASB Board Minutes, 27 September 1982). How could progress be made? The views expressed (given in the same order as in the meeting) are interesting:

Morgan suggested the competing theories (loosely HC and CV) should be worked on in parallel with equal effort and time being devoted to each.

Walters wanted to move ahead with a majority concepts document.

Sprouse wanted to divide the project into three parts dealing with:
 (a) acquisition and disposal of assets and income and settlement of liabilities (he felt agreement on this was likely);
 (b) changes in existing assets (he felt agreement was unlikely); and
 (c) address revenues, expenses, gains, losses, investment and distributions (he felt agreement was likely only if measurement was not an issue).

Mosso advocated development of a majority-supported document to confront the measurement issue, using Sterling's work (later published as Sterling [1985]) as a basis.

March wanted the Board to produce a succinct document setting out the issues and then to seek comments on it.

Kirk wanted one document to express all points of view.

Clearly some Board members wanted to go forward slowly, some faster, but nearly all in differing directions! Eventually a majority document with minority views expressed within it and a 'thorough exposition' was decided upon.

As a way of working out the two main cases to be presented, two teams were set up. The main team (Sprouse/Mosso/Walters) was staffed by existing staff members: the other one was headed by Professor Robert Mautz, who was brought in because the conservatives felt they needed 'one of their own' to put the case. Discussion went on for a very long time, and the issues raised crossed the boundaries of the various

parts of the CF project. For example, in the minutes to a 26 January 1983 meeting on amending SFAC No. 3 for nonbusiness organisations, it is stated that 'Mr. March expressed a fundamental concern that this document and the original concepts Statement No. 3 fail to account for differences between capital and income', a warning of the dissent to SFAC No. 5 to come.

By June 1983, just before Sterling was to leave Stamford, Mautz suggested changing from an attempt to produce two parallel documents to a unified approach. He wanted to build on SFAC Nos. 1, 2 and 3 and suggested a flexible, experimental development. The discussion that followed covered old ground before focusing on the attribute to be used. Views expressed were:

Mosso ⎫ Sprouse ⎬ Walters ⎭	thought current prices most relevant, but others may be necessary due to reliability problems
Block	thought current prices were relevant, but not necessarily the most relevant
Brown*	could not give an opinion due to lack of evidence
March	thought current prices were not relevant, whereas historical costs were
Kirk	thought that current prices were not necessarily relevant for all assets and liabilities

* replaced Robert Morgan on 1 January 1983.

With differences so great, agreement was clearly unlikely and so Tim Lucas, then a project manager, and now Director of RTA at FASB, was given the task of helping each Board member to state their own perceptions of what a statement of assets and liabilities should show. The wheel was indeed being reinvented. Over the next few weeks discussion continued, intertwined with those on reported earnings and other related topics. The Board even reopened old issues such as the definition of comprehensive income.

By September 1983 Mautz was suggesting that it might be better to admit that the Board could not agree. This was not acceptable, Don Kirk in particular being worried that the Board should not be seen to have failed on so fundamental a matter. A Board sub-committee, consisting of Sprouse, Walters and Brown, was set up to seek the common ground. By December most Board members could at least agree on what was actually in use in reality (although John March objected to the description in ED – R&M of present practice as a 'multi-attribute system'). The ED was issued at the end of December 1983 and

eventually, after further discussion, the SFAC in December 1984. It was severely criticised for saying nothing, merely restating SFAC Nos. 1, 2 and 3 and noting that change will be evolutionary rather than revolutionary. It was a big disappointment to those expecting a definitive statement on recognition and measurement (see Chapter 3).

Summary

If the above exposition seems rather confusing, it does no more than reflect the reality of the process. The topics of recognition and measurement, together with others such as reported earnings, were intertwined, confused and discussed many times without any real conclusions being reached. Whether the outcome would have been any clearer if the agenda had not been altered is a moot point, but it is difficult to envisage that it could have been any more confused.

Despite the criticism, no-one seriously wanted the discussion to continue and hence the final document, SFAC No. 5, was accepted. This also explains the lack of any final document on display. To have suggested further CF work after all the years it had taken to develop the recognition and measurement stage would not have been popular. The topic of display was quietly dropped and everyone decided once more to devote all their time and energies to 'real world' topics, i.e. standard setting.

Does the above agree with the predictions of theory? Accepting functional fixation and agency theory, one might expect many preparers to oppose moves towards current values, for this tends to lead to lower reported profits or to more volatile, less easily managed reported earnings (that might be felt likely to result in misinterpretation by the market). Moves in this direction were frustrated by the conservative group and so preparer wishes were met. But can one attribute causality in this way? The simple answer is no. The decisions on the agenda were:

(i) to defer measurement – at the suggestion of the academic Robert Sprouse;
(ii) to mix recognition and measurement – seen as inevitable given the nature of the topics;
(iii) the *de facto* decision to mix in other topics – as (ii): and
(iv) to split into two teams for the last part of the R&M work – a decision forced on Don Kirk by the clear split of the Board. It was this or the admission of failure.

Similarly, the dropping of display issues presumably pleased preparers who would have preferred to retain the flexibility necessary for 'favourable' presentation of their results.

None of these events can be directly attributed to industry pressure. Industry did not have to exert pressure: the project developed in such a way that the preparers' wishes were complied with anyway. However, one can suggest with a reasonable degree of justification that the very presence of a conservative grouping on the Board led to the course of events, and hence one is led back to the matters discussed in the three dimensional section above.

A number of other anomalies are worthy of consideration. Some of these were noted by Professor Anthony in his 1987 article on the CF. As noted previously, he claimed that the FASB had ducked all the big issues in the CF. His main points of contention were:

(a) the view taken of the company, i.e. entity v. proprietary views;
(b) the view taken of capital maintenance; and
(c) the definition of earnings.

Professor Anthony claimed that issue (i) was never seriously considered, (ii) was left unresolved, as was (iii). In examining these, one has to say that he overstates his case regarding (ii), for financial capital mainten-ance was quite explicitly accepted in SFAC No. 3 (although Board minutes make it clear that John March never really accepted this). However, the other two points are worth pursuing.

In terms of the theories under consideration here, it is difficult to form a view of the likely response by interest groups to the entity v. proprietary dichotomy. The entity view, which sees shareholders as just another group with a claim on the company's resources, seems to have few direct implications for preparers' wealth except perhaps that it might weaken the manager–shareholder bond somewhat. One might therefore expect managers to support moves in this direction. Auditors, working (nominally at least) for the shareholders, might oppose this, although if they wished for a more cosy relationship with company managements they might support it. As was seen in Chapter 3, this issue was barely discussed. Storey [1988] indicates that it was never seen as an issue worthy of much debate: in the US legal environment, the pro-prietary view would be the obvious choice.

Regarding the choice of earnings concept, one could expect great interest on the part of preparers and auditors for the economic reasons explained earlier. One would therefore expect lobbying to prevent any definition that resulted in a lower bottom line. Examination of the submissions received in response to the relevant documents leading up to SFAC Nos. 3 and 5 bear this out. Additionally, it is noticeable that responses to the latter, by the time of which bottom line effects were

more apparent, were more specific. However, as has been seen above, such was the disagreement within the Board on this issue that preparers need not have worried. No definitive statement was forthcoming and nor was it ever likely to have been. Once again, although the Board's deliberations produced a result consistent with the prediction of the theories discussed, it would seem that the chain of causality was somewhat less straightforward.

Three dimensional

One topic will be considered under this heading that was touched upon above, namely the lack of development by the Board of a full CF for nonbusiness organisations. Although objectives for NBOs were produced, qualitative characteristics for business enterprises were stated to apply to NBOs also, and elements for business enterprises were adapted for NBOs, no R&M statement was produced. Why was this?

One cannot with any justification use the views of private-sector auditors and preparers as the reason here. Another interest group, the NBO and local government preparers, is relevant. They were and are a powerful group; and the FASB's intention of producing rules for their accounts produced a serious 'turf dispute'. Thus, whilst FASB was working on the NBO aspects of the CF, its very right to do so was being questioned.[17]

The FASB's intentions were undoubtedly changed in this instance by pressure from the relevant interest group, and a separate body was set up to deal with the new area. However, since then demarcation has caused problems, leading eventually to the clash over depreciation mentioned in Chapter 3 and a thorough review of the way the two bodies (fail to) work together.

The influences of individuals

The analysis carried out above is largely based on the power or influence of groups, be they interest groups or companies or firms. However, it was noted earlier that individuals can sometimes wield power and cause a change of direction in a project such as the CF. The following notes the ways in which the actions of certain individuals affected the CF.

David Solomons

Professor Solomons was the principal drafter of the Wheat Report that set up the FAF/FASB/FASAC structure and hence was heavily involved

in creating the environment in which the CF was formed. However, he is best known for the contributions he made to the CF in the form of writing the documents on qualitative characteristics. Taking over the work after the 1976 DM, he produced both the ED and SFAC No. 2 (apart from late pre-publication editorial changes). This document series has been the least criticised of all those produced. As a result he set the tone for much of the rest of the FASB's discussion.

Donald Kirk

It would be hard to overestimate Kirk's contribution to the CF. It was he who initiated it by suggesting the need for broad qualitative standards. He was chairman of the FASB for most of the CF project's life and hence he led its development. As chairman he had a major say in the resources devoted to it and day-to-day he led the discussion of it. His publicly expressed views have been consistently pro-CF.

George Staubus

Although not heavily involved in the project itself, Staubus had a great influence through the people he brought to the FASB (Solomons, Anthony, Carsberg) and by stifling lobbying based on economic consequences arguments.

Robert Mautz

Mautz was a member of the original CF task force in the early days of the project. Later he led the unsuccessful but influential campaign to stifle discussion of the A&L view of accounting. Finally, he was called in to aid in resolving the recognition and measurement part of the project as adviser to the conservative grouping in the two-teams phase.

Robert Anthony

Anthony was another member of the original CF task force and hence helped to set its course. Most notably he wrote the Research Report that initiated the whole nonbusiness aspect of the CF, although this did not go as far as he would have liked. He continued to seek changes to the CF's direction but largely failed.

Bryan Carsberg

Carsberg worked extensively on the CF, being involved in the documents on 'Reporting Earning', 'Reporting Income, etc.', and 'Financial Statements and Other Means of Reporting'. In addition he was largely responsible for SFAS No. 33. He has been criticised for his approach,

described elsewhere as 'diplomatic'. Sterling argues that this diplomacy led to the papering over of cracks rather than to the construction of a sound edifice.

Robert Sterling

Brought in to 'save' the project or at least to help resolve problems in the area of recognition and measurement, Sterling brought with him a (justified) reputation as an advocate of current exit value accounting. This led to the more conservative-minded Board members distrusting his intentions, looking for ulterior motives in even the most straight-forward actions. In addition, Sterling rejected Carsberg's approach, preferring simply to identify differences and argue points out. To this end he utilised case studies that ultimately led to double guessing or 'peeking' by Board members, thereby effectively reversing the logical flow of the project from deductive to inductive. Sterling regards the CF as 'his' greatest failure (Sterling [1988]).

John March

March was the Board member most mentioned by anyone involved in the CF project. The son of an accounting academic and the brother of a Stamford professor of organisational behaviour, he moved from Arthur Andersen to the FASB and stayed only one term. In those five years, he came to be viewed by many as a form of conservative, status-quo-seeking figurehead whose views confused and confounded all those involved in the project. His actions (together with those of Robert Morgan and Frank Block) led to the two-teams situation. Eventually it was March who dissented from SFAC No. 5, the only dissent in the whole CF.

Reed Storey

The real author of much of the CF. Joining the FASB staff in 1975, he was one-third of the team (with Oscar Gellein and Robert Sprouse) that really took the CF project by the scruff of the neck. Storey was largely responsible for the 1976 DM on Elements, wrote most of SFAC No. 3, and was almost solely responsible for SFAC No. 6. He is the authority on the CF whom all at the FASB turn to.

Summary

The above shows just how much influence certain key people may have on a process such as the one under consideration. Their contributions are the ingredients from which the CF was made.

Summary and conclusion

This chapter has ranged far and wide. It has outlined economic and political theories intended to explain and predict the behaviour of various parties to a regulatory process. An attempt has been made to test the abilities of these theories to explain the particular case under consideration, the formation of the FASB's CF. These theories were then applied to some of the anomalies in the CF noted in the previous chapter.

Summing up, it would seem that what actually happened is in many cases consistent with the predictions of the theories. However, further investigation, consisting of close inspection of documentation and reports of events and discussion with those involved, suggests that often the actual reasons for actions in fact differed from those suggested by theory. In other words, the process involved is richer than these broad theories can describe. In order to gain a fuller understanding of a process such as that under consideration, one must 'go out and look under a few stones'.[18]

Even then a final cautionary note is called for. One may interview many people involved in a process such as the formulation of a CF, but even this cannot be expected to provide a completely accurate picture: memory is fallible.[19] However, this approach offers far greater insights into the actual process than simply seeking to apply theory.

Notes

1 A further argument along these lines is that the accounting firms, subject to frequent large law suits for alleged auditing failures, would welcome the creation of a CF. Once in place, it could act as a point of reference, a defence in legal actions.

2 Such reasoning underlies much of the testing of the Efficient Market Hypothesis that occurred in the early 1970s: see Dyckman and Morse [1986].

3 Notice how this parallels the agency theory idea of managers demanding monitoring contracts. Neither idea is immediately obvious.

4 Note that some of the work examined later in the section on power, whilst not being grounded in this economic literature, sheds light on similar matters. It is also worth noting that Peltzman states that Stigler had, by 1976, moved from his initial view that a single group could capture the regulatory process, and that a more pluralistic, shifting coalition view was appropriate. Such a change of position parallels that which developed in the power literature. See Tinker [1984].

5 For example, Walton [1966] asserts that sociologists tend to produce elitist results, political scientists pluralist ones: see Clegg [1979] for discussion.

6 This view is reflected in Kelly-Newton's [1980] description of the company – investor relationship.

7 Could not, rather than cannot, for as will be seen below recently there have been attempts to undermine the Board, reflecting perhaps an admission that the 'shared norms' presupposed in legitimate authority no longer exist.

8 They also found that sophisticated indices such as Shapley and Shubik underperformed the simple nominal, proportional index. This may have been due to the fact that the SS index assumes random order of voting: Don Kirk as chairman tended to stick to one particular order of voting, starting with John March (Miller [1988]), which may have introduced systematic bias into the procedure.

9 The same reasoning applies to the three dimensional approach.

10 The attitudes of the business community towards the Board have been made evident since in a continuing campaign. However, this is more appropriately dealt with in the next section on the three dimensional approach.

11 Wyatt left the Board only nine months after Beresford's appointment, ostensibly due to his concern that the Board could not do its job properly due to preparer pressure (Wyatt [1987]). Other rumours circulating are that he left disappointed at not becoming chairman, and that he could not work with Beresford. However, when Raymond Lauver retired from the Board at the end of 1990, he too expressed concern over the influence of outside groups on the standard setting process.

12 Miller and Redding [1988], despite their fears, point out that Beresford does not seem to follow the preparer line.

13 Some incidental support to this view is given by the changes over time in make up of the FASAC. Again a shift towards preparers is apparent with, in 1987, 9 of 29 members (or 31 per cent) being preparers, the largest single group by a wide margin.

14 See below for the effects Sterling himself had on the development of the CF.

15 See Stamp [1985], quoted in Chapter 2.

16 It also highlights an inherent problem of a deductive schema – once those developing rules realise where the process of deduction is leading them, if they do not like that direction they seek ways of circumventing the process.

17 The development of GASB, which flowed form this dispute, is detailed in Appendix 1.

18 This parallels Kaplan's [1984] call for a greater level of fieldwork than is common in accounting research.

19 See also the comments in the introduction to this study.

5 The impact of the CF

Introduction

By investing as many years and dollars in producing the CF as it did, the FASB obviously expected a substantial return. This would take the form of influence in a number of related areas, some within the Board's direct control, others outside. To assess whether the desired return was achieved, the following examines a number of areas where the FASB's CF might have been expected to have had an impact, and assesses whether this is in fact the case. Immediately, one caveat is appropriate. In selecting particular key areas and seeking evidence of influence by the CF, one leaves oneself open to the type of criticism levelled at the pluralist (Dahlian) power analysts, noted in Chapter 4. The only defence against this is once again to use as a basis of assessment the FASB's own stated objectives: this should mitigate some of the subjectivity. In other words, if the FASB's own definition of a CF as 'a constitution, a coherent system of interrelated objectives and fundamentals that can lead to consistent standards and that prescribes the nature, function and limits of financial accounting and financial statements' (S&I, p. 2) is valid, do actual events reflect these aims?

The areas in which evidence of influence might be expected to be found may be split broadly between those within the USA and those outside. In the former group, one may look for and assess the CF's influence on:

(a) communication within the financial and accounting community (including the FASB);
(b) accounting education; and
(c) accounting standards.

Outside the USA one may seek to assess the influence of the FASB's CF project on similar projects elsewhere.

Influence inside the USA

Effect on communication

> The need for improved communication, especially between the Board and its
> constituents, provides much of the rationale for the whole conceptual frame-
> work project and particularly for this Statement. Indeed, improved com-
> munications may be the principal benefit to be gained from it. (SFAC No. 2,
> para. 12)

The above statement makes clear the importance attached by the FASB
to improved communication between itself and its constituents. Without
a common language understood and accepted by all communicants,
there can be no meeting of minds. It is therefore pertinent to question
how successful the CF was in opening up the lines of communication.

There are various ways of assessing this. One may suggest that a
framework that sets out its objectives, specifies the qualities desirable in
information, and defines the component parts of its end product must
help in this respect. The recipients of this information must have a
better idea of what the providers intend and think. This is true, but as
Heath [1988] points out, the CF is a very long and unwieldy series of
documents, not easily accessible to the non-specialist. Even this one-way
communication may fail as a result.

Communication is, however, usually two-way, and evidence for the
existence of this may be found in submissions made to the Board on
accounting standards. According to Storey [1988] from within FASB,
and Keeling [1988] from without, the constituents have indeed learnt
the language, or at least picked up a number of useful phrases. The
terminology of the CF is now used in letters of comment responding to
DMs or EDs issued by the Board. However, the terms are sometimes
used in a manner different to that intended. Occasionally arguments put
forward by respondents consist of a jigsaw of quotes from the CF to
justify a position that is inconsistent with the thrust of the CF as a
whole. Rather than speaking the language, lip service is being paid.

Thus, as a vehicle for the improvement of communication, the CF has
been only partly successful. As well as providing a structure within
which problems may be resolved through the use of an agreed language,
it has allowed the introduction of a degree of crosstalk.[1]

Effects on accounting education

Admitting that problems of meaningful communication exist between
the FASB and its constituents is one thing; ameliorating the situation is

another. One way this situation might be expected to improve is via the educational effect of the CF. Although obviously a longer term benefit, this might be expected to be a major impact of the project.

In this context, education, like communication, is a two-way process. Not only can the CF be of educational benefit to accountants and accounting trainees but, by increasing the general level of understanding of conceptual matters, the CF could transform the quality of debate surrounding conceptual issues and the standards ostensibly to be derived from them.

Heath [1988] criticises the CF on grounds of poor readability and failure to influence education, the latter, in part, flowing from the former. In detail, he argues that the output from the project is too great to be handled adequately, is too abstract for all but a specialist, and was produced in an order unsuitable for an uninitiated reader. In other words, in order to gain a real understanding of the CF, one must already be familiar with its structure and content.

If the work is to influence future generations in the way the classic text by Paton and Littleton [1940] has certainly done, it must be cited and discussed in textbooks. Here a problem arises. Zeff [1988] has pointed out that many US intermediate accounting textbooks are growing to gargantuan proportions due to the inclusion and discussion of many FASB SFAS's. The CF, it is true, also receives some coverage. However, generally the concepts are not integrated into the body of the text and followed through in the discussion of statements. Instead, a chapter on the CF is simply appended to an existing text when a new edition appears. As a result, the CF and the issues it covers may fail to permeate the minds of accounting students.[2]

The above, however, assumes that the FASB plays a passive role. It releases its 'product' (the CF documents) into a critical world and waits for the textbook writers to pick up on the major points. Unfortunately, to a very large extent this is what happens. It is surprising to find how little the FASB actively promotes its output in a manner likely to gain a wider audience. Occasionally documents were produced with an eye to education (e.g., Johnson and Storey: FASB [1982]), but generally this was not the case. This is all the more surprising, given the FASB's task in its Rules of Procedures to 'improve the common understanding of the nature and purposes of information contained in financial reports' (FASB [1987]).

Have opportunities been missed? Some clearly think so. For example, Robert Spouse suggested at a 1988 meeting of ex-Board members that someone, a good writer, should be given the task by the FASB of

summarising the CF documents into one readable volume, accessible to a greater range of readers. This is obviously an attractive idea but is likely to cause difficulties for the Board for two main reasons:

(a) who would the writer be? Could this be agreed upon? The choice would obviously be crucial.
(b) once produced, what would be the status of the volume? Would the current or a future Board authorise the issue of such a document? Even if it did, would it be truly authoritative? The case of the 'Original Pronouncements', a compilation of standards and interpretations published commercially, indicates that problems could arise. In this case, changes made by the publisher to ensure consistency and/or promote brevity have led to the authority of the volume being questioned. Since, it is argued, the wording is not as in the original document, this volume cannot be authoritative.

Such problems could be avoided by the Board making clear that the 'Concise CF' was not authoritative, but then part of the point of an official document would be lost. Perhaps the answer lies in persuading academics to attempt the task and hence seek to promote the creation of, as in the law, persuasive but not authoritative texts. This, however, might be seen as undermining the FASB's own position.

Another missed opportunity concerns the recognition and measurement case studies produced by Professor Sterling for the Board. They would undoubtedly make excellent teaching aids but have never been published. Professor Sterling is himself considering writing them up and the Board has already asked Robert Hampton, an ex-Price Waterhouse partner and APB member, to do so. But this is over eight years after the case studies were produced. Greater impact could have been achieved by early issuance.

Thus, in summary, this aspect of the CF must be viewed as a missed opportunity. Developments flowing from the CF would have had maximum impact at the time the project was in progress, not years later. The lack of emphasis given to the educational aspects of the CF was a major error. It is not too late, however, to make amends. Currently the 'cookbook' approach to accounting education is under attack in the USA and a more conceptual approach is being advocated. The CF would seem to be an ideal starting place for a new breed of texts.

Effects on accounting standards

The most obvious way one might be able to judge the efficacy of the CF is by examining accounting standards. Those issued during the later

stages of, or after, the CF might be expected to show evidence of its influence, i.e. to be consistent with it and between themselves.

To assess the veracity of this, three main topics leading to SFAS's, issued soon after the CF was completed, have been selected for brief consideration, these being:

(a) pensions;
(b) deferred taxation; and
(c) cash flow statements.

Each is now examined in turn.

Pensions
The first accounting topic considered here is 'Employers' Accounting for Pensions'. This project had one of the longest gestation periods of any undertaken by the FASB, being initiated in 1974 with the eventual standard, SFAS No. 87, being issued in December 1985. The many stages of the due process are detailed in Appendix C of the SFAS, which provides notes (a) to (x) to explain the steps taken (DM, Preliminary Views, ED, SFAS, etc.).

Part of the reason for the time taken was the need to clarify the issues to be addressed. Early on the project was split in two, with accounting for employee benefit plans being separated from the employers' account-ing for pensions. At later stages, too, the scope and applicability was altered (e.g., *re* local government pension schemes). However, the main issues remained constant throughout: what is the nature of a pension arrangement? What assumptions are relevant in determining future benefit payments? What method of attribution of pension costs to individual years should be selected? How should pension liability be determined?

The length of the project and the many submissions received at each stage of the process (see SFAS No. 87, Appendix C for details) testify that the development of the standard was not a smooth process. Many references are made in the SFAS to the CF and its implications for the project (see, for example, paras. 107 and 263). However, one soon gains the distinct impression that purely conceptual considerations were not the sole determining factor in the process to produce a standard. This is confirmed by paragraph 107 of SFAS No. 87 which states that:

> The Board believes it would be conceptually appropriate and preferable to recognize a net pension liability or asset measured as the difference between

the projected benefit obligation and plan assets either with no delay in recognition of gains and losses, or perhaps with gains and losses reported currently in comprehensive income but not in earnings. However, it concluded that those approaches would be too great a change from past practice to be adopted at the present time.

In other words, the Board openly acknowledges that its standard is not fully consistent with the CF; that consistency is desirable but, in line with the view expressed in SFAC No. 5, evolutionary change is the best that can be expected (see also Lucas [1987]). Improvements in financial reporting are possible, while great leaps forward, however conceptually pure, are not.

Deferred taxation

Deferred taxation (or 'Accounting for Income Taxes' as the eventual SFAS was named) is a topic that has long been the subject of debate. In the USA, APB Opinion 11 had, since its issuance in 1967, determined the accounting treatment of deferred tax. However, in early 1982 the FASB decided that the topic needed attention once again. The process to produce a standard was (and continues to be) a long one, involving the full due process: the issue of a Research Report, a Discussion Memorandum, and Exposure Draft, and eventually a Statement (No. 96). This, however, occurred in December 1987, nearly six years after the start of the project. Since then two further standards (SFAS Nos. 100 and 103) have been issued deferring the effective date of SFAS No. 96 by one and two (further) years respectively. A further ED, issued in June 1991, defers SFAS No. 96 yet again, this time until December 1992, in large part to allow for the passage of a separate ED that amends and simplifies the recognition and measurement aspects of SFAS No. 96.

The DM issued in August 1983 set out various issues to be discussed and it is useful to consider the more important of these when compared to Opinion 11 and SFAS No. 96.

	Op. 11	*SFAS No. 96*
Defer or not?	Defer	Defer
Method?	Deferral	Liability
Current *v.* future tax rates?	Current	Future

The differences between the two documents are clear and major. But are the changes made consistent with the CF? Simply put, the answer is yes: the major change, the adoption of the liability approach, is a clear shift in line with the CF's emphasis on the A&L view. And it would

seem from arguments presented in the SFAS itself (for example, in the summary and at paragraphs 83 and 184) that this was indeed due to the influence of the CF.

But matters are not that simple. Swieringa [1988] charts in detail the development of the standard and makes clear that simply adopting the CF's implications was not the sole reason for the eventual outcome. Other reasons were changes in US tax law, the reaction of those (preparers) affected by the law and the standard, and, once more, a feeling within the Board that an evolutionary, iterative approach should be adopted. These pressures have become even more evident with the events surrounding the delays to the effective date of SFAS No. 96 and the recent proposals for its amendment. If conceptual purity, free from political interference, is desired, this is clearly not one area within which to begin looking.

Additionally, even in the 1981 DM itself, it was noted that, depending on the view taken, both the liability and the net-of-tax methods are consistent with the CF. This is an important point, for it undermines one of the major arguments for a CF. It is often suggested that a CF will lead to a coherent, consistent set of standards and it is implied that a CF leads to one such set. However, unless a CF is very tightly-drawn it will be the case that, as in this instance, more than one accounting method in any given area can be compatible with it. This leaves room for argument and dispute, and thus may not resolve issues. (Of course, it was the possibility of a tightly-drawn CF being produced, possibly leading to unpopular, restrictive accounting standards, that led to much of the opposition to the project.)

Such may be the flexibility still permissible under a regime making use of the CF that inconsistencies may still occur. At the public hearing on the deferred tax ED, Walter Schuetze, an ex-Board member, there representing the AICPA's AcSEC, pointed out that the idea expressed in the ED that no future income or expense may be assumed was completely at odds with the view taken in the then topical pensions statement: in pension accounting, great reliance was to be placed upon assumptions regarding future events (Liebtag [1987, p. 81]). Thus, incoherence was apparent between statements on two major issues being discussed at roughly the same (post-CF) time.

Cash flow statements
The third topic selected for examination is cash flow statements. This actually started out as a part of the CF itself, being considered in DM – RFF (FASB [1980g]) and in ED – RI (FASB [1981]).

The subject was then dropped, partly because of the problems centring on the R&M issues, and partly because it was felt more appropriate to deal with the topic in the context of an accounting standard. Such a standard would amend or replace APB Opinion No. 19, the then current statement. The topic was picked up again later and an ED issued in July 1986 and the statement, SFAS No. 95, in November 1987. The latter has since been amended by SFAS Nos.102 [February 1989], which exempted certain employee benefit plans, and 104 [December 1989] which allowed net, rather than gross, reporting of some transactions by banks and other financial institutions.

The major issues to be considered were set out in the 1980 DM. These were (i) the concept of funds (cash, working capital, etc.); (ii) whether all companies should produce such a statement; (iii) the method of computation (direct or indirect), and (iv) the presentation of the information (sources and applications, type of inflow and outflow, etc.).

A comparison of the conclusions of the various documents shows that changes did occur over time, but that they were minor.

	APB OP. 19	*ED (1981)*	*ED (1986)*	*SFAS No. 95*
Concept?	Cash or WC	Cash	Cash	Cash
All companies?	All	Unclear	All	All
Presentation?	Flexible	Type (i.e. Op. *v.* Fin.)	Type	Type
Method	Flexible	No pref.	Either	Direct

The lack of change from the 1981 ED to SFAS No. 95 could be taken as indicating that in this case the CF was implemented without problem. Once again, however, this would be an oversimplification. Even Appendix A to SFAS No. 95 notes a process involving co-operation with the FEI, lobbying by financial institutions, and advice from the AICPA before the 1986 ED was issued. (One might point out that such descriptions in SFASs/SFACs are usually a palatable simplification of the process that actually occurs.) Once again, politics and lobbying were involved, although the end result was consistent with the CF.

Also of importance is the point made earlier: the CF as it stands does not offer useful guidance in determining which concept of funds should be used in a standard, nor the method of computation, nor the manner of presentation. It is silent on such topics, and thus although the cash flow project was clearly derived from CF work, its resolution was not determined by that work. As with deferred taxation, alternative outcomes would also have been compatible with the framework.

Summary

The points raised regarding the influence of the CF in accounting standards are rather depressing from a pro-CF point of view. The pension accounting statement admitted not following the CF; the deferred tax statement was consistent with but not necessarily determined by the CF; and the cash flow standard, although consistent with the CF, could have taken any number of other forms and still not have deviated from the CF.

Since, as noted above, the FASB saw the CF as a way of ensuring consistent standards, these points indicate that, if not demonstrably failing in its intention, the CF can claim little effect on the various outcomes. As with communication and education, the best that can be said is that the CF offers opportunities, but these have yet to be fully grasped.

Influence outside the USA

Since 1973, when the FASB initiated its CF project, professional accounting and regulatory bodies in most of the major Anglo-Saxon countries of the world have pursued a similar path. Each has perceived a need for an explicitly sound conceptual foundation for their standard setting efforts. These will now be considered.

The following organisations have undertaken their own projects or sponsored others to do so on their behalf:

(a) Australian Accounting Research Foundation;
(b) International Accounting Standards Committee;
(c) Canadian Institute of Chartered Accountants;
(d) Institute of Chartered Accountants in England and Wales; and
(e) (UK) Accounting Standards Board.

Since the above bodies are based in Anglo-Saxon countries, and each commenced after the FASB's project, one might expect to see some evidence of influence from the US project. Is this so? The following is a brief outline of each framework.

AARF

The AARF published its first CF project exposure draft in December 1987 (AARF [1987]). Since then, three final documents (Statements of

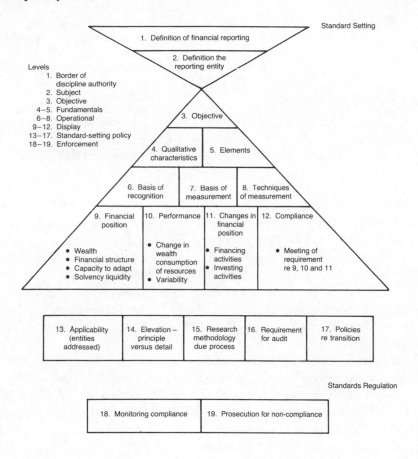

Levels
 1. Border of
 discipline authority
 2. Subject
 3. Objective
 4–5. Fundamentals
 6–8. Operational
 9–12. Display
 13–17. Standard-setting policy
 18–19. Enforcement

Figure 17 Structure of the AARF CF project

Accounting Concepts – SACs) have appeared and five EDs remain to be finalised. Other EDs and SACs will appear as the project progresses. In addition, an overall guide to the project has been produced. One soon realises that the Australians have a very clear idea of the components of a CF and of the way in which they fit together. The introductory guide sets out the structure (see Figure 17). One notes again that the overall structure is quite similar to that of the FASB project. However, it is clear that this structure has been worked out in more detail than was the FASB's. The documents published to date cover the following:

Final Documents (SACs): Definition of the Reporting Entity
 Objectives of General Purpose Financial
 Reporting
 Qualitative Characteristics of Financial
 Information

Exposure Drafts: Definition and Recognition of Assets
 Definition and Recognition of Liabilities
 Definition and Recognition of Expenses
 Definition of Equity
 Definition and Recognition of Revenues

An examination leads one to see similarities to the FASB's CF, e.g., the objective for financial reporting selected is decision usefulness, and relevance and reliability once again dominate the qualitative characteristics section. However, perhaps the most interesting point is that definition and recognition (of assets, liabilities, revenues and expenses) are being dealt with together. Whereas the FASB and others have covered definitions in one document (or section) and recognition (and usually measurement) in another, AARF links definition and recognition. (Even the 1976 FASB DM did not do this – instead it linked definition and measurement.)

This is an interesting development, and makes more substantial the links between the recognition criteria and the elements suggested by the Ijiri and Jaenicke research reports for the FASB (RR – CONT and RR – SURV). Also, the fact that the definition of the reporting entity was dealt with as the first document in the SAC series indicates that AARF is throwing its net wider than some of the other organisations.

IASC

The Exposure Draft for the IASC's 'Framework for the Preparation and Presentation of Financial Statements' was published on 1 May 1988, i.e. two-and-a-half years after the completion of the FASB's work, and the final document in July 1989. Unlike the FASB's massive documentary output, the IASC framework consists of just 110 paragraphs on thirty-six pages.

The framework was stated to apply 'to the financial statements of all commercial, industrial and business reporting enterprises, whether in the public or the private sectors' (para. 8). In structure, the document is very similar to the FASB CF. The main sections cover the objectives of financial statements; the qualitative characteristics that determine the usefulness of information in financial statements; the definition, recog-

nition and measurement of the elements from which financial statements are constructed; and concepts of capital and capital maintenance. (Note that reference is always to financial statements, not to financial reporting. IASC has not followed FASB in broadening its role.)

Within the sections, the similarities to the FASB work continue. For example, in the objectives section, users and their needs are discussed (as they were in the FASB work), although it is investors only who are selected as the focus for the statements. The main qualitative characteristics are again relevance and reliability, with comparability, materiality, timeliness and cost/benefit also being covered.

Elements defined regarding financial position are assets, liabilities and equity; regarding performance, income and expenses. The latter are defined in terms of the former, i.e. an A&L view is taken, per the FASB.

Recognition is dealt with in a section separate from measurement and the criteria for recognition differ from, and are simpler than, the FASB's. The criteria for each element are based on the probability of the future economic benefit that will flow to the enterprise, and the possession of an attribute that can be measured reliably, i.e. similar to the FASB criteria.

Instead of reproducing the FASB's five possible attributes to be measured, IASC gives four – Historic Cost, Current Cost, Realisable (Settlement) Value and Present Value. Little discussion is provided and no conclusions are offered concerning choice between the attributes.

The short discussion of capital and capital maintenance covers the well-trodden ground of financial capital maintenance *v.* physical capital maintenance, but again no conclusions are reached. Indeed, it is specifically stated (para. 110) that the IASC is not going to prescribe a particular measurement model.

The similarities to the FASB's CF are striking: it is clear that the FASB CF had a profound effect on the drafting of the IASC's CF, influencing its structure and much of the ground it covers.

CICA

The CICA handbook added a new section 1000 in its updating filing instruction No. 59 in December 1988. This consisted of what was broadly a CF, although it was explicitly stated to be descriptive, not normative. Despite this fundamental difference in approach, the resulting framework was strikingly similar in structure and basic content to the FASB product. The relevant sections consisted of twelve pages and

sixty-one paragraphs. In that short space, material was set out covering all the major sections of accounting as in the FASB CF.

In addition, the structure again broadly paralleled the FASB's CF. On closer examination, similarities to and differences from the FASB's project are apparent, notably:

(a) the objectives statement hedges between a decision usefulness and a stewardship point of view;
(b) the qualitative characteristics are very similar to the FASB document's as are the elements: only Comprehensive Income is missing from the latter;
(c) the discussion of recognition criteria is short and results in two criteria being proposed, the wording of which allows a number of interpretations;
(d) measurement bases offered are HC, RC, NRV and PV which is in accordance with the IASC. HC is the primary base with the other to be used in a limited number of circumstances;
(e) capital maintenance merits only one paragraph of discussion and it is stated that financial capital maintenance with no purchasing power adjustment is used;
(f) a specific point is made about the assumption of a going concern; and it is stated that if this assumption is not appropriate different bases of measurement may be used; and
(g) the discussion of GAAP (three paragraphs) lists the authorities upon which decisions should be based.

Thus although differences do exist, the similarities to the FASB CF are again apparent.

ICAEW (Solomons Report)

The Solomons Report (or 'Guidelines for Financial Reporting Standards' (Solomons [1989])) was published by the ICAEW in early 1989, having been completed in October 1988. A far more substantial work (77 pages) than most of the others noted here (although still a single document), it too follows a similar pattern to the FASB's CF. Chapter 2, on objectives, provides a purpose that is worded so as to find favour with the decision usefulness and stewardship schools, and the discussion that follows covers similar ground to the FASB document.

Chapter 3 starts off with a discussion of the accounting entity (previously noted to have been omitted from the FASB's CF work) and goes on to define elements and sub-elements. The two main elements are assets and liabilities (and hence an A&L view is taken). The subelements are revenues, expenses, gains, losses, equity and income. Each of the detailed definitions differs from their FASB equivalents, although usually only slightly.

The qualitative characteristics offered are again based on relevance and reliability, but differ in that relevance is split into predictive, confirmatory and corrective values and timeliness, whilst reliability covers representational faithfulness, comprehensiveness and verifiability, with consistency, neutrality and feasibility being the remaining characteristics.

Recognition and measurement are dealt with together as per the FASB, and hence this aspect differs from the IASC and CICA frameworks. Solomons offers three recognition criteria, although one is effectively just a materiality condition. Measurement is in fact dealt with in Chapter 5 of the report.

The report expresses considerable doubts about the usefulness of historic cost, and proceeds to discuss the merits of various other valuation bases. Solomons differs from the FASB and IASC by coming down in favour of a specific model: valuation of assets and liabilities at their value-to-the-business, with income calculated in real financial capital maintenance terms.

Once again, the structure adopted by the FASB is apparent, although the results achieved differ greatly.

Accounting Standards Board

In August 1990, the Accounting Standards Board (ASB) took over responsibility for setting accounting standards in the UK from the Accounting Standards Committee. The earlier body had previously adopted the IASC CF as a basis for its considerations of topics, but ASB decided early on to produce its own 'Statement of Principles'. This will constitute a CF and is scheduled to consist of the following 'chapters':

(a) the objective of financial statements;
(b) the attributes of financial information that enable financial statements to fulfil their purpose;
(c) the elements that make up financial statements;
(d) when items are to be recognised in financial statements;
(e) how net resources, and performance and changes in these, are to be measured;
(f) how items can best be presented in the financial statements; and
(g) the nature of the reporting entity, leading to the principles underlying consolidation, full and partial, and equity accounting.

To date the Board has issued one Exposure Draft (ED) covering parts (a) and (b) above, plus one Discussion Draft (DD) on item (f).

In the ED, it is stated that: 'in these initial chapters, ... the Board proposes to use wherever possible the IASC text from [its CF]' so as to promote harmonisation and save duplication of effort. That the ASB feels able to do this indicated just how similar are the factors driving the IASC effort to those in the UK. The ED adopts investors as the prime focus of the CF and a decision usefulness plus stewardship prime objective. The qualitative characteristics are again very similar to IASC (and hence all the other CFs), although the diagrammatic display of them, whilst showing evidence of considerable thought, is somewhat complicated.

The DD is a more detailed document than any in a final CF yet published, although quite similar in some respects to DMs and EDs published by FASB. It is primarily concerned with display, and in particular with differentiating extraordinary from normal items.

Summary of the other CFs

It is noticeable that each of the CFs produced to date, and indeed those still in progress, are very similar in their approach and structure. There may be many good reasons for this, but the most obvious one is that each body has adopted (perhaps copied is a better word) the FASB approach. In this respect then, the FASB CF has influenced strongly the way in which accounting researchers or bodies internationally have approached the subject. Given the lack of a well-thought-out plan for the FASB effort noted earlier and the problems the FASB faced, perhaps this is regrettable. The AARF project diverges most notably from the US model and is perhaps the most interesting. ASB too promises interesting aspects, but the project is in too early a stage properly to judge.

Clearly these projects deserve far more detailed consideration than is possible here. For example, the effects of the legal, economic, professional, etc. environment in which they will have to operate warrants much greater attention.

Overall summary

This chapter has sought to establish the influence of the FASB's CF project. It has examined areas within and outside the USA. Those within lead one to conclude that the FASB has inadvertently missed many opportunities to use the CF – or is even choosing to do so. In part

this is due to the very nature of the framework itself. Another fault is the lack of promotion of the framework. The FASB has, in the CF, a means of strengthening the conceptual understanding of accountants, a substantial educational tool. Again, it is not being used. Outside the USA, it is clear that the FASB project has influenced others greatly. Each of the other CFs examined show signs of following the American lead, whether in detail or in broad structure. These two conclusions sit uneasily together. An unsatisfactory product is having great influence. Current CF producers, such as those in the UK and Australia, should be aware of the dangers before going further down the same path.

Notes

1 One is reminded of Humpty Dumpty in 'Through the Looking Glass' who stated that 'When I use a word . . . it means just what I choose it to mean'.
2 This point was forcefully brought home to the author when, in 1988, discussing accounting issues in the USA with a part-qualified American accounting graduate working for one of the Big Eight firms, the latter admitted to having never heard of the CF!

Summary and Conclusions

Introduction

This study has examined various aspects of the FASB's CF project. The origins, execution and legacy of the project have each been considered, and the many problems associated with each noted. The ways in which these problems arose and the manner, successful or not, in which they were tackled is of considerable current importance to others, such as the AARF and ASB, who are following a similar path to the one already trodden by the Americans. Already it is clear that these later projects have been very strongly influenced, directly or via the IASC framework, by the FASB effort. An understanding of the pitfalls of CF production as exemplified by the US experience is therefore important.

This chapter draws together the strands of the study and is structured as follows. Firstly, a summary of each substantive chapter is given, noting the main points made. Then a synthesis of the problems noted from the US experience is presented. Next, the reasons why these lessons should be of interest to those still pursuing a CF are explored in greater detail, and lastly, consideration is given to the possible outcome of those projects still running.

Summary and synthesis of the perceding chapters

Summary

The various factors that constituted the crisis leading to the formation of the FASB and the initiation of the CF project were outlined in Chapter 1. These factors were: problems with the setting of accounting standards, particularly a continuing tension between the bodies involved in the area; uncertainty over the nature of accounting standards, and

certain specific events deriving from the formulation of such standards; flexibility in permitted accounting methods resulting in differing accounting treatments of similar transactions; and, deriving in part from the flexibility noted, a series of frauds and failures by auditors to detect them.

Each of these factors fuelled a credibility crisis for the American accounting profession. Standard setting was a major responsibility for the profession, and its failure adequately to deal with this task, via the APB, cast doubt upon its abilities generally. Add to this the inability of the 'ordinary man' to understand how the same transaction could be accounted for in a variety of ways, and the apparent ease with which crooked businessmen managed to evade detection by their auditors, and the solid foundations of the accounting profession began to appear shaky. The underlying strength of feeling over such matters was eventually revealed by the actions, taken by the AAA and Touche Ross, that precipitated the crisis.

The possible responses of the accounting profession were considered next, and also the actual choice made. The formation and recommendations of the Wheat and Trueblood study groups were examined. It was shown that the accounting profession had gradually painted itself into a corner, the only way of escaping from which was by the radical step of partially giving up control of the very process that had played such a large part in bringing the profession into crisis. Standard setting moved from being solely the preserve of the accountants to a concern of the whole business community, albeit still with a pre-eminent position for the accounting profession.

The feeling of inevitability evident in the events described in Chapter 1 continued in Chapter 2 which considered the options open to the FASB when it set out on its self-imposed task of producing a CF. Various options were outlined and previous attempts discussed. The FASB's choice was placed in context and identified as a normative, decision-usefulness-based framework.

Various advantages of this new approach were identified, being mainly responses to previous criticisms. These included the elevation of users as an interest group and the adoption of a deductive approach (in contrast to the previously tried and unsuccessful inductive approach). In addition, a breathing space was gained for the standard setters. However, a number of disadvantages were also noted that cast doubt on the outcome of the project. These disadvantages were concerned with past experience of such undertakings, the similarity of the process to the setting of accounting standards, the philosophical underpinnings of the

deductive 'hard systems' approach, and the difficulty of producing a result that would match observers' expectations. This last point in particular would suggest the rejection of an otherwise complete and coherent framework. Further, it was suggested that the FASB project was not adequately planned, and that no deep consideration had been given to the way the project was to proceed. It seems that alternative techniques for solving problems were not assessed before FASB initiated its project.

Chapter 3 examined, both in broad and in detailed terms, the CF project in practice. Basic data were given and then an assessment made, initially by considering the criteria against which the project should be judged. Once more, an unsatisfactory situation was identified. The stated objective of producing a constitution was questioned, the ideal of coherence was shown not to be present in the FASB's own approach, the prescription that formed a basic tenet of the project was not adhered to, and the production of specific components was simply not carried through.

Various themes present in the CF were noted, a number of them (e.g., cash flows, current values, and the anti-income smoothing implications of the A&L view) providing grounds for opposition to the project. Detailed consideration of the output of the project again led to mainly negative conclusions, with many points of inconsistency or confusion being identified, and some points simply being left unresolved. A number of innovations were also identified, such as the idea of comprehensive income and the use of diagrams in explanation. The biggest innovation was, however, making a wide range of interested parties think deeply about major issues and providing a common language so that they could express their views.

Theories of regulation that could shed light on the process of CF formulation were explored in Chapter 4. Using both economic and political theories, insights were sought into both why and how interest groups, notably the preparers of accounts, influence the process. The economic theories examined were functional fixation, agency theory, economic consequences, lobbying, and capture theory. Power was the central concern of the political section.

Having established the suitability of these theories in the context of the CF, they were applied to some of the changes and anomalies noted in Chapter 3. Although often the events described were found to be in accordance with the predictions of the theories, it was difficult to prove any causal link. Thus, for example, despite the clear attempt, now seemingly successful, of the Business Roundtable to capture the FASB

process, linking this action with specific changes in the CF proved problematic. Thus it was suggested that in studies such as this the theories may best be used as tools to focus attention on relevant areas. Further fieldwork research is required to discover the true cause of actions and events.

The influences of the CF were considered in Chapter 5. Within the USA, communication, education and accounting standards themselves were all considered. It was found that in each case, whilst the CF had a great potential for influence, this had not yet come about. Communication was not yet truly in line with the CF, education had nearly ignored it, and accounting standards were produced which explicitly stated that they were not following it. Additionally, it is clear that pressure from outside bodies still plays a major role in the standards setting process, mitigating, if not overriding, the influence of the CF.

Outside the USA, it was shown that the FASB's work has greatly influenced attempts by the AARF, IASC, CICA, ICAEW (the Solomons Report) and ASB to produce a CF. This was seen as a source of concern for, as is now clear, the FASB CF is a flawed work.

Synthesis

What, then, may be distilled from above? The first and most important point to be made is that in undertaking a CF project, it is vital for the relevant body to ensure that the CF's true purpose and its potential are explained thoroughly and completely, both to those involved in the project and to those parties interested in its outcome. Failure on this front simply stores up trouble for later when unrealised expectations lead to negative reactions. Some of the problems caused by the failure to communicate adequately with outsiders were considered in Chapter 4. The problems of misplaced expectations potentially affect those producing a CF as well as those outside the process, and are worth drawing out more explicitly.

The idea of a CF project can lead some to believe that it will solve all of the problems confronting accountants. Once the CF is produced, standard setting will be easier: it is almost a matter of feeding in the problem at one end of the framework and waiting for the solution to pop out of the other. This is not the case. A CF is not a panacea. Unless drawn very tightly, a CF will not eliminate disputes over the correct treatment for any particular accounting problem And a tightly-drawn, coherent CF is unlikely to come about simply due to the way in which a committee, the probable producer of an 'official' CF, works. The FASB

CF's silence (considered in Chapter 5) on the major issues determining the form of cash flow statements – one of the three primary financial statements – exemplifies the way in which a CF does not necessarily solve problems.

Another problem is with the expectation that the end product of a 'CF-producing process' will be a coherent document (or series of documents). This is unlikely unless, as in the case of Professor Solomons, the CF is the product of one person. A committee, as noted, will probably produce a compromise document and thus fall between a number of stools.

Further, even if a CF is successfully produced, it need not be followed. Existing or future standard setters may simply choose to ignore the framework if circumstances dictate. The example of the FASB pension accounting standard supports this contention.

Perhaps more important than any other of these issues that must be tackled prior to starting a CF project is its very conceptual basis.[1] The FASB adopted a normative, deductive, decision-usefulness approach without, as was noted, investigating in-depth alternative approaches to CF formulation. In other words, an attempt was made to solve a problem without adequately considering the various methods available to solve such problems. Thus, methodological bases such as jurisprudence, 'soft systems' and induction were not explicitly considered, and no statement made explaining their dismissal as a possible method. To have so considered the alternatives would have been an important step in justifying the approach actually adopted. This was done by Moonitz in the earlier ARS No. 1 (AICPA [1961]).

Akin to this is the need to define the scope of the project. Is a CF to cover financial reporting by business entities, by all non-governmental enterprises, or by all organisations? How wide should the net be cast? This must be decided in advance to avoid the problems encountered by the FASB over, for example, SFAS No. 93 and the redrafting SFAC No. 3 as SFAC No. 6.

To the above must be added the complicating factor that interest groups will have a desire to influence the outcome of any such project. This may take any of the forms outlined in Chapter 4. Thus it is very apparent that those seeking to produce a CF must have a full understanding of these issues before they start. If they do not, they will almost certainly fall foul of many of the problems experienced by the FASB.

Thus, the FASB experience is relevant to accountants and others involved in CF production and standard setting in a number of ways.

To take a specific example, one may consider a major accounting topic. In recent years one of the main issues in the UK, Australia and elsewhere, at least in terms of the amount of attention it received, was the issue of brands. Companies placed on their balance sheets valuations for their product brand names. This was done both for acquired and non-acquired (created) brands. The common justification for this was that brands are assets of value and that they had been wrongly omitted from financial statements produced previously. By including brands, the reader of accounts is presented with a clearer picture of the true nature, the economic substance, of the company.

This practice raised many issues, largely conceptual in nature. What is the nature of an asset, and does a brand name fulfil the necessary conditions? If a brand name is an asset, what figure should be included in the balance sheet? How can companies justify placing a current value on such items while retaining historic costs for others? What is the nature of the balance sheet? Is it a statement of corporate worth or simply a sheet of balances of purely historical interest? Just as the inflation accounting debate had done in the 1970s, the brands issue revealed the inherent conceptual weaknesses and contradictions of our present mixed valuation base accounting system.

Each of the straightforward questions noted above raises serious issues with far-reaching consequences. Each has major conceptual aspects to it. Solutions of such problems and others that will arise over time must, in part, be conceptual. Thus a familiarity with, and understanding of, the major conceptual project so far completed, the FASB's CF, is an important starting-point.

If the above were not enough to make us take note of the FASB's work, the similarities between the path that led the Americans to the CF and in particular the path in the UK in recent years should do so. There are echoes here of the inevitability noted in Chapters 1 and 2. Fortunately, recognising this fact gives us the opportunity to avoid the pitfalls.

A number of factors are similar in the UK of today to the USA of twenty years ago. Firstly, as has been seen, there was public disquiet there over the quality of financial reporting and problems of auditing lapses and fraud. Similar concerns have been expressed in the UK over such matters as off-balance sheet financing schemes, law suits against auditors, and a number of corporate failures and frauds.

Secondly, accounting standards in themselves have caused problems in the UK, just as they did in the USA. This might have been anticipated as the structures involved were quite similar, i.e. the ASC

was similar in many respects to the APB. However, it is perhaps surprising that the very same issues that caused so many problems for the Americans – mergers and goodwill – have also caused problems in the UK, with a review of SSAP 23 on mergers necessary so soon after its issue.

Thirdly, the US response to the problems was to set up the Wheat and Trueblood study groups. In the UK, despite not having arrived at quite the same crisis point, we too have had our own 'Wheat Report' in the form of the report of the Dearing committee. This recommended the changes that led to the Financial Reporting Council (FRC), ASB and Urgent Issues Task Force (UITF), similar to the FAF/FASB/EITF structure. (The Review Panel, the enforcement arm of the new UK set-up, was not needed in the USA, due to the SEC's presence and role.)

Not only has the UK followed the USA in changing its standard setting structure; it has now done so in pursuing the path of CF formulation. The 'Statement of Principles' project is well under way. As noted, it is modelled on the IASC document that, with certain exceptions noted in Chapter 5, resembles a generalised summary of the FASB effort. Whether this will prove a sound foundation for British efforts remains to be seen. However, one is again troubled by the seeming lack of consideration of alternative approaches.

Prognosis

At the time of writing, the detail of the ASB's CF is not yet available. It is clear from the information given to date, however, that ASB is adopting the FASB's basic structure and approach. So too is AARF in Australia, although as noted, greater variation and innovation seems likely if the declared approach is adhered to. What does this augur for standard setting in these countries?

Unfortunately, the UK approach suggests either of two not very appealing results, unless specific actions are taken. The first is that the ASB CF will be a slightly amplified version of the IASC framework, covering the same material, perhaps at slightly greater length. This would, however, not produce the answers (rightly or wrongly) expected of it. This suggests that it will not satisfy those anticipating 'the answer' and will produce criticism of the Board.[2]

The second possibility is that the ASB is simply following the FASB structure because it too has not considered the alternatives. This is more worrying than the first possibility as it leads one to suspect that ASB will

suffer the same travails as FASB with no firm explanatory basis to fall back on.

One hopes that the first possibility is the correct assessment of the situation, for the second would indicate many problems ahead, perhaps a re-run of the FASB experience. If the IASC-type document is to be produced, provided (and this is crucial) that this fact is clear to those producing the CF and is effectively communicated to the outside world, much good can come of the project. Discussion of difficult issues can be focused and meaningful. But this does depend so much on equating the expectations raised with the intended target. This is in the hands of the ASB itself.

In Australia the position is also unclear. The early documents hint that more radical changes may be under way. These would constitute a break with the FASB mould and offer a novel situation. The fate of the AARF CF may yet be determined by the changes in the Australian profession, such as the on/off merger of the two main accounting bodies and discussion of the method of standard setting.

This last point emphasises another matter of which there is little evidence of consideration being given. This is the environmental differences between countries. Whilst it is obvious that the CF producers to date have all come from the Anglo-Saxon world (i.e. not the (tax) law-driven, continental European influenced countries), the difference between the CF producing countries in terms of legal backing for standards, the dichotomy between those countries whose reporting regulation are company law rather than securities law driven, and enforcement procedures, etc., has been little studied and may prove to have profound implications for the style and content of a CF. Until such international comparisons work is focused on the specific area of CF production, these implications will not be understood. Much remains to be done, and if, as seems likely to be the case, the CF producers will not, or cannot, devote resources to such matters, the accounting academics must rise to the challenge.

Conclusion

In a 1980 article on SFAC No. 1 and ED – EL, Dopuch and Sunder (p. 1) quote Baxter [1962, pp. 419–20]. His words are, at least in part, as appropriate now as then: 'We have thus cause to feel grateful to the drafters of recommendations; and this review should on no account be construed as an attack on them. Obviously they have devoted much

time and care to their task, and have been prompted by a high sense of public service.' Whilst today, when we are much more aware of the political nature of the standard setting process than seems to have been the case in 1962, we might question the last phrase, there is no doubt that we should be grateful to the FASB for their efforts in attempting to produce a conceptual framework. They may have produced a product that failed to meet their own high expectations and also disappointed many others, but by examining their work we can learn much of value.

The task now is to learn these lessons from the FASB's efforts and to produce a more coherent and successful end result.

Notes

1 Producing a series of 'meta' statements is perhaps not very helpful, but clearly there exist a variety of concepts relevant to the approach to producing a CF.
2 Already the Hundred Group of UK companies has expressed some concern over the ASB's approach to complex issues of reform and called for preparers of accounts to have a more active role in the ASB's work (*Accountancy Age* [1991]).

Appendix 1 Structure and Processes of The FAF, FASB and FASAC

This appendix describes the structure originated by the Wheat Report for a new standard setting organisation, the Financial Accounting Standards Board (FASB). Also covered are the associated supervisory and advisory bodies and the working methods of the new structure. The structure provided by Wheat has changed since its inception: alterations have been made to a number of important features. Some of these affected the CF's development and are detailed here.

The appendix provides information about the environment within which the CF project grew. It is organised as follows. The initial sections are devoted to a description of the various bodies set up as a result of Wheat, and to their interrelationship. (Developments over time are considered within each section.) Covered next are developments not envisaged by Wheat, but brought about by changes in the scope of the standard setting work required. Additionally, the financial basis of the organisation is described and evaluated. Finally, the 'due process' used by the FASB for all its work and hence to develop the CF is explained.

The new standard setting structure

The Wheat Report recommended the creation of a new structure for the setting of accounting standards, and this was endorsed by the AICPA in May 1972. Three new bodies were to be set up, namely:

(a) Financial Accounting Foundation (FAF)
(b) Financial Accounting Standards Board (FASB)
(c) Financial Accounting Standards Advisory Council (FASAC)

Financial Accounting Foundation

The FAF was formed in June 1972 to undertake two main tasks: to organise the raising of funds necessary for the running of the new

structure, and to appoint the members of the FASB and FASAC. To these ends, the Foundation was constituted as a corporation in the state of Delaware, having charitable status to ensure favourable tax treatment of its income. Its formal objectives were set out in the Certificate of Incorporation (FAF [1973, p. 1]) as follows:

> the purposes of the Corporation shall be to advance and contribute to the education of the public, investors, creditors, preparers and suppliers of financial information, reporting entities and certified public accountants in regard to standards of financial accounting and reporting; to establish and improve the standards of financial accounting and reporting by defining, issuing and promoting such standards; to conduct and commission research, statistical compilations and other studies and surveys; and to sponsor meetings, conferences, hearings and seminars, in respect of financial accounting and reporting.

The trustees of the Foundation are nominated by a number of sponsoring organisations and appointed by the Members (or Electors) of the Corporation. Initially, in order to ensure acceptance of the FAF by the accounting profession, these Members were the Board of Directors of the AICPA, and thus the profession continued (in theory at least) to have strong control over the appointment of trustees.

Later, however, this situation changed. The 1977 report of the FAF Structure Committee concluded that there was no longer any justification for this dominant role for the accounting profession, and recommended that the composition of the membership of the Corporation be changed to include one member from each of the sponsoring organisations. This reflected a continuation of the moves towards greater representation of 'outsiders' in the standard setting process already noted in Chapter 1. This move was approved by the existing trustees and implemented (*Journal of Accountancy* [August 1977, p. 14]).

The sponsoring bodies referred to consisted of those involved in the preparation and use of financial reports. Once more, over time, these changed: initially the sponsors were the American Institute of Certified Public Accountants (AICPA); the Financial Executives Institute (FEI); the National Association of Accountants (NAA); the Financial Analysts Federation (normally referred to as the FAF but here as FA Fed to differentiate it from the Financial Accounting Foundation), and the American Accounting Association (AAA). The Securities Industry Association (SIA) was added to the list in 1976, and the Government Finance Officers Association and the National Association of State Auditors, Comptrollers and Treasurers in 1984.

The number of trustees has also grown over time, from the initial nine to the present sixteen. The evolution was as follows:

	1973	*Nominated by*
	1 AICPA president	AICPA
	4 CPAs in public practice	AICPA
	2 financial executives	1 FEI, 1 NAA
	1 financial analyst	FA Fed
	1 accounting educator	AAA
		Total 9
1976	Addition of two new trustees:	
	1 nominated by SIA	
	1 extra nominated by the FEI	
		Total 11
1979	One 'at large' trustee added, but nominated by the banking sector (as suggested by the 1977 Structure Committee report, p. 33).	
		Total 12
1984	Three governmental organisation nominees added	
		Total 15
1985	Two additional 'at large' places created. The AICPA president ceased, as of right, to be a trustee: in practice he continues to have a place, as one of the 'at large' trustees.	
		Total 16

Once more, the broadening of the 'constituent base' is evident.

The normal term of office for a trustee is three years, with re-appointment for one additional term possible. Exceptions to this occur in the case of resignations and the consequent need to fill the vacated post, and with the AICPA president who is a trustee only for his year of presidency (unless subsequently re-elected in the normal way).

Given its roles in fundraising and the appointment of FASB and FASAC members, the FAF has great power in determining the direction and likely outcome of the standard setting and other work. It is, however, much less in the limelight than the FASB itself, and hence avoids much of the controversy: it is truly a power behind the throne.

Financial accounting standards board

The FASB was constituted to replace the APB as the rule-making body for financial accounting, and started work in June 1973. Of immediate

interest was the use in the FASB's name of the word 'standards'. This change reflected the previously-noted realisation and acceptance that the rules being produced to control financial reporting were not merely opinions or agreed principles, but were standards in the sense of methods selected from a number of possible alternatives.

The members of the FASB are appointed by the trustees of the FAF. They are employed full-time and are well paid (in 1987 the salaries of Board members were $240,000, of the chairman, $300,000). However, as a condition of service members have to sever all connections with their previous employment. These terms were intended to obviate criticisms of lack of independence, such as those made of the APB. As its first chairman, Marshall Armstrong, said of independence at the time the FASB was set up, 'I think it is the biggest thing we have going for us' (*Chartered Accountant in Australia* [July 1973, p. 52]). It is worth noting, however, that two members resigned from the Board and later returned to their previous positions in public accounting practice.

Since its formation the Board has consisted of seven members including the chairman. The 1977 report of the FAF Structure Committee mentioned the possibility of reducing the size of the Board, and its 1982 report specifically considered a change to five members. However, that report recommended, and the FAF trustees unanimously accepted, that the original size should be retained. (The arguments put forward for five members were those supporting the radical changes from the eighteen-man APB to the seven-man FASB, i.e. greater efficiency in setting standards through easier communication and access and speedier decision making. It is interesting to note that for the later-formed GASB, only five members were deemed necessary.)

Board members are normally appointed for five-year terms with a maximum of two terms allowed. However, appointment to fulfil an uncompleted term, or because of a change of status such as appointment to chairman, can result in longer total service, e.g., Don Kirk served from 1973 to 1986.

Whereas all the APB members were CPAs, the FASB is not a closed shop. The original by-laws of the FAF (FAF [1973, p. 13]) state that: 'only 4 members shall be certified public accountants drawn from public practice or, in the judgement of the Trustees, principally experienced as public practitioners; and the remaining three members need not but may be [CPAs] and shall be persons who, in the judgement of the trustees, are well versed in the problems of financial reporting.' Later, however, even this restriction was removed (as another of the changes brought about by the 1977 Structure Committee report). However, in practice CPAs have remained numerically dominant.

The 1975 Special Review Committee report stated that members should have: knowledge of financial accounting and reporting; a high level of intellect applied with integrity and discipline; a judicial temperament; the ability to work in a collegial atmosphere; communication skills; awareness of the financial reporting environment, and commitment to the FASB's mission (quoted in Miller and Redding [1988, p. 37]).

Although these qualities were felt to override the previous employment-type of the Board members, it was also recognised that a mix of backgrounds is desirable, and hence people with 'experience in public accounting, in business or industry, as a user of financial information, and as an accounting educator' would be advantageous (Special Review committee report, p. 4, quoted in Miller and Redding [1988, p. 37]). Further, it was suggested, and has been generally adhered to, that on the retirement of a Board member the replacement should have a similar background to the outgoing member. However, it has never been the intention that members should merely represent the views of their professions (van Riper [1987, p. 130]): the mix was to ensure representation of experience, not of opinion.

Initially, votes of the FASB had to be at least five-two for a proposal to be carried. The 1977 Structure Committee report, however, recommended that this should be changed to a simple majority as part of the relaxation of the rules determining background, i.e., if no one group was to have an in-built majority, a four-three rule would be adequate. In July 1981, however, Ray J. Groves, managing partner of Ernst & Whinney, proposed a return to the five-two voting requirement as a way of boosting confidence in the Board's decisions (see *Journal of Accountancy* [December 1981, p. 114]). In early 1982 the FAF rejected this call, instead supporting the Structure Committee's recommendation that the four-three rule be retained. It is interesting to note that the Structure Committee stated as reasons for not returning to five-two that it 'could result in fewer FASB pronouncements, affect the quality of the Board's work' and possibly lead to greater involvement by the SEC in the 'unresolved' accounting issues (*Journal of Accountancy* [March 1982, p. 14]), i.e., the fear of SEC involvement remained even then.

Financial accounting standards advisory council

As its name suggests, the purpose of the FASAC is to advise the FASB, both members and technical staff. Officially it has responsibility for: 'consulting with the Standards Board as to major policy questions,

technical issues on the board's agenda, project priorities, matters likely
to require the attention of the FASB, selection and organization of task
forces, and such other matters as may be requested by the FASB or its
chairman' (*Facts About FASB* [1987, p. 2]). Thus, its functions cover
not only the initiation of work, but also responding to requests for
views, advice, etc.

The members of the FASAC, whose numbers started at about twenty
but has grown over time to nearer forty, are appointed by the trustees of
the FAF. All except the chairman are unpaid and are appointed for one-
year terms, four consecutive terms being the maximum. (Originally the
chairman of the FASB doubled as chairman of the FASAC, but since
1979 the Council has had its own chairman.)

Like that of the FAF and FASB, the FASAC membership is intended
to be broadly based, to be a 'microcosm' of the business community
(Kolton, quoted in Miller and Redding [1988, p. 41]). Miller and
Redding analysed the 1985 and 1987 council memberships as follows:

	1985	1987
Academics	5	2
Attorneys	1	1
Bankers	5	4
CPA – largest firms	5	4
CPA – other firms	2	2
Economists	–	1
Government	1	1
Health care	–	1
Insurance	–	1
Public at large	1	–
Security industry	–	3
Statement preparers	13	9
Statement users	4	–
Total	37	29

(The proportions of users and preparers is considered in more detail in
the body of the text.) In addition, the chief accountant of the SEC,
although not a member, attends each of the Council's quarterly meet-
ings (most of which are held in New York).

One part of the process adopted by the Council is of particular
interest. Preceding the main meeting, an eight-to-ten-member Agenda
Advisory Committee meets. Present also are one FASB member, and
the Director and Assistant Director of the Research and Technical
Activities staff. The members of this committee are selected by the
FASAC chairman, ostensibly to ensure a fair reflection of opinion. Their

discussions lead to suggested agenda items being submitted to the FASB. The FASAC does not vote on such issues: this function is merely to ensure that a range of opinions is brought forward and communicated to the FASB. However, even this is potentially influential.

Support staff

As with any 'legislative' body, support staff are required. The FAF/FASB/FASAC originally had technical staff working for individual Board members, plus a Senior Technical Advisor for the Board as a whole. In addition, there was a Director of Research with a staff of ten.

In mid-1974 a Technical Activities division was formed to combine technical and research functions, and take the day-to-day running of research projects away from the Board members (FASB Status Report [28 May 1974]). Later changes resulted in a Research and Technical Activities staff to provide the necessary back-up. Consisting of 40–50 people, the RTA is responsible, as were its predecessors, for much basic research, for the preparation of proposals for discussion and of later documents for publication, and for the administrative work necessary to keep control over the work of the various working bodies of the FAF/FASB/FASAC.

Heading the RTA is a Director (who has equal status with FASB members) and his assistant. Additionally there are two Senior Technical Advisors, plus a number of project managers, the latter being assigned to lead work on individual topics.

Interrelationship of the bodies

The way in which the three main bodies within the FAF structure interrelate is shown in Figure 18. The importance of these relationships are examined in some detail in the sections in Chapter 4 dealing with power relationships and lobbying.

Later developments

The role of the FAF/FASB/FASAC was initially seen as confined to the private sector. During the CF project, however, attention also focused on nonbusiness or not-for-profit organisations and the governmental

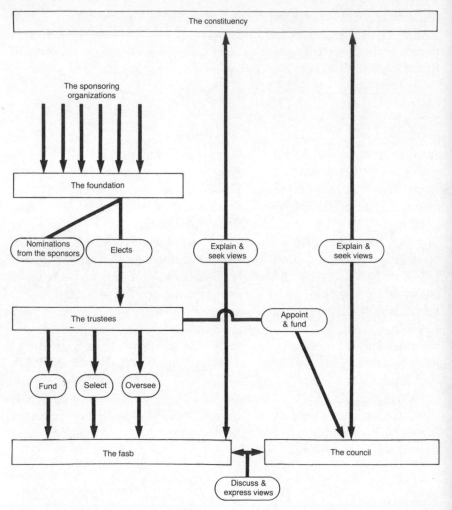

Figure 18 Interrelationship of FAF, FASB and FASAC

sector. In 1979 this interest broadened to include discussion of whether 'an improved structure for setting standards of financial accounting and reporting for state and local government' (but not federal government) could be developed (FAF Annual Report [1983, p. 3]).

Initially the discussion centred on whether the proposed Governmental Accounting Standards Board (GASB) should be separate from or linked to the FAF. Eventually GASB (and GASAC) came to be constituted as bodies parallel to FASB and FASAC, with their jurisdiction covering activities and transactions of state and local governmental

entities: FASB pronouncements apply to all other entities. In doing this, GASB succeeded the National Council on Governmental Accounting as the designated standard setting authority in this sector (FASB Annual Report [1984, p. 5]).

GASB differs from FASB in having only five members, who are unpaid. They also are appointed for five-year terms by the FAF trustees, but only after approval by GASAC, the members of which are nominated by various interested organisations.

As with the FASB, a permanent staff working under a full time chairman and a Director of Research was established. In January 1987, however, a new joint administrative structure supporting both FASB and GASB was set up (*Journal of Accountancy* [January 1987, p. 26]), i.e. the administration is run jointly, but RTA separately.

When GASB statements have been issued, state and local government bodies will be expected to follow them: if no such pronouncements exist but there is a relevant FASB statement, this applies. However, potential for conflict existed, particularly as GASB is developing a CF of its own: similar entities, e.g., hospitals or schools, could have been subject to different accounting regimes depending upon their legal status. However, the jurisdiction of the two standard setting bodies has been resolved, with FASB rules dominating for colleges and health care facilities unless they are government entities and their governing boards opt to apply GASB rules.

Financing

The financial structure of the FAF/FASB/FASAC/GASB is so organised as to preclude the charge of excessive influence by suppliers of finance. (Of course, under the APB financing came solely from the AICPA, so at least any charges were directed in only one direction.) Under the new structure, the trustees of the FAF have the responsibility to raise funds and they have been successful in this task.

Two main sources of funds exist: sales of publications, and donations by interested parties. Each contributes approximately half of total funds. Of the donated part, about 80 per cent comes from the large accounting firms, mostly through the Accounting Research Association of the AICPA, the remainder from user groups and others (Miller and Redding [1986, p. 34]). No single contribution of more than the lesser of $50,000 or 1 per cent of the budget can be accepted under FAF by-

laws (*Journal of Accountancy* [August 1977, p. 14]). The main expenses are salaries.

The importance of finance can be appreciated if one considers the cost of the CF project. Whilst joint cost allocations make an accurate assessment difficult, if the estimate (by Pacter [1981], p. 7]) is accurate that, for periods, 40 per cent of FASB resources was devoted to the project, the total bill certainly runs into tens of millions of dollars.

Due process

Due process refers to the procedures adopted by the FASB in performing its role of setting standards, etc. The process itself is based on the Federal Administrative Procedure Act of 1946 (Swieringa [1988]), and is described in some detail by Miller and Redding [1988, pp. 56–75] and van Riper [1987].

This was also the process that was used for the development of the CF project although, as pointed out by the above-mentioned writers, not all stages need be, nor were, adopted for each topic considered by the FASB. This is evident from an examination of the CF project's output.

Certain specific features of the interrelationship of the due process and CF project are worthy of note:

(a) the due process as set out above reflects a reactive approach to pre-existing problems, whereas the CF project, albeit reactive in a wider sense, was proactive, in that the production of a coherent CF would, it was felt, pre-empt many later disputes. Also, the process above envisages a fairly quick identification, discussion and solution of a given problem: the CF was always seen as a longer-term project (although its eventual length was greater than expected).

(b) a recommendation of the Agenda Advisory Committee of the FASAC is sufficient (although not necessary) for an item to be discussed by the FASB. As a result, it has had the potential to exert influence over the direction of the FASB's work.

(c) van Riper [1987, p. 132] indicates that for a topic to be added to the FASB agenda, it must have certain characteristics, these being:
 (i) pervasiveness of the problem;
 (ii) likelihood that one or more alternative solutions that will improve financial reporting can be developed;
 (iii) likelihood that a technically sound solution can be developed, and
 (iv) the extent to which an improved solution is likely to be accepted generally, and the extent to which addressing a particular subject (or not addressing it) might cause others to act, e.g. the SEC or Congress.

Again the shadow of the SEC is seen to loom over the work of standard setting.

(d) initially, meetings of the FASB were held behind closed doors. As a result of the 1977 Structure Committee report, most meetings of the FAF/FASB/FASAC were made open to the public (*Journal of Accountancy* [August 1977, p. 14]). Although a positive step on grounds of accountability and the process being seen to work, it has been suggested by a number of observers that the very openness resulted in a cautious, even defensive approach from Board members. Conscious that their every word might be interpreted as expressing strong support or dissent from a given viewpoint, they 'played safe' and became entrenched in positions that they might have wished to move from. This became evident in the Recognition and Measurement phase of the project – see Chapter 4.

(e) public hearings are held on important topics and position papers filed beforehand. Van Riper [1987, p. 134] notes that these are analysed by FASB staff, as are the financial statements of the companies represented. This is done to understand the economic consequences of the possible outcomes to the companies and hence divine any special pleading – a point of importance during the development of the CF, particularly at the stage considering recognition and measurement.

(f) variations from the 'normal' sequence of documentary output, i.e. DM/ITC → ED → Statement, can be interpreted as reflecting disagreement amongst the Board members, heavy lobbying against an initial position, or similar. On a number of occasions, the issuance of more than one ED on a topic within the CF occurred, suggesting such problems.

Summary

This appendix has described the initial FAF/FASB/FASAC organisation and later changes to it. These constitute the environment within which the CF was formed, as examined in Chapters 2, 3 and 4.

Appendix 2 Full list of Conceptual
Framework Documents

Date of issue	Document type	Title	Abbreviation used in study	Format	Pages	Paragraphs
6 June 1974	DM	Consideration of the Report of the Study Group on the Objectives of Financial Statements	CONSIDERA-TIONS	11 × 8	20	47 + 21 in App.
2 Dec. 1976	DM	Scope and Implications of the Conceptual Framework Project	S&I	11 × 8	24	Unnumbered
2 Dec. 1976	DM	Tentative Conclusions on Objectives of Financial Statements of Business Enterprises	TC	11 × 8	78	196 + 36 in App.
2 Dec. 1976	DM	Elements of Financial Statements and Their Measurement	DM – EL	11 × 8	360	576 + App. + Tables
29 Dec. 1977	ED	Objectives of Financial Reporting and Elements of Financial Statements of Business Enterprises	ED – OBJ&EL	9 × 6	44	75 + 25 in App.
May 1978	RR	Financial Accounting in Nonbusiness Organizations: An Exploratory Study of Conceptual Issues	RR – NBO	9 × 6	205	Unnumbered
May 1978	RR	An Overview of the Research Report on Financial Accounting in Nonbusiness Organizations	RR – OVER	9 × 6	7	16

Date	Type	Title	Code	Size	No.	Paragraphs
15 June 1978	DM	Objectives of Financial Reporting by Nonbusiness Organizations	DM – NBO	11 × 8	10	Unnumbered
July 1978	RR	Economic Consequences of Financial Accounting Standards, Selected Papers	RR – EC	9 × 6	278	Unnumbered
Nov. 1978	SFAC	Objectives of Financial Reporting by Business Enterprises	SFAC No. 1	9 × 6	31	56 + 7 in App.
31 July 1979	DM	An Analysis of Issues Related to Reporting Earnings	DM – RE	11 × 8	105	243
9 Aug. 1979	ED	Qualitative Characteristics: Criteria for Selecting and Evaluating Financial Accounting and Reporting Policies	ED – QC	9 × 6	53	123 + 7 in App.
28 Dec. 1979	ED	Elements of Financial Statements of Business Enterprises	ED – EL	9 × 6	99	83 + 139 in App.
14 Mar. 1980	ED	Objectives of Financial Reporting by Nonbusiness Organizations	ED – NBO	9 × 6	27	50 + 13 in App.
12 May 1980	ITC	Financial Statements and Other Means of Financial Reporting	ITC – FS	11 × 8	49	Unnumbered
May 1980	SFAC	Qualitative Characteristics of Accounting Information	SFAC No. 2	9 × 6	73	144 + 26 in App.

Date of issue	Document type	Title	Abbreviation used in study	Format	Pages	Paragraphs
Nov. 1980	RR	Reporting of Service Efforts and Accomplishments	RR – SE&A	9 × 6	114	Unnumbered
Dec. 1980	SFAC	Elements of Financial Statements of Business Enterprises	SFAC No. 3	9 × 6	80	89 + 91 in App.
Dec. 1980	SFAC	Objectives of Financial Reporting by Nonbusiness Organizations	SFAC No. 4	9 × 6	37	56 + 66 in App.
15 Dec. 1980	DM	An Analysis of Issues Related to Reporting Funds Flows, Liquidity, and Financial Flexibility	DM – RFF	11 × 8	141	320 + App.
Dec. 1980	RR	Recognition of Contractual Rights and Obligations: An Exploratory Study of Conceptual Issues	RR – CONT	9 × 6	92	Unnumbered
Jan. 1981	RR	Survey of Present Practices in Recognizing Revenues, Expenses, Gains, and Losses	RR – SURV	9 × 6	165	Unnumbered
16 Nov. 1981	ED	Reporting Income, Cash Flows and Financial Position of Business Enterprises	ED – RI	9 × 6	74	54 + 133 in App.

July 1982	RR	Recognition in Financial Statements: Underlying Concepts and Practical Conventions	RR – J&S	9 × 6	267	Unnumbered
7 July 1983	ED	Proposed Amendments to FASB Concepts Statements 2 and 3 to Apply Them to Nonbusiness Organizations	ED – EL (NBO)	9 × 6	106	120 + 102 in App.
30 Dec. 1983	ED	Recognition and Measurement in Financial Statements of Business Enterprises	ED – R&M	9 × 6	27	78 + 3 in App.
Dec. 1984	SFAC	Recognition and Measurement in Financial Statements of Business Enterprises	SFAC No. 5	9 × 6	40	91 + 17 in App.
18 Sept. 1985	ED	Elements of Financial Statements	ED – EL (REV)	9 × 6	91	150 + 102 in App.
Dec. 1985	SFAC	Elements of Financial Statements	SFAC No. 6	9 × 6	93	152 + 103 in App.

Series on inflation accounting

Date of issue	Document type	Title	Abbreviation	Format	Pages	Paragraphs
15 Feb. 1974	DM	Reporting the Effects of GPL Changes in Financial Statements	DM – GPL	11 × 8	19	Unnumbered
31 Dec. 1974	ED	Financial Reporting in Units of General Purchasing Power	ED – GPP	9 × 6	95	111 inc. App.
May 1977	RR	Field Tests on Financial Reporting in Units of GPP	RR – FT	11 × 8	81	Unnumbered
28 Dec. 1978	ED	Financial Reporting and Changing Prices	ED – FR&CP	9 × 6	72	107 inc. App.
2 Mar. 1979	ED	Constant Dollar Accounting	ED – CON. $	9 × 6	24	16'''
June 1979	RR	Financial Reporting and Changing Prices: The Conference	CONF 1	9 × 6	242	Unnumbered
Sept. 1979	SFAS	Financial Reporting and Changing Prices	SFAS No. 33	9 × 6	127	241 inc. App.
Dec. 1979	Sp.R	Illustrations of Financial Reporting and Changing Prices	ILLUS	9 × 6	112	Unnumbered
21 Apr. 1980	ED	Financial Reporting and Changing Prices: Specialised Assets	ED – SP.AS.	9 × 6	57	115 inc. App.
Oct. 1980	SFAS	Financial Reporting and Changing Prices Specialised Assets: Mining & Oil & Gas	SFAS No. 39	9 × 6	30	58'''

Nov. 1980	SFAS	Financial Reporting and Changing Prices Specialised Assets: Timber	SFAS No. 40	9 × 6	11	27'''
Nov. 1980	SFAS	Financial Reporting and Changing Prices Specialised Assets: Real Estate	SFAS No. 41	9 × 6	13	25'''
Nov. 1980	Sp.R	Examples of the Use of FASB Statement No. 33, Financial Reporting and Changing Prices	EGS	11 × 8	167	Unnumbered
9 Feb. 1981	ED	Financial Reporting and Changing Prices: Motion Picture Films	ED – FILMS	9 × 6	3	8
Mar. 1981	SFAS	Financial Reporting and Changing Prices: Motion Picture Films	SFAS No. 46	9 × 6	3	9
June 1981	ITC	Financial Reporting and Changing Prices: The Need for Research	ITC – FR&CP	11 × 8	10	39
Dec. 1981	ED	Financial Reporting and Changing Prices: Foreign Currency Translation	ED – FX	9 × 6	Un-available	
Mar. 1982	RR	Financial Reporting and Changing Prices: A Review of Empirical Research	RR – EMP	9 × 6	7	Unnumbered
19 Aug. 1982	ED	Financial Reporting and Changing Prices: Foreign Currency Translation	ED – FX(rev)	9 × 6	39	87 inc. App.

Date of issue	Document type	Title	Abbreviation	Format	Pages	Paragraphs
1983	Sp.R	Research on Financial Reporting and Changing Prices	CONF 2	11 × 8	178	Unnumbered
Nov. 1983	RR	Incremental information Content of SFAS 33 Disclosures	RR – INC	9 × 6	108	"
Dec. 1983	ITC	Supplementary Disclosures about the Effects of Changing Prices	ITC – SUPP	9 × 6	22	70 + App.
Oct. 1984	ED	Financial Reporting and Changing Elimination of Certain Disclosures	ED – ELIM	9 × 6	3	8 inc. App.
Nov. 1984	SFAS	Financial Reporting and Changing Prices: Elimination of Certain Disclosures	SFAS No. 82	9 × 6	4	10 inc. App.
Dec. 1984	ED	Financial Reporting and Changing Prices: Current Cost Information	ED – CCI	9 × 6	81	124 inc. App.
Sept. 1986	ED	Financial Reporting and Changing Prices	ED – END	9 × 6	15	27 inc. App.

Appendix 3 List of Conceptual Framework Documents by 'Family'

Date of issue	Document type	Title	Abbreviation used in study	Format	Pages	Paragraphs
Series on objectives						
6 June 1974	DM	Considerations of the Report of the Study Group on the Objectives of Financial Statements	CONSIDE-RATIONS	11 × 8	20	47 + 21 in App.
2 Dec. 1976	DM	Tentative Conclusions on Objectives of Financial Statements of Business Enterprises	TC	11 × 8	78	196 + 36 in App.
29 Dec. 1977	ED	Objectives of Financial Reporting and Elements of Financial Statements of Business Enterprises	ED – OBJ&EL	9 × 6	44	75 + 25 in App.
Nov. 1978	SFAC	Objectives of Financial Reporting by Business Enterprises	SFAC No. 1	9 × 6	31	63

Series on qualitative characteristics

6 June 1974	DM	Considerations of the Report of the Study Group on the Objectives of Financial Statements	CONSIDERA-TIONS	11 × 8	20	47 + 21 in App.
2 Dec. 1976	DM	Tentative Conclusions on Objectives of Financial Statements of Business Enterprises	TC	11 × 8	78	196 + 36 in App.
2 Dec. 1976	DM	Elements of Financial Statements and Their Measurement (Part II)	DM – EL	11 × 8	360	576 + App. + Tables
9 Aug. 1979	ED	Qualitative Characteristics: Criteria for Selecting and Evaluating Financial Accounting and Reporting Policies	ED – QC	9 × 6	53	123 + 7 in App.
May 1980	SFAC	Qualitative Characteristics of Accounting Information	SFAC No. 2	9 × 6	73	144 + 26 in App.

Date of issue	Document type	Title	Abbreviation used in study	Format	Pages	Paragraphs
Series on elements						
2 Dec. 1976	DM	Elements of Financial Statements and Their Measurement (Part I)	DM – EL	11 × 8	360	576 + App.
29 Dec. 1977	ED	Objectives of Financial Reporting and Elements of Financial Statements of Business Enterprises	ED – OBJ&EL	9 × 6	44	75 + 25 in App.
28 Dec. 1979	ED	Elements of Financial Statements of Business Enterprises	ED – EL	9 × 6	99	83 + 139 in App.
Dec. 1980	SFAC	Elements of Financial Statements of Business Enterprises	SFAC No. 3	9 × 6	80	89 + 91 in App.

Series on nonbusiness organisations

May 1978	RR	Financial Accounting in Nonbusiness Organizations: An Exploratory Study of Conceptual Issues	RR – NBO	9 × 6	205	Unnumbered
May 1978	RR	An overview of the Research Report on Financial Accounting in Nonbusiness Organizations	RR – OVER	9 × 6	7	16
15 June 1978	DM	Objectives of Financial Reporting by Nonbusiness Organizations	DM – NBO	11 × 8	10	Unnumbered
14 Mar. 1980	ED	Objectives of Financial Reporting by Nonbusiness Organizations	ED – NBO	9 × 6	27	50 + 13 in App.
Nov. 1980	RR	Reporting of Service Efforts and Accomplishments	RR – SE&A	9 × 6	114	Unnumbered
Dec. 1980	SFAC	Objectives of Financial Reporting by Nonbusiness Organizations	SFAC No. 4	9 × 6	37	56 + 66 in App.

Date of issue	Document type	Title	Abbreviation used in study	Format	Pages	Paragraphs
Series on recognition and measurement, etc.						
2 Dec. 1976	DM	Elements of Financial Statements and Their Measurement (Part III)	DM – EL	11 × 8	360	576 + App. + Tables
31 July 1979	DM	An Analysis of Issues Related to Reporting Earnings	DM – RE	11 × 8	105	243
12 May 1980	ITC	Financial Statements and Other Means of Financial Reporting	ITC – FS	11 × 8	49	Unnumbered
15 Dec. 1980	DM	An Analysis of Issues Related to Reporting Funds Flows, Liquidity, and Financial Flexibility	DM – RFF	11 × 8	141	320 + App.
Dec. 1980	RR	Recognition of Contractual Rights and Obligations: An Exploratory Study of Conceptual Issues	RR – CONT	9 × 6	92	Unnumbered

Jan. 1981	RR	Survey of Present Practice in Recognizing Revenues, Expenses, Gains, and Losses	RR – SURV	9 × 6	165	Unnumbered
Nov. 1981	ED	Reporting Income, Cash Flows and Financial Position of Business Enterprises	ED – RI	9 × 6	74	54 + 133 in App.
July 1982	RR	Recognition in Financial Statements: Underlying Concepts and Practical Conventions	RR – J&S	9 × 6	267	Unnumbered
30 Dec. 1983	ED	Recognition and Measurement in Financial Statements of Business Enterprises	ED – R&M	9 × 6	27	78 + 3 in App.
Dec. 1984	SFAC	Recognition and Measurement in Financial Statements of Business Enterprises	SFAC No. 5	9 × 6	40	91 + 17 in App.

Date of issue	Document type	Title	Abbreviation used in study	Format	Pages	Paragraphs
Series on updating SFAC No. 3						
7 July 1983	ED	Proposed Amendments to FASB Concepts Statements 2 and 3 to Apply Them to Nonbusiness Organizations	ED – EL (NBO)	9 × 6	106	120 + 102 in App.
18 Sept. 1985	ED	Elements of Financial Statements	ED – EL (REV)	9 × 6	91	150 + 102 in App.
Dec. 1985	SFAC	Elements of Financial Statements	SFAC No. 6	9 × 6	93	152 + 103 in App.
Miscellaneous documents						
2 Dec. 1976	DM	Scope and Implications of the Conceptual Framework Project	S&I	11 × 8	24	Unnumbered
June 1978	RR	Economic Consequences of Financial Accounting Standards, Selected Papers	RR – EC	9 × 6	278	Unnumbered

Appendix 4 Dates of Service of FASB Board Members

	Name	Appointed	Retired/left
1	Marshall S. ARMSTRONG	1 Nov. 1972	31 Dec. 1977
2	John W. QUEENAN	1. Mar. 1973	31 Dec. 1974
3	Donald J. KIRK	1 Mar. 1973	31 Dec. 1986
4	Walter P. SCHUETZE	1 Mar. 1973	30 Jun. 1976
5	Arthur L. LITKE	1 Apr. 1973	31 Dec. 1977
6	Robert T. SPROUSE	1 Apr. 1973	31 Dec. 1985
7	Robert E. MAYS	1 Jul. 1973	31 Dec. 1977
8	Oscar S. GELLEIN	1 Jan. 1975	31 Dec. 1978
9	Ralph E. WALTERS	1 Apr. 1977	31 Dec. 1983
10	David MOSSO	1 Jan. 1978	31 Dec. 1987
11	Robert A. MORGAN	1 Feb. 1978	31 Dec. 1982
12	John W. MARCH	10 Jan. 1978	31 Dec. 1984
13	Frank E. BLOCK	Mar. 1979	31 Dec. 1985
14	Victor H. BROWN	1 Jan. 1983	Current member
15	Raymond C. LAUVER	1 Jan. 1984	31 Dec. 1990
16	Arthur R. WYATT	1 Jan. 1985	30 Sep. 1987
17	C. Arthur NORTHROP	1 Jan. 1986	Current member
18	Robert J. SWIERINGA	1 Jan. 1986	Current member
19	Dennis J. BERESFORD	1 Jan. 1987	Current chairman
20	James J. LEISENRING	1 Oct. 1987	Current member
21	A. Clarence SAMPSON	1 Jan. 1988	Current member
22	James ANANIA	1 Jan. 1991	Current member

Bibliography

AAA [1936] 'A Tentative Set of Accounting Principles Affecting Corporate Reports' *The Accounting Review* Vol. XI (June 1936) pp. 187–91

AAA [1940] see Paton and Littleton [1940]

AAA [1966] *A Statement of Basic Accounting Theory* American Accounting Association (1966)

AAA [1977] *Statement on Accounting Theory and Theory Acceptance* American Accounting Association (1977)

AARF [1987] *Proposed Statements of Accounting Concepts ED 42* Australian Accounting Research Foundation (December 1987)

AARF [1988] *Proposed Statements of Accounting Concepts ED 46* Australian Accounting Research Foundation (April 1988)

AARF [1990] *Proposed Statements of Accounting Concepts ED 51* Australian Accounting Research Foundation (August 1990)

ACCOUNTANCY [1989] 'ASC to use IASC's work' *Accountancy* (June 1989) p. 9

ACCOUNTANCY AGE [1991] 'Call for ASB Reform by Hundred Group' *Accountancy Age* (17 October 1991), p. 6

ACCOUNTING REVIEW [1971] 'Report of the Committee on Establishment of an Accounting Commission' *Accounting Review* Vol. XLVI No. 3 (July 1971)

AGRAWAL, Surrenda P. [1987] 'On the Conceptual Framework of Accounting' *Journal of Accounting Literature* Vol. 6 (1987) pp. 165-78

AIA [1938] see Sanders, Hatfield and Moore [1938]

AICPA [1961] Accounting Research Study No. 1, see Moonitz, M. (1961)

AICPA [1962] Accounting Research Study No. 3, see Sprouse and Moonitz (1962)

AICPA [1965] Accounting Research Study No. 7, see Grady (1965)

AICPA [1970] *Statement of the Accounting Principles Board No. 4: Basic Concepts and Accounting Principles Underlying Financial Statements of Business Enterprises* AICPA (APB) (October 1970)

AICPA [1972] *Establishing Financial Accounting Standards: Report of the Study on Establishment of Accounting Principles* (The Wheat Report) AICPA (March 1972)

AICPA [1973] *Objectives of Financial Statements: Report of the Study Group on the Objectives of Financial Statements* (The Trueblood Report) AICPA

(October 1973)

ANDERSON, James A. [1982] 'A Discussion of "Coalition Formation in the APB and the FASB"' (see Newman [1981b]) *Accounting Review* Vol. LVII No. 1 (January 1982) pp. 190–9

ANDREWS, Wesley T. and Charles H. SMITH 'The Economic Consequences of Financial Accounting Information' *The Chartered Accountant in Australia* (April 1977) pp. 43–5

ANTHONY, Robert N. [1963] 'Showdown on Accounting Principles' *Harvard Business Review* (May – June 1963) pp. 99–106

ANTHONY, Robert N. [1983] *Tell It Like It Was: A Conceptual Framework for Financial Accounting* Irwin (1983)

ANTHONY, Robert N. [1987] 'We Don't Have The Accounting Concepts We Need' *Harvard Business Review* (Jan. – Feb. 1987) pp. 75–83

ANTHONY, Robert N. [1988] Interview with the author, 26 September 1988

ARCHER, Simon [1981] *Accounting, Jurisprudence and 'Soft Systems' Methodology* Lancaster Accounting and Finance Working Paper Series No. 23, University of Lancaster (1981)

ARMSTRONG, Marshall S. [1969] 'Some Thoughts on Substantial Authoritative Support' *Journal of Accountancy* Vol. 127 (April 1969) pp. 44–50

ARROW, Kenneth [1963] *Social Choice and Individual Values* Wiley (1963)

ARTHUR ANDERSEN & CO. [1972] *Cases in Public Accounting Practice (Volume 11): AICPA Study on Establishment of Accounting Principles* Arthur Andersen & Co. (1972)

ASR [1938], see Securities and Exchange Commission [1938]

BACHRACH, Peter and Morton S. BARATZ [1962] 'The Two Faces of Power' *American Political Science Review* 56 (November 1962) pp. 947–52

BACHRACH, Peter and Morton S. BARATZ [1963] 'Decisions and Nondecisions: An Analytical Framework *American Political Science Review* 57 (September 1963) pp. 641–51

BACHRACH, Peter and Morton S. BARATZ [1970] *Power and Poverty: Theory and Practice* Oxford University Press (1970)

BARTHOLOMEW, D. J. and E. E. BASSETT [1971] *Let's Look at the Figures: The Quantitative Approach to Human Affairs* Penguin (1971)

BAXTER, W. T. [1962] 'Recommendations on Accounting Theory' in Baxter and Davidson [1962]

BAXTER, W. T. and S. DAVIDSON *Studies in Accounting Theory* Sweet & Maxwell (1962)

BEAVER, William H. [1989] *Financial Reporting: An Accounting Revolution* Prentice-Hall, 2nd ed. (1989)

BEAVER, William H. and Joel S. DEMSKI [1974] 'The Nature of Financial Accounting Objectives: A Summary and Synthesis' *Supplement to the Journal of Accounting Research* (1974) pp. 170–87

BELKAOUI, Ahmed [1985] *Accounting Theory* Harcourt Brace Jovanovich (2nd ed.) (1985)

BENSTON, George J. [1980] 'The Market for Accounting Services: Demand, Supply and Regulation' *The Accounting Journal* Vol. II No. 1 (Winter 1979–80) pp. 2–46

BENSTON, George J. [1981] 'Are Accounting Standards Necessary?' in Leach and Stamp (1981)

BRADSHAW, Alan [1976] 'A Critique of Steven Lukes' "Power: A Radical View"' *Sociology* 10 (10 January 1976) pp. 121–8

BRILOFF, Abraham J. [1972] *Unaccountable Accounting: Games Accountants Play* Harper & Row (1972)

BROMWICH, Michael [1980] 'The Possibility of Partial Accounting Standards' *Accounting Review* Vol. LV No. 2 (April 1980) pp.288–301

BROMWICH, Michael [1985] *The Economics of Accounting Standard Setting* Prentice-Hall/ICAEW (1985)

BROMWICH, Michael and Anthony HOPWOOD (eds.) [1983] *Accounting Standard Setting: An International Perspective* Pitman (1983)

BROWN, Paul R. [1981] 'A Descriptive Analysis of Select Input Bases of the Financial Accounting Standards Board' *Journal of Accounting Research* Vol. 19 No. 1 (Spring 1981) pp. 232–46

BUCHANAN, James M. and Gordon TULLOCK [1962] *The Calculus of Consent: Logical Foundations of Constitutional Democracy* University of Michigan Press (1962)

BURNS, Paul [1977] 'Deferred Tax Accounting – A Critique of ED 19' *Accountancy* (October 1977), pp. 80–4

BURTON, John C. [1973] 'The SEC and the Changing World of Accounting' *Journal of Contemporary Business* (Spring 1973), quoted in Kripke [1979]

BURTON, John C. [1982] 'The SEC and Financial Reporting: The Sand in the Oyster' *Journal of Accountancy* Vol. 154 (June 1982) pp. 34–48

BUSINESS WEEK [1976] Report in issue dated 26 January 1976, cited in Watts and Zimmerman [1986]

BUSINESS WEEK [1977] Report in issue dated 14 February 1977, cited in Watts and Zimmerman [1986]

CICA [1988] CICA Handbook Revisions – Release No. 59, Canadian Institute of Chartered Accountants (December 1988)

CAREY, John L. [1969] *The Rise of the Accounting Profession: From Technician to Professional 1896–1936* AICPA (1969)

CAREY, John L. [1970] *The Rise of the Accounting Profession: To Responsibility and Authority 1937–1969* AICPA (1970)

CARR, E. H. [1961] *What is History?* Penguin edition (1964)

CHAMBERS, Raymond J. [1976] 'The Possibility of a Normative Accounting Standard' *Accounting Review* Vol. LI No. 3 (July 1976) pp. 646–52

CHARTERED ACCOUNTANT IN AUSTRALIA [1973] 'FASB Chairman says Board has SEC Co-Operation' *Chartered Accountant in Australia* (July 1973) p. 52

CHECKLAND, Peter B. *Systems Thinking, Systems Practice* Wiley (1981)

CHRISTENSON, Charles [1983] 'The Methodology of Positive Accounting' *Accounting Review* Vol. LVIII No. 1 (January 1983) pp. 1–22

CLEGG, Stewart [1979] *The Theory of Power and Organization* Routledge & Kegan Paul (1979)

COLLINGWOOD, R. G. [1946] *The Idea of History* Oxford at the Clarendon Press (1946)

COULSON, Edmund [1988] Letter to Rholan E. Larson, President of the

Board of Trustees, Financial Accounting Foundation, dated 15 April 1988

CUSHING, Barry E. [1977] 'On the Possibility of Optimal Accounting Principles' *Accounting Review* Vol. LII No. 2 (April 1977) pp. 308–21

CYERT, Richard M. and Yuji IJIRI [1974] 'Problems of Implementing the Trueblood Objectives Report' *Supplement to the Journal of Accounting Research* (1974) pp. 29–42

DAHL, Robert A. [1957] 'The Concept of Power' *Behavioral Science* 2 (1957) pp. 201–5

DAHL, Robert A. [1958] 'A Critique of the Ruling Elite Model' *American Political Science Review* 52 (June 1958) pp. 463–9

DAHL, Robert A. [1961] *Who Governs? Democracy and Power in an American City* Yale University Press (1961)

DAVIS, Stanley W., Krishnagopal MENON and Gareth MORGAN [1982] 'The Images That Have Shaped Accounting Theory' *Accounting, Organizations and Society* Vol. 7 No. 4 (1982) pp. 307–18

DEBNAM, Geoffrey [1984] *The Analysis of Power: A Realist Approach* Macmillan (1984)

DEMSKI, Joel S. [1973] 'The General Impossibility of Normative Accounting Standards' *Accounting Review* Vol. XLVIII No. 4 (October 1973) pp. 718–23

DEMSKI, Joel S. [1974] 'Choice Among Financial Reporting Alternatives' *Accounting Review* Vol. XLIX No. 2 (April 1974) pp. 221–32

DEMSKI, Joel S. [1976] 'An Economic Analysis of the Chambers' Normative Standard' *Accounting Review* Vol. LI No. 3 (July 1976) pp. 653–6

DINGELL, John D. [1988] Letter to Davis S. Ruder, Chairman, SEC, dated 26 August 1988

DOPUCH, Nicholas and Shyam SUNDER [1980] 'FASB's Statements on Objectives and Elements of Financial Accounting: A Review' *Accounting Review* Vol. LV No. 1 (January 1980) pp. 1-21

DOWNS, Anthony [1957] *An Economic Theory of Democracy* Harper and Brothers (1957)

DYCKMAN, Thomas R. and Dale MORSE [1986] *Efficient Capital Markets and Accounting: A Critical Analysis* Prentice-Hall (1986)

ENVIRONMENT DIGEST [1988] 'US waste clean-up threatens bankruptcies' *Environment Digest* No. 13 (June 1988)

ETZIONI, Amitai [1968] *The Active Society* Free Press (1968)

FAF [1973] *Certificate of Incorporation/By Laws* Financial Accounting Foundation (1973)

FAF [1977] *The Structure of Establishing Financial Accounting Standards: Report of the Structure Committee, The Financial Accounting Foundation* Financial Accounting Foundation (April 1977)

FAF [1983] *Establishing Standards for Financial Reporting* The Annual Report of the FAF/FASB/FASAC (1983)

FAF [1984] *Establishing Standards for Financial Reporting* The Annual Report of the FAF/FASB/FASAC (1984)

FAF [1989] *The Structure for Establishing Financial Accounting Standards: Report of the Committee to Review Structure for Financial Accounting Standards* Financial Accounting Foundation (26 January 1989)

FASB [1974] 'Considerations of the Report of the Study Group on the

Objectives of Financial Statements' Financial Accounting Standards Board (1974)

FASB [1975] 'Accounting for the Translation of Foreign Currency Transactions and Foreign Currency Financial Statements' (SFAS No. 8) (October 1975)

FASB [1976a] 'Tentative Conclusions on Objectives of Financial Statements of Business Enterprises' Financial Accounting Standards Board (December 1976)

FASB [1976b] 'Scope and Implications of the Conceptual Framework Project' Financial Accounting Standards Board (December 1976)

FASB [1976c] 'Elements of Financial Statements and Their Measurement' Financial Accounting Standards Board (December 1976)

FASB [1977] 'Objectives of Financial Reporting and Elements of Financial Statements of Business Enterprises' Financial Accounting Standards Board (December 1977)

FASB [1978a] 'Financial Accounting in Nonbusiness Organizations: An Exploratory Study of Conceptual Issues' Financial Accounting Standards Board (May 1978)

FASB [1978b] 'An Overview of the Research Report on Financial Accounting in Nonbusiness Organizations' Financial Accounting Standards Board (May 1978)

FASB [1978c] 'Objectives of Financial Reporting by Nonbusiness Organizations' Financial Accounting Standards Board (June 1978)

FASB [1978d] 'Economic Consequences of Financial Accounting Standards, Selected Papers' Financial Accounting Standards Board (July 1978)

FASB [1978e] 'Objectives of Financial Reporting by Business Enterprises' (SFAC No. 1) Financial Accounting Standards Board (November 1978)

FASB [1979a] 'An Analysis of Issues Related to Reporting Earnings' Financial Accounting Standards Board (July 1979)

FASB [1979b] 'Qualitative Characteristics: Criteria for Selecting and Evaluating Financial Accounting and Reporting Policies' Financial Accounting Standards Board (August 1979)

FASB [1979c] 'Elements of Financial Statements of Business Enterprises' Financial Accounting Standards Board (December 1979)

FASB [1980a] 'Objectives of Financial Reporting by Nonbusiness Organizations' Financial Accounting Standards Board (March 1980)

FASB [1980b] 'Financial Statements and Other Means of Financial Reporting' Financial Accounting Standards Board (May 1980)

FASB [1980c] 'Qualitative Characteristics of Accounting Information' (SFAC No. 2) Financial Accounting Standards Board (May 1980)

FASB [1980d] 'Reporting of Service Efforts and Accomplishments' Financial Accounting Standards Board (November 1980)

FASB [1980e] 'Elements of Financial Statements of Business Enterprises' (SFAC No. 3) Financial Accounting Standards Board (December 1980)

FASB [1980f] 'Objectives of Financial Reporting by Nonbusiness Organizations' (SFAC No. 4) Financial Accounting Standards Board (December 1980)

FASB [1980g] 'An Analysis of Issues Related to Reporting Funds Flows, Liquidity, and Financial Flexibility' Financial Accounting Standards Board

(December 1980)

FASB [1980h] 'Recognition of Contractual Rights and Obligations: An Exploratory Study of Conceptual Issues' Financial Accounting Standards Board (December 1980)

FASB [1981a] 'Survey of Present Practices in Recognizing Revenues, Expenses, Gains, and Losses' Financial Accounting Standards Board (January 1981)

FASB [1981b] 'Reporting Income, Cash Flows and Financial Position of Business Enterprises' Financial Accounting Standards Board (November 1981)

FASB [1982] 'Recognition in Financial Statements: Underlying Concepts and Practical Conventions' Financial Accounting Standards Board (July 1982)

FASB [1983a] 'Proposed Amendments to FASB Concepts Statements 2 and 3 to Apply Them to Nonbusiness Organizations' Financial Accounting Standards Board (July 1983)

FASB [1983b] 'Recognition and Measurement in Financial Statements of Business Enterprises' Financial Accounting Standards Board (December 1983)

FASB [1984] 'Recognition and Measurement in Financial Statements of Business Enterprises' (SFAC No. 5) Financial Accounting Standards Board (December 1984)

FASB [1985a] 'Element of Financial Statements' Financial Accounting Standards Board (September 1985)

FASB [1985b] 'Element of Financial Statements' (SFAC No. 6) Financial Accounting Standards Board (December 1985)

FASB [1985c] 'Employers' Accounting for Pensions' (SFAS No. 87) Financial Accounting Standards Board (December 1985)

FASB [1987a] *Rules of Procedure* Financial Accounting Standards Board (January 1987)

FASB [1987b] 'Recognition of Depreciation by Not-for-Profit Organizations' (SFAS No. 93) Financial Accounting Standards Board (August 1987)

FASB [1987c] 'Statement of Cash Flows' (SFAS No. 95) Financial Accounting Standards Board (November 1987)

FASB [1987d] 'Accounting for Income Taxes' (SFAS No. 96) Financial Accounting Standards Board (December 1987)

FASB [1988] 'Accounting for Income Taxes – Deferral of the Effective Date of FASB Statement No. 96' (SFAS No. 100) Financial Accounting Standards Board (December 1988)

FASB [1989a] 'Statement of Cash Flows – Exemption of Certain Enterprises and Classification of Cash Flows from Certain Securities Acquired for Reseale' (SFAS No. 102) Financial Accounting Standards Board (February 1989)

FASB [1989b] 'Accounting for Income Taxes – Deferral of the Effective Date of FASB Statement No. 96' (SFAS No. 103) Financial Accounting Standards Board (December 1989)

FASB [1989c] 'Statement of Cash Flows – Net Reporting of Certain Cash Receipts and Cash Payments and Classification of Cash Flows from Hedging Transactions' (SFAS No. 104) Financial Accounting Standards Board (December 1989)

Accounting Standards Board (Various dates)

FASB [Various] *Status Report* (The Newsletter of the FASB) Financial Accounting Standards Board (Various dates)

FASB [Various] *Board Minutes* FASB (Weekly meetings)

FEYERABEND, Paul [1975] *Against Method: Outline of and Anarchist Theory of Knowledge* Verso edition (1978)

FOSTER, George [1978] *Financial Statement Analysis* Prentice-Hall (1978)

GARDINER, Patrick (ed.) [1974] *The Philosophy of History* Oxford University Press (1974)

GELLEIN, Oscar S. [1988] Interview with the author, 17 September 1988

GERBOTH, Dale L. [1972] '"Muddling Through" With the APB' *Journal of Accountancy* Vol. 133 (May 1972) pp. 42–9

GRADY, Paul *Inventory of Generally Accepted Accounting Principles for Business Enterprises* (Accounting Research Study No. 7) AICPA (1965)

HARING, John R. [1979] 'Accounting Rules and "The Accounting Establishment"' *Journal of Business* Vol. 52 No. 4 (1979) pp. 507–19

HARSANYI, John C. [1962] 'Measurement of Social Power in n-Person Reciprocal Power Situations' *Behavioral Science* 1 (1962) pp. 81–91

HEATH, Loyd C. [1988] 'The Conceptual Framework as Literature' *Accounting Horizons* Vol. 2 No. 2 (June 1988) pp. 100–4

HINES, Ruth D. [1986] *The Emerging Sociopolitical Research Program in Accounting: A Contribution to its Conceptual Foundation* Paper presented at the BAA Conference, Aberystwyth (April 1986)

HINES, Ruth D. [undated] *Why Won't the FASB Conceptual Framework Work?* Working paper (undated)

HOPE, Tony [1985] *Accounting Policy Making Research – Do We Know Where The Real Power Lies?* Tom Robinson Memorial Lecture, University of Edinburgh (March 1985)

HOPE, Tony and Rob GRAY [1982] 'Power and Policy Making: The Development of an R&D Standard' *Journal of Business Finance and Accounting* 9, 4 (1982) pp. 531–58

HORNGREN, Charles T. [1972] 'Accounting Principles: Private or Public Sector?' *Journal of Accountancy* Vol. 133 (May 1972) pp. 37–41

HORNGREN, Charles T. [1973] 'The Marketing of Accounting Standards' *Journal of Accountancy* Vol. 136 (October 1973) pp. 61–6

HUNTER, Floyd [1953] *Community Power Structure* University of North Carolina Press (1953)

HUSSEIN, Mohamed Elmuttasim and J. Edward KETZ [1980] 'Ruling Elites of the FASB: A Study of the Big Eight' *Journal of Accounting, Auditing and Finance* (1980) pp. 354–67

IASC [1988] *Proposed Statement: Framework for the Preparation and Presentation of Financial Statements* International Accounting Standards Committee (May 1988)

IASC [1989] *Framework for the Preparation and Presentation of Financial Statements* International Accounting Standards Committee (July 1989)

IJIRI, Yuji [1975] *Theory of Accounting Measurement* Studies in Accounting Research No. 10, American Accounting Association (1975)

IJIRI, Yuji [1982] 'On the Accountability-Based Conceptual Framework of

Accounting' *Journal of Accounting and Public Policy* Vol. 2 Pt. 2 (Summer 1982) pp. 75–81

JENSEN, Michael C. and William H. MECKLING [1976] 'Theory of the Firm: Managerial Behavior, Agency Costs, and Ownership Structure' *Journal of Financial Economics* 3 (1976) pp. 305–360

JOHNSON, L. Todd [1988] Interview with the author, 9 September 1988

JOHNSON, Steven B. and William F. MESSIER [1982] 'The Nature of Accounting Standards Setting: An Alternative Explanation' *Journal of Accounting, Auditing and Finance* Vol. 5 No. 3 (Spring 1982) pp. 195–213

JOHNSON, Steven B. and David SOLOMONS [1984] 'Institutional Legitimacy and the FASB' *Journal of Accounting and Public Policy* 3 (1984) pp. 165–83

JORDAN, William A. [1972] 'Producer Protection, Prior Market Structure and the Effects of Government Regulation' *Journal of Law and Economics* Vol. XV No. 1 (April 1972) pp. 151–76

JOURNAL OF ACCOUNTANCY [1971] 'Conference Recommends Study of Efforts to Establish Accounting Principles' *Journal of Accountancy* Vol. 131 (February 1971) p. 11

JOURNAL OF ACCOUNTANCY [1977] 'Board Meetings to be Opened to the Public' *Journal of Accountancy* Vol. 144 (August 1977) p. 14

JOURNAL OF ACCOUNTANCY [1981] 'FASB Vote Change Mulled' *Journal of Accountancy* Vol. 152 (December 1981) p. 114

JOURNAL OF ACCOUNTANCY [1982] 'FAF Retains Requirement of a Simple Majority Vote for Adoption of FASB Rules' *Journal of Accountancy* Vol. 153 (March 1982) p. 14

JOURNAL OF ACCOUNTANCY [1987] 'FAF Names La Gambina in Administrative Change' *Journal of Accountancy* Vol. 163 (January 1987) pp. 26–8

KAPLAN, Robert S. [1984] 'The Evolution of Management Accounting' *Accounting Review* Vol. LIX No. 3 (July 1984) pp. 390–418

KEELING, Richard [1988] Interview with the author, 12 October 1988

KELLY-NEWTON, Lauren [1980] *Accounting Policy Formulation: The Role of Corporate Managers* Addison-Wesley (1980)

Re KINGSTON COTTON MILLS (No. 2) case [1896] 2 Chancery 279 (1896)

KIRK, Donald J. [1988] Interview with the author, 29 September 1988

KRIPKE, Homer [1979] *The SEC and Corporate Disclosure: Regulation in Search of a Purpose* Law and Business (1979) reprinted in Zeff and Keller (1985)

KUHN, Thomas S. [1970] *The Structure of Scientific Revolutions* (2nd ed.) University of Chicago Press (1970)

LAKATOS, Imre [1970] *Falsification and the Methodology of Scientific Research Programs*, pp. 91–196 of Lakatos and Musgrave [1970]

LAKATOS, Imre and Alan MUSGRAVE (eds.) [1970] *Criticism and the Growth of Knowledge* Cambridge University Press (1970)

LEACH, Ronald and Edward STAMP (eds.) [1981] *British Accounting Standards: The First Ten Years* Woodhead Faulkner (1981)

LIEBTAG, Bill [1987] 'FASB on Income Taxes: Complexity, Dispute Still Mark Project' *Journal of Accountancy* Vol. 163 (March 1987) pp. 80–4

LINDBLOM, Charles E. 'The Science of "Muddling Through"' *Public Administration Review* Vol. XIX No. 2 (1959) cited in Archer [1982]

LOOMIS, Carol J. [1988] 'Will "FASBEE" Pinch Your Bottom Line?' *Fortune* (19 December 1988)

LOVEJOY, Arthur O. [1959] 'Present Standpoints and Past History' *Journal of Philosophy* (1939), reprinted as pp. 173–87 of Meyerhoff, H. (1959)

LUCAS, Timothy S. [1987] 'Financial Reporting Standards – Pensions as a Case Study' Text of speech given at Rice University (1987)

LUKES, Steven [1974] *Power: A Radical View* Macmillan (1974)

LYAS, Colin [1984] 'Philosophers and Accountants' *Philosophy* 59 (1984) pp. 99–110

MAUTZ, Robert K. [1988] Interview with the author, 15 September 1988

MEDAWAR, Peter [1984] *Pluto's Republic* Oxford University Press (1984)

MERELMAN, Richard M. [1968] 'On the Neo-Elitist Critique of Community Power' *American Political Science Review* 62 (1968) pp. 451–60

MEYER, Philip E. [1974] 'The APB's Independence and Its Implications for the FASB' *Journal of Accounting Research* Vol. 12 No. 1 (1974) pp. 188–96

MEYERHOFF, H. (ed.) [1959] *The Philosophy of History in Our Time* Doubleday Anchor (1959)

MILLER, Paul B. W. [1988] Interview with the author, 16 September 1988

MILLER, Paul B.W. and Rodney REDDING [1988] *The FASB: The People, The Process, and The Politics* Irwin (1988)

MILLS, C. Wright [1956] *The Power Elite* Oxford University Press (1956)

MITNICK, Barry M. [1980] *The Political Economy of Regulation: Creating Designing, and Removing Regulatory Forms* Columbia University Press (1980)

MOONITZ, Maurice [1961] *The Basic Postulates of Accounting* (Accounting Research Study No. 1) AICPA (1961)

MOORE, Thomas G. [1961] 'The Purpose of Licensing' *Journal of Law and Economics* Vol. IV (1961) pp. 93–117

NEWMAN, D. Paul [1981a] 'An Investigation of the Distribution of Power in the APB and FASB' *Journal of Accounting Research* Vol. 19 No. 1 (Spring 1981) pp. 247–62

NEWMAN, D. Paul [1981b] 'Coalition Formation in the APB and the FASB: Some Evidence on the Size Principle' *Accounting Review* Vol. LVI No. 4 (October 1981) pp. 897–909

NEWMAN, D. Paul [1982] 'The SEC's Influence on Accounting Standards: The Power of the Veto' *Supplement to the Journal of Accounting Research* (1981) pp. 134–73

OLSON, Mancur [1965] *The Logic of Collective Action: Public Goods and the Theory of Groups* Harvard University Press (1965)

PACTER, Paul [1981] 'What's the FASB up to these days?' *Directors and Boards* (Winter 1981) pp. 7–16

PATON, William A. and A. C. LITTLETON [1940] *An Introduction to Corporate Accounting Standards* AAA (January 1940)

PATTON, James M. [1980] 'Analysis of FASB Voting Patterns' University of Pittsburgh Working Paper No. 388 (1980)

PEARSON, Michael A., John H. LINDGREN and Buddy L. MEYERS [1979] 'A Preliminary Analysis of AudSEC Voting Patterns' *Journal of Accounting,*

Auditing and Finance Vol. 2 No. 2 (Winter 1979) pp. 122–34

PEASNELL, Kenneth V. [1978] 'Statement of Accounting Theory and Theory Acceptance' *Accounting and Business Research* Vol. 8 (Summer 1978) pp. 217–25

PEASNELL, Kenneth V. [1982] 'The Function of a Conceptual Framework for Corporate Financial Reporting' *Accounting and Business Research* Vol. 12 (Autumn 1982) pp.243–56

PELTZMAN, Sam [1976] 'Towards a More General Theory of Regulation' *Journal of Law and Economics* Vol. 19 (1976) pp. 211–40

POLSBY, Nelson W. [1963] *Community Power and Political Theory* Yale University Press (1963)

POPPER, Karl R. *The Logic of Scientific Discovery* Hutchinson (1959)

POSNER, Richard A. [1974] 'Theories of Economic Regulation' *Bell Journal of Economics and Management Science* Vol. 5 Pt. 2 (August 1974) pp. 335–58

POWER, Michael [1984] *Do We Require A Conceptual Framework For Accounting?* Unpublished working paper (1984)

PURO, Marsha [1984] 'Audit Firm Lobbying Before the FASB: An Empirical Study' *Journal of Accounting Research* Vol. 22 No. 2 (1984) pp. 624–46

PURO, Marsha [1985] 'Do Large Accounting Firms Collude in the Standards-Setting Process' *Journal of Accounting, Auditing and Finance* Vol. 8 No. 3 (Spring 1985) pp. 165–77

RAPPAPORT, Alfred [1977] 'Economic Impact of Accounting Standards – Implications for the FASB' *Journal of Accountancy* Vol. 143 (May 1977) pp. 89–98

RAVETZ, Jerry R. [1971] *Scientific Knowledge and Its Social Problems* Oxford University Press (1971)

ROCKNESS, Howard O. and Loren A. Nikolai [1977] 'An Assessment of APB Voting Patterns' *Journal of Accounting Research* Vol. 15 No. 1 (1977) pp. 154–67

SANDERS, Thomas Henry, Henry Rand HATFIELD and Underhill MOORE [1938] *A Statement of Accounting Principles* AIA (1938)

SECURITIES AND EXCHANGE COMMISION (SEC) [1938] *Accounting Series Release No. 4* 'Administrative Policy on Financial Statements' (25 April 1938)

SELTO, Frank H. and Hugh D. GROVE [1982] 'Voting Power Indices and the Setting of Financial Accounting Standards: Extensions' *Journal of Accounting Research* Vol. 20 No. 2 (Autumn 1982) pp. 676–88

SELTO, Frank H. and Hugh D. GROVE [1983] 'The Predictive Power of Voting Power Indices: FASB Voting on Statements of Financial Accounting Standards Nos. 45–69' *Journal of Accounting Research* Vol. 21 No. 2 (Autumn 1983) pp. 619–22

SHAPLEY, L. S. and M. SHUBIK 'A Method for Evaluating the Distribution of Power in a Committee System' *American Political Science Review* 48 (1954) pp. 787–92

SKINNER, Ross M. [1973] 'Brave New Beginning or Dead End?' *CA Magazine* Vol. 106 No. 12 (December 1973) pp. 12–15

SKOUSEN, K. Fred [1976] *An Introduction to the SEC* South-Western Publishing Co. (1976)

SOLOMONS, David [1978] 'The Politicization of Accounting: The Impact of Politics on Accounting Standards' *Journal of Accountancy* Vol. 146 (November 1978) pp. 65–72

SOLOMONS, David [1983] 'The Political Implications of Accounting and Accounting Standard Setting' *Accounting and Business Research* Vol. 13 No. 50 (Spring 1983) pp. 107–18

SOLOMONS, David [1986a] 'The FASB's Conceptual Framework: An Evaluation' *Journal of Accountancy* Vol. 161 (June 1986) pp. 114–24

SOLOMONS, David [1986b] *Making Accounting Policy: The Quest for Credibility in Financial Reporting* Oxford University Press (1986)

SOLOMONS, David [1989] *Guidelines for Financial Reporting Standards* ICAEW (1989)

SPROUSE, Robert T. [1983] 'Standard Setting: the American Experience' in (ed.) Bromwich and Hopwood (1983)

SPROUSE, Robert T. [1988] Interview with the author, 6 September 1988

SPROUSE, Robert T. and Maurice MOONITZ [1962] *A Tentative Set of Broad Accounting Principles for Business Enterprises* (Accounting Research Study No. 3) AICPA (1962)

STAMP, Edward [1980] 'Accounting Standard Setting . . . A New Beginning, Evolution not Revolution' *CA Magazine* Vol. 113 No. 9 (September 1980) pp. 38–43

STAMP, Edward [1981] 'Accounting Standards and the Conceptual Framework: A Plan for Their Evolution' *The Accountant's Magazine* (July 1981) pp. 216–22

STAMP, Edward [1982] 'First Steps Towards a British Conceptual Framework' *Accountancy* (March 1982) pp. 123–30

STAMP, Edward [1985] 'The Politics of Professional Accounting Research: Some Personal Reflections' *Accounting, Organizations and Society* Vol. 10 No. 1 (1985) pp. 111–23

STAMP, Edward, G. W. DEAN and P. W. WOLNIZER (eds.) [1980] *Notable Financial Causes Célèbres* Arno Press (1980)

STAUBUS, George [1988] Interview with the author, 12 September 1988

STERLING, Robert R. [1979] *Towards a Science of Accounting* Scholars Book Co. (1979)

STERLING, Robert R. [1985] *An Essay on Recognition* R. J. Chambers Research Lecture, University of Sydney (1985)

STERLING, Robert R. [1988] Interview with the author, 14 September 1988

STIGLER, George J. [1971] 'The Theory of Economic Regulation' *Bell Journal of Economics and Management* (Spring 1971) pp. 3–21

STOREY, Reed K. [1964] *The Search for Accounting Principles: Today's Problems in Perspective* AICPA (1964)

STOREY, Reed K. [1988] Interview with the author, 7 October 1988

STREIT, Robert [1988] Interview with the author, 19 September 1988

SUTTON, Timothy G. [1984] 'Lobbying of Accounting Standard-Setting Bodies in the UK and the USA: a Downsian Analysis' *Accounting, Organizations and Society* Vol. 9 No. 1 (1984) pp. 81–95

SWIERINGA, Robert J. [1988] *An Anatomy of an Accounting Standard: Accounting for Income Taxes* R. J. Chambers Research Lecture, University of

Sydney (1988)

TINKER, Anthony M. [1984] 'Theories of the State and the State of Accounting: Economic Reductionism and Political Voluntarism in Accounting Regulation Theory' *Journal of Accounting and Public Policy* 3 (1984) pp. 55–74

TINKER, Anthony M., Barbara D. MERINO and Marilyn Dale NEIMARK [1982] 'The Normative Origins of Positive Theories: Ideology and Accounting Thought' *Accounting, Organizations and Society* Vol. 7 No. 2 (1982) pp. 167–200

TRUEBLOOD, Robert M. 'The Trueblood Report', see AICPA [1973]

VAN RIPER, Robert [1987] 'How Accounting Standards Are Set' *Journal of Accountancy* Vol. 163 (April 1987) pp. 130–6

WALL STREET JOURNAL [1989] 'SEC Chief Rejects Idea of Watchdog to Monitor FASB' *Wall Street Journal* (11 January 1989)

WALSH, W. H. [1967] 'Colligatory Concepts in History' from *Studies in the Nature and Teaching of History*, W. H. Burston and D. Thompson (eds.), reprinted in Gardiner (1974)

WALTON, J. [1966] 'Discipline, Method and Community Power: a Note on the Sociology of Power' *American Sociological Review* 31 (1966) pp. 684–9

WATTS, Ross L. and Jerald L. Zimmerman [1978] 'Towards a Positive Theory of the Determination of Accounting Standards' *Accounting Review* Vol. LIII No. 1 (January 1978) pp. 112–34

WATTS, Ross L. and Jerald L. Zimmerman [1979] 'The Demand for and the Supply of Accounting Theories: The Market for Excuses' *Accounting Review* Vol. LIV No. 2 (April 1979) pp. 273–305

WATTS, Ross L. and Jerald L. Zimmerman [1986] *Positive Accounting Theory* Prentice-Hall (1986)

WEBER, Max [1968] *Economy and Society* trans. and ed. by Guenther ROTH and Claus WITTCH, Bedminster Press (1968)

WESTON, Frank T. [1988] Interview with the author, 7 September 1988

WHEAT, Francis M. 'The Wheat Report', see AICPA [1972]

WHITTINGTON, Geoffrey [1987] 'Positive Accounting Theory. A Review Article' *Accounting and Business Research* Vol. 17 No. 68 (Autumn 1987) pp. 327–36

WOLFINGER, Raymond E. [1971] 'Nondecisions and the Study of Local Politics' *American Political Science Review* Vol. 65 (1971) pp. 1063–80

WOOLF, Emile [1976] 'The Astonishing Story of the Salad Oil Swindle' *Accountancy* (June 1976) pp. 78–83. (Reprinted in Stamp, Dean and Wolnizer [1980].)

WRONG, Dennis H. [1979] *Power: Its Forms, Bases and Uses* Blackwell (1979)

WYATT, Arthur [1977] 'The Economic Impact of Financial Accounting Standards' *Journal of Accountancy* Vol. 144 (October 1977) pp. 92–5

WYATT, Arthur [1987] 'Users and Abusers: Here's the Bottom Line on the Accounting Profession' *Barrons* (14 September 1987) pp. 13–21

ZEFF, Stephen A. [1972] *Forging Accounting Principles in Five Countries: A History and An Analysis of Trends* Stipes (1972)

ZEFF, Stephen A. [1978] 'The Rise of "Economic Consequences"' *Journal of Accountancy* Vol. 146 (December 1978) pp. 56–63

ZEFF, Stephen A. [1982] (ed.) *The Accounting Postulates and Principles Controversy of the 1960s* Garland (1982)

ZEFF, Stephen A. [1988] *Recent Trends in Accounting Education and Research in the USA: Some Implications for UK Academics* Paper given at the BAA Conference, Trent Polytechnic (April 1988)

ZEFF, Stephen A. and Thomas F. KELLER (eds.) *Financial Accounting Theory: Issues and Controversies* McGraw Hill (1985)

Index